STORYWORK
THE PRINTS OF MARIE WATT

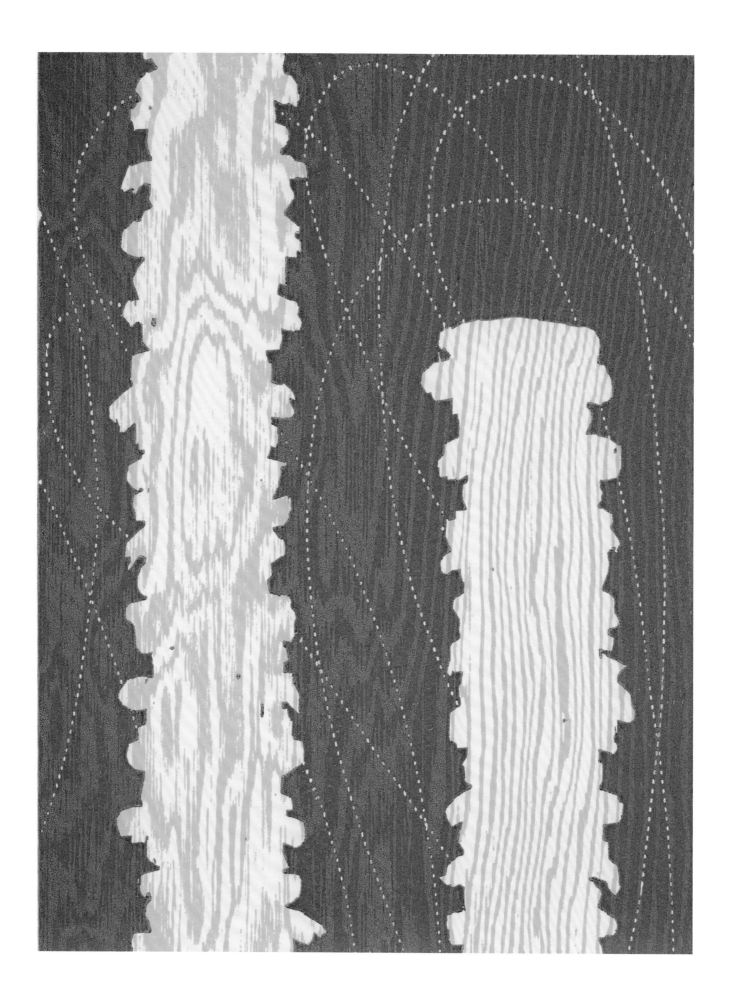

STORYWORK
THE PRINTS OF MARIE WATT

FROM THE COLLECTIONS OF JORDAN D. SCHNITZER AND HIS FAMILY FOUNDATION

JOHN P. MURPHY

with an essay by JOLENE RICKARD

JORDAN SCHNITZER FAMILY FOUNDATION
UNIVERSITY GALLERIES, UNIVERSITY OF SAN DIEGO

CONTENTS

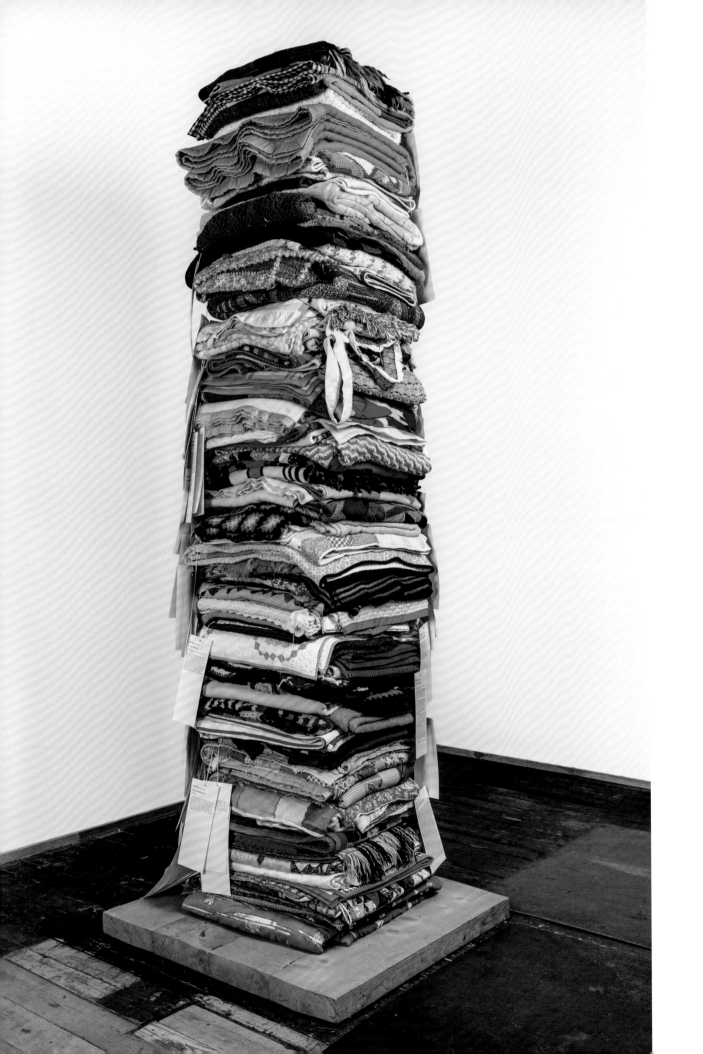

COLLECTOR'S STATEMENT

WHEN I WAS IN THE THIRD GRADE in my home-town of Portland, Oregon, my mother opened the Fountain Gallery of Art, which focused on contemporary Pacific Northwest artists—so my love of art started at a young age. In the late 1980s, I began to collect prints and multiples by leading modern and contemporary American artists, and that collection is now in excess of 19,000 works. This collection supports our exhibition program, which has traveled to more than 160 museums in this country and abroad.

I first encountered Marie Watt's prints at Crow's Shadow Institute of the Arts, which is on the Confederated Tribes of the Umatilla Indian Reservation in the foothills of Oregon's Blue Mountains. Marie has since been an artist-in-residence there five times. I fell in love with the subtle beauty of her prints, their delicate textures and organic shapes, which often relate to the stories behind her amazing blanket sculptures. Her work at Crow's Shadow, along with that of other artists-in-residence there, inspired me to begin a printmaking residency of my own at the Sitka Center for Art and Ecology near the beautiful town of Otis on the coast of Oregon. Marie has since done four residencies at

Sitka as well, producing many breathtaking works. Following Marie's career over the past several years, I feel very fortunate to now own more than sixty works by her. She is an essential part of the Pacific Northwest arts community, and I am proud of the critical acclaim she has received nationally and internationally.

When Derrick R. Cartwright, director of the University Galleries at the University of San Diego, and John Murphy, then Hoehn Curatorial Fellow for Prints, University Galleries, first approached me three years ago about doing an exhibition of Watt's work from my collections, I was delighted. As Watt is a member of the Seneca Nation and a Portland-based artist, we were thrilled to showcase her amazing work and let it speak to new audiences. In addition to thanking Derrick, John, and their staff at the University Galleries, I am always appreciative of the work of William Morrow, our director of exhibitions; Catherine Malone, our director of collections; and our team of eleven hardworking staff—without whom the art would not make its way from our warehouse to world-class gallery spaces like those at the University of San Diego.

I have often said that artists are chroniclers of their times. They force us to confront issues that are often difficult but also important for us to face as individuals. Marie's art takes us on a journey to another time and place. We travel back thousands of years to Native communities that lived on this honored land. She teaches us to see Native symbols and images that tell the story of those who came before us. Marie brilliantly uses that same symbolism to help us understand contemporary Indian Country. Thank you, Marie, for being our guide, for helping us see and understand the history of our land and the people who have lived amid its grandeur.

JORDAN D. SCHNITZER
AUGUST 17, 2021

DIRECTOR'S FOREWORD

WORKING CLOSELY WITH LIVING ARTISTS is always a privilege. The opportunity to observe Marie Watt's creative vision over the past several years has been a special honor, however. This project exposed everyone involved to the artist's generous habits at an unusual time. Closures forced by a global pandemic and the demands of her own widening critical success affected its outcome. In the end, I think those forces have only sharpened the significance of the exhibition and this accompanying scholarly catalogue. I would like to express appreciation, first and foremost, to Marie, for her investments of time and ideas, twin commitments that sometimes meant being away from the studio and apart from the family she cherishes. More than anything else, the artist's uncompromising dedication has ensured the success of *Storywork: The Prints of Marie Watt*. For her part, the artist wishes to thank her team, Madalyn Barelle, studio director, and Stephanie Sun, project manager. Additional gratitude goes to her parents, Dave and Romayne Watt; husband, Adam; and kids, Max and Evelyn McIsaac—all of whom are known for rolling up their sleeves and pitching in. As prints and collaboration are interwoven in her practice, Watt wishes to acknowledge community participants who've imprinted social gatherings with lasting stories and multigenerational connections.

This publication owes its elegant form to the inspired philanthropy of Jordan Schnitzer and the staff at the Jordan Schnitzer Family Foundation, based in Portland, Oregon. I seize this chance to acknowledge a friendship with Jordan Schnitzer that stretches over several decades and which is accompanied by admiration for his vision of collecting and sharing original prints with the museum world. The vast collection that Schnitzer has built pays tribute to artists, like Marie Watt, who bring a deep sense of social responsibility to bear on their printmaking practices. I thank him for lending important, in some cases unique, impressions by Marie to this survey effort. Within the Jordan Schnitzer Family Foundation, I express heartfelt gratitude to William Morrow, director of exhibitions; Catherine Malone, director of collections; Emily Kramer, exhibitions registrar; and Jessica Butler-Roberts, publications coordinator, for their facilitating roles. The sharp editorial skills of Carolyn Vaughan and Carrie Wicks and the design work of Phil Kovacevich, also merit

special recognition. I hope that these talented colleagues will enjoy sharing credit for this project's timely success.

Due in great measure to William Morrow's promotional effort, an exhibition that was first imagined only for the University of San Diego will ultimately travel to multiple venues and will be seen by a larger, more diverse audience. With pride in this collaboration, I signal thanks to the talented teams at those partner institutions. At the Art Museum of West Virginia Unversity in Morgantown, I am grateful to Todd J. Tubutis, director; Robert Bridges, curator; and Heather Harris, educational programs manager. At Cornell University, I am grateful especially to Jolene Rickard, associate professor in the Departments of History of Art and Art, who, in addition to providing enthusiastic support, has contributed an insightful essay to this catalogue. At the Herbert F. Johnson Museum of Art on Cornell's campus, I wish to acknowledge Jessica Levin Martinez, the Richard J. Schwartz Director; Andrea Inselmann, curator of modern and contemporary art; and Matt Conway, registrar. At the Krannert Art Museum at the University of Illinois at Urbana-Champaign, I wish to especially thank Jon Seydl, director; Amy L. Powell, curator of modern and contemporary art; Maureen Taylor, curator of European and American Art; and Christine Virginia Saniat, museum registrar and exhibitions director. At the Virginia Museum of Contemporary Art in Virginia Beach, I thank Heather Hakimzadeh, curator; and at the Crocker Art Museum in Sacramento, Scott A. Shields, associate director and chief curator.

This project benefited from the involvement of numerous individuals over the past three years. In particular, we thank Jane Beebe and Jordan Pieper at PDX Gallery in Portland, Greg Kucera at Greg Kucera Gallery in Seattle, and Marc Straus and Tim Hawkinson at the Marc Straus Gallery in New York

City. They are caring stewards of Marie's work. The artist's excellent relationships with master printers extended to us, too: Karl Davis and Frank Janzen at Crow's Shadow, Nancy Zastudil at Tamarind Institute, and Julia D'Amario and Tamara Jennings at Sitka Center for Art and Ecology all shared essential knowledge, for which we are grateful. Willamette University's Hallie Ford Museum of Art has long demonstrated a commitment to its alumna's work, and it holds the print archive of Crow's Shadow; Jonathan Bucci, curator at Hallie Ford, shared these resources. Mullowney Printing, including Paul Mullowney, Harry Schneider, and Alejandra Arias Sevilla, has also contributed to the artist's most recently published prints. Here in San Diego, we record our appreciation to Kathryn Kanjo, the David C. Copley Director, and Anthony Graham, associate curator, at the Museum of Contemporary Art, as well as to Mary Beebe, the long-serving director of the Stuart Collection at the University of California San Diego. All these colleagues were early and ardent supporters of Marie's practice in all media.

At the University of San Diego, appreciation begins with the acknowledgment that our institution exists on the historic lands of the Kumeyaay Indian Nation. I am grateful to Gail F. Baker, vice president and provost, for her steadfast support of University Galleries' primary mission to expose our community to "the finest things that artists have created." Like us, she believes Watt's print oeuvre counts high among such things. Acknowledging the key roles of Roger C. Pace and Jennifer Zwolinski, vice provosts, respectively, from 2020 to the present and from 2016 to 2019, is a professional pleasure. They took interest in this project from the start and were passionate supporters of its continuation even when the campus itself shut down due to public health precautions. Noelle Norton, dean of the College

of Arts and Sciences, immediately understood the importance of bringing Marie Watt to campus as a Knapp Chair of the Liberal Arts, an annual honor reserved for distinguished scholars across the humanities. In the same way, I thank Persephone Hooper-Lewis, tribal liaison, and Jesse Mills, Angel Hinzo, and Josen Diaz, professors of ethnic studies, and Atreyee Phukan, associate professor of English, for their unstinting support over several years' time. Bill Kelly, printmaking instructor in the Department of Art, Architecture + Art History, was an ongoing source of inspiration and encouragement. Members of University Galleries' Curatorial Advisory Committee were engaged and enthusiastic throughout the planning stages and through to these compelling works' installation in several of the campus galleries. Names of those current and former volunteers appear here along with my appreciation: Vanessa Herbert, Robert Hoehn, Victoria Sancho Lobis, Juliana Maxim, Erin Sullivan Maynes, Jessica Patterson, Roxana Velàsquez, Malcolm Warner, John Wilson, and Sally Yard. Finally, I wish to express my admiration to Susanne Stanford, USD trustee, for her wise counsel and her enthusiasm for the galleries' increasingly diverse efforts.

For the University Galleries team, *Storywork: The Prints of Marie Watt* stands as a demonstration of what careful strategic planning can deliver to a small program like ours. A primary goal of that planning has been to involve students in all projects that we undertake. In this case, my colleagues and I learned much from interns over a period of several years, Sarah Kushner (class of '21) and Cara Treu (class of

'19) most particularly. Suzie Smith, assistant curator, and Joyce Antorietto, formerly collections specialist, played an integral role in cataloguing works by Marie Watt that became part of the May Collection. Katherine Powers Noland, operations manager, handled all logistics of planning and installation. She did so with typical precision and good attitude, in spite of physical distance and other unforeseen obstacles. A lesser professional might have faltered under these conditions, but not Katherine.

Most critically, this exhibition is the product of John P. Murphy's highly successful tenure as the Hoehn Curatorial Fellow for Prints (2018–21). When first presented with a concept for this show, John immediately grasped the significance of Marie's work in print media and made the project entirely his own. His scholarly gifts are evident in the comprehensive essay he crafted for this book as well as the scope of the exhibition itself. We all owe John a large debt of gratitude for the commitment and vision he brought to a little-studied aspect of this important artist's career. The connections that John has revealed between printmaking and wider dimensions of Marie's creative practice may have even surprised the artist herself. And while that is saying quite a lot, what follows these pages says still more.

DERRICK R. CARTWRIGHT

DIRECTOR OF UNIVERSITY GALLERIES AND ASSOCIATE PROFESSOR OF ART HISTORY

STORYWORK
THE PRINTS OF MARIE WATT

JOHN P. MURPHY

MARIE WATT IS A STORYTELLER, a weaver of dreams, a visual poet of warp and weft. Her artistic practice—traversing sculpture, textile, installation, and print-making—is knit together by recurring themes, symbols, forms, and materials. The granddaughter of Wyoming ranchers and an enrolled member in the Turtle Clan of Seneca Nation (Haudenosaunee), Watt has described herself as "half cowboy and half Indian," conscious of the entangled histories of colonizer and colonized. Braids, circles, loops, and Möbius strips regularly appear in her work, signs of the complex plaiting of personal and cultural identity, memory and myth, past and present (fig. 1).

This catalogue offers the first sustained inquiry into Watt's engagement with print processes and techniques, an engagement that is ongoing and central to her practice. Residencies at the Crow's Shadow Institute of the Arts, the Sitka Center for Art and Ecology, and the Tamarind Institute have afforded Watt the opportunity to collaborate with master printers in producing formally and conceptually ambi-tious print editions. The logic of printmaking—collaborative, artisanal, translational, multiple, open-ended—informs Watt's work across media.

A survey of Watt's prints highlights thematic through lines: dreams, thresholds, myths, mem-ories, motherhood, and the meanings that inhere in everyday objects. Watt frequently draws on the Seneca Creation Story and key Seneca principles related to kinship and ecological stewardship. As Jolene Rickard (Skarù·rę? / Tuscarora) has written, "The deployment of tradition as strategic cultural resistance is part of Haudenosaunee history."[1] Watt imbricates Seneca tradition with other traditions, Native and non-Native: Greco-Roman mythology, the cultures of Coast Salish and Plains tribes, the pop culture myths of *Star Wars* and *Star Trek*, the social sculpture of Joseph Beuys, and the geometric hard edges of minimalism. Watt's prints testify to Seneca culture as a dynamic tradition, alive to the ever-shifting and evolving cultural landscape, a form of sovereignty and "survivance"—Indigenous self-expression and self-determination that bear witness to the active presence of Native peoples today.[2]

FIG. 1. *Portal*, 2002, lithograph (detail of p. 81).

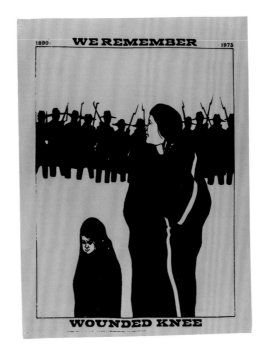

FIG. 2. **BRUCE CARTER** (American, 1930–2016), *We Remember Wounded Knee*, 1974; offset lithograph, 23 × 17½ in. (58.4 × 44.5 cm); Print Collection, University of San Diego.

FIRST IMPRESSIONS

The Haudenosaunee ("People of the Longhouse") is a confederacy of Six Nations—Mohawk, Oneida, Onondaga, Cayuga, Seneca, and Tuscarora—whose historical territories comprise the area of present-day New York between the Adirondacks to the east and Lakes Ontario and Erie to the west. Watt's mother grew up on the Cattaraugus Reservation in upstate New York and worked for nearly three decades as a Title IX Indian Education Specialist for the Lake Washington School District in the suburbs east of Seattle. The Seneca is a matrilineal society: the rights of clan, land ownership, and tribal enrollment are passed down through women. Watt's mother has proved the vital link to the artist's Seneca heritage.

Born and raised in the Pacific Northwest, Watt attended Willamette University in Salem, Oregon, where she made her first print in a course taught by James Thompson. The principles of printmaking are straightforward. Artists make a design on a matrix

(a woodblock, metal plate, or limestone, for example), and the matrix is used to transfer the design to paper, often with the aid of a press. The process can be simple or elaborate, but the goal remains the same: to produce multiple versions of the original design. Each print pulled from the matrix is an "impression," an independent work of art, most often issued in signed limited editions.

As Rebecca J. Dobkins and heather ahtone remind us, printmaking relies on a material, paper, that has "historically functioned as a weapon of domination and power over Native peoples."[3] Paper was integral to the legal and economic systems of settler colonialism that dispossessed Indigenous communities of lands and rights, often on the basis of paper edicts or treaties. Yet printmaking has also served as a valuable resource for Native artists historically excluded from mainstream galleries and museums. Prints, relatively cheap and reproducible, have a long history of speaking truth to power, in

FIG. 3. JEAN LAMARR (Northern Paiute/Achomawi, b. 1945), *Cover Girl Series*, edition 13/15, 1990; lithograph on paper, 28¼ × 37¼ in. (71.8 × 94.6 cm) PU-75; Gift of the Artist, 1991; Courtesy of the IAIA Museum of Contemporary Native Arts, Santa Fe, New Mexico. © Jean LaMarr

FIG. 4. *When More Than Knees Have Been Wounded*, edition 4/5, 1990; lithograph on paper, 29¾ × 22 in. (75.6 × 55.9 cm) SEN-36; Printmaking Studio Collection, 1995; Courtesy of the IAIA Museum of Contemporary Native Arts, Santa Fe, New Mexico.

support of a range of social justice causes and protest movements, including the American Indian movement (fig. 2).

Printmaking is part of the curriculum at the Institute of American Indian Arts (IAIA), founded in Santa Fe in 1962. Established and operated by Native artists, the IAIA gives Native students an opportunity to receive professional art training in a context that honors their heritage. Watt enrolled as a post-baccalaureate student in IAIA's Museum Studies program and studied printmaking with Jean LaMarr (Northern Paiute/Achomawi), "one of the hardest teachers I had, but also one of the best," Watt remembered. LaMarr had attended the University of California, Berkeley, in the early to mid-1970s, where her encounters with the Chicano and American Indian movements supplied concrete examples of print deployed as a form of political speech and agitprop. Watt recalled that LaMarr "had high expectations and she wanted you to truly

understand printmaking, its subtleties, and all its applications." Her work as an artist-activist—such as her ironic *Cover Girl* lithographic series (fig. 3)—made an impression on the young Watt, who described her time at IAIA as a "crash course on Native art and politics."[4]

Watt's grappling with her self-conception as a Native person and artist is evident in an early etching, *More Than Knees Have Been Wounded* (fig. 4). The title refers to the 1890 Massacre at Wounded Knee, South Dakota—the mass slaughter of Lakota people by the United States Army—as well as the 1973 occupation of Wounded Knee during the American Indian Movement. Watt cites several stereotypical associations with "Indianness"—the teepee, the feathered headdresses, and a line of figures stretching horizontally in a paper-doll chain. Snatches of words and phrases in stenciled block letters intersperse throughout the composition, including the racist lyrics of the children's song *Ten Little*

Indians. The apple in the lower left (above and below which appear the words "What Is Your Core") is the proverbial gift to a teacher but also the poisoned fruit of the Tree of Knowledge. In Native vernacular, an apple symbolizes an assimilated Indian, "red on the outside, white on the inside"—someone who had internalized white settler colonial biases and prejudices. The etching makes visible the psychological wounds of a traumatic history, both collective and personal.[5]

YALE AND PORTLAND

After the Native immersion of IAIA, the relative homogeneity of New Haven, Connecticut, where Watt relocated as a graduate student in Yale University's MFA program, came as a shock. Adrift from the anchor of an Indigenous community, Watt sought out motifs that would tether her to Seneca culture. She began incorporating corn husks in her work; the material was "personally meaningful," she remembered, and "metaphorically represented home."

Corn was one of the staple crops of the Seneca; corn, beans, and squash were honored as Diohe'ko, the Three Sisters, life-sustaining crops given by the Creator. In hills and fields, women planted, cultivated, and harvested the crops close together in a method known as companion planting, generating a mutually beneficial ecosystem.[6] Watt explained: "The Three Sisters have more strength and vitality when they support each other. They represent the nutritional and spiritual sustenance of our community."[7] The husks of a corncob, strong but flexible, came to serve many purposes in Seneca culture: for kindling, twining, or food storage; they could also be woven to make baskets, mats, bottles, or ceremonial items. Dry corn husks are fragile, but tough and resilient when wet—qualities that Watt associated with the Seneca Nation.

At Yale, the overt politics of Watt's IAIA work sublimated into a more cerebral and minimalist, if still personal, exploration of meaning and materiality. The translucent quality of corn husks captivated Watt, their surfaces animated by a network of veins that form brick and lozenge shapes. She engraved several studies of corn husks, gouging long, sinuous lines into the square plates that resemble thick strands of hair (pp. 58, 59). The prints register a sense of Watt's physical effort; dragging or plowing the burin, a sharp instrument, through the plate generates metal burrs on either side of the incised line, velvety when inked. Watt's Yale engravings charted a new aesthetic path toward repeated motifs, and an almost meditative rhythm or patterning of pared-down elements.

After graduating from Yale in 1996, Watt returned to the Pacific Northwest as art instructor at Portland Community College. She continued to experiment with intaglio techniques at Inkling Studio, a printmaking cooperative in Southwest Portland formed in the early 1980s. Watt had initiated but never realized a series of prints as part of her MFA thesis project at Yale; she carried on the unfinished work in Portland. At Inkling, Watt editioned a study of corn, lozenge, and brick: two rectangular plates, side by side, contrasting studies of dark and light (p. 60). The lozenge shapes could be epidermal, a magnified view of the surface of skin; they also form a kind of brick wall or masonry, while also referring to kernels of corn. These lozenge-shaped marks recur as a reflexive feature of Watt's prints, reconceptualizing repetition (a formal as well as technical feature of printmaking) as intimate, even corporeal, rather than mechanical.

An untitled soft-ground etching from 2000 (p. 61) introduced the motif of braided hair in a limited two-color palette. Hair is a synecdoche for the human, a part that symbolically represents the

whole: it grows, it contains DNA, it records our age and experience. Strong yet pliant, hair shares qualities with corn husks; Watt combined the two motifs by evoking husks in the etching's yellow ground and texture. The hunk of hair seems severed, a reference to the practice in government boarding schools of shearing the plaited hair worn by Indigenous children. That practice was part of the strategy of assimilation and repressing tribal language and culture. Hair and braids for Watt evoked at once "traditional native identity, a genetic marker, a ledger of passing time, and the intrusion of western educational reform."[8]

SITKA CENTER FOR ART AND ECOLOGY

The year 2002 marked a turning point in Watt's print practice, an *annus mirabilis* in which she editioned no fewer than twelve prints and established enduring partnerships with two master printers.

In the spring of 2002, Watt arrived as one of the first artists to participate in the Sitka Center for Art and Ecology's Jordan Schnitzer Printmaking Residency. Named for the Sitka spruce trees native to the area, the center is located on the central Oregon coast, ancestral homeland of the Nachesna/ Salmon River people of the Tillamook, the southernmost tribe belonging to the Coast Salish language group. The nearest town is seven miles away, and the remote setting is part of the residency's character. Residents are encouraged to explore the ecosystem of the Cascade Head and Salmon River estuary: the forest, river, marshes, grasslands, and coastline.

Collaboration, so central to Watt's practice, is intrinsic to the procedure of the professional print studio, where an artist works in concert with a master printer to achieve desired results. At Sitka, Watt began a partnership with Julia D'Amario, a seventeen-year veteran of Pace Editions in New York,

where she worked with artists such as Jim Dine and Chuck Close. D'Amario came to Sitka as a resident artist in 1997 and agreed to return as the center's master printer when it established the Schnitzer Printmaking Residency in 2002. Watt, who taught during the week in Portland, made weekend trips to Sitka over the course of April and May, ultimately editioning eight etchings with D'Amario.

The residency's emphasis on ecology suggested to Watt forms inspired by the coastal region. *Three Rocks* (p. 73) referenced one of the Oregon coast's famous natural landmarks: Three Arch Rocks off the northern Oregon coast, a habitat for endangered seabirds and sea lions. Seen from a bird's-eye view, the three rocks dissolve into a dappled mist. In *Untitled* (p. 71) and *Proposal (Variation)* (p. 69), thin hoops twist and twine around a spectral shape that resembles Proposal Rock, a sea stack just off the coast of Neskowin, Oregon.

The prints coalesced around a cluster of themes suggested by the titles: curtains, gates, clouds. Watt based her prints on a series of minimalist drawings made with alabaster dust and white ink, exhibited in 2002 at PDX Contemporary Art as *Sleep and Sleeplessness: Blanket/Sieve*. The dreamlike etchings evoke the threshold between sleep and waking, with forms more suggested than delineated. Crepuscular light suffuses *Curtain* (p. 77), and the vignette effect in *Gate* (p. 70) suggests the slow dispersal of darkness. Watt deployed a stippling technique to create the ethereal *Cloud/Dust* (p. 75), a nod to the fabled sandman who sprinkles sand in the eyes of children to induce sleep.

The weblike hoops visible throughout the Sitka prints suggest the loops of a dream catcher, an amulet that features prominently in Watt's early prints. The dream catcher supposedly originated with the Ojibwe tribe north of the Great Lakes. Nightmares tangled in the sinewy strands and scattered with the

morning light. The collective sharing and interpretation of dreams played an important role in Seneca culture—the sacred dream-guessing ceremony, for example—and the dream catcher shares qualities with medicine objects in that tradition. Yet the dream catcher remains a fraught symbol, popularized during the pan-Indian movement in the sixties and seventies as part of an ersatz "neo-Indian spirituality."[9] The twisting parabolas of Watt's dream catchers limn the intricate webs of post-contact Native experience: new myths and identities born of the feedback loops between colonizer and colonized, assimilation and resistance.

CROW'S SHADOW INSTITUTE OF THE ARTS

In 2002, Watt also began a fruitful creative partnership with the Tamarind-trained master printer Frank Janzen, who has printed eighteen of Watt's editions at Crow's Shadow Institute of the Arts over the course of five separate residencies spanning fifteen years. This long-standing association has led Watt to describe herself as the "poster child" for Crow's Shadow, which has emerged in recent decades as a major force for contemporary Indigenous art.

The artists James Lavadour (Walla Walla) and Phillip Cash Cash (Cayuse and Nez Perce) founded Crow's Shadow in 1992 on the Confederated Tribes of the Umatilla Indian Reservation outside Pendleton, Oregon. In spite of its remote location in eastern Oregon, surrounded by wheat fields at the foothills of the Blue Mountains, CSIA has flourished as a center for contemporary Native art. Over its twenty-five-year history, visiting artists have included Rick Bartow (Wiyot), Joe Feddersen (Colville), Edgar Heap of Birds (Cheyenne/Arapaho), Wendy Red Star (Apsáalooke), and Kay WalkingStick (Cherokee).[10]

James Lavadour grew up on the reservation,

established by treaty with the US government in 1855 and home to the Confederated Tribes that includes the Umatilla, Walla Walla, and Cayuse tribes. Betty Feves, an artist whose husband served as the reservation's doctor, offered Lavadour early encouragement and support. He would later say that he founded Crow's Shadow "to institutionalize the help Betty gave me" by paying forward mentorship and training to young artists.[11] (Watt honored Feves, along with two other significant Oregonian women artists, in her 2009 lithograph, *Loom: Betty Feves, Hilda Morris, and Amanda Snyder [off stage]*, [p. 113].) Lavadour and his cofounders converted a vacant Catholic mission schoolhouse into a printmaking facility, formally dedicated in 1997.

Crow's Shadow hired Frank Janzen in 2001 to professionalize the studio and to establish CSIA as a premier print atelier with a focus on lithography. In the fall of that year Watt attended CSIA's "Conduit to the Mainstream," a symposium that gathered pre-eminent Native and non-Native artists, scholars, and museum professionals for dialogue about how Native art could gain wider exposure (see fig. 44, p. 157). Watt connected with several notable art-world figures who would prove formative in her career development, including Eileen Foti, the curator Truman Lowe, and Marjorie Devon, the director of the Tamarind Institute. As Watt put it, "If I connect the dots of the most significant experiences and opportunities in my career, they lead back to this charismatic, quirky, small yet visionary organization in rural Oregon, and it all started with being a participant in the 'Conduit to the Mainstream' symposium."[12]

Crow's Shadow invited Watt in August 2002 to collaborate with Janzen as an artist-in-residence. Her printmaking experience gave them a shared vocabulary, but it was her first attempt editioning in the technically demanding medium of lithography. Watt recalled:

Frank showed me prints that he made at Tamarind. He looked and listened to what I was doing in my studio and suggested things that mirrored my drawing practice, which was really useful. I was drawing with a reed or quill pen at the time and I experimented with that on the plates. They are some of my favorite plates I've ever made.[13]

To create a lithograph, an artist makes a design on the surface of a limestone or plate with a greasy crayon or pencil. The stone's surface is treated with a solution so that ink adheres only to the design elements when passed through a press. Watt applied marks to the lithographic plate with meticulous care; it took her two full days to draw the design for *Sanctuary* (p. 85). She and Janzen spent the first week testing from plates and the second week color trial proofing and working toward an edition. Janzen recalled Watt's painstaking commitment to color mixing, spending up to seven hours testing various combinations of inks to achieve the desired color.[14] In these early prints Watt favored muted earth tones—dusky sage and taupe—that resemble the natural dyes used to tint wool textiles.

Guardian and *Portal* (pp. 84, 81) continue the theme of the dream catcher explored at Sitka: the wires loop and overlap, bending and twisting in curving, graceful lines. *Omphalos* (p. 83) is the earliest instance of the "blanket stack" motif in Watt's prints, with three vertical forms starkly outlined against a field of coiling dream catchers. *Omphalos* is an ancient Greek word meaning "navel": in Greek mythology, a rounded stone symbolized the center of the world and served as a means to communicate with the gods. For Watt, the three blanket stacks have similarly mythic significance: made from the pelts of animals, blankets are dream catchers, warmth-giving shelter, and "ledgers of secrets."

In the early 2000s, Watt began salvaging and stockpiling blankets purchased from thrift stores or donated by friends and acquaintances. Watt considers them "reclaimed" rather than "found" objects, marking the process as part of a larger Indigenous project to reclaim land and sovereignty. Blankets appealed to Watt on a formal and thematic level. They swaddle newborns and cover us on our deathbeds; they are scaled to human bodies and mold to their shapes over time. Stacking them in vertical columns conjured for Watt a host of associations: the Douglas firs of her native Northwest, the towering totems of Coast Salish tribes, Constantin Brancusi's *Endless Column* (1938), or Donald Judd's minimalist sculptures.

When Watt returned to Crow's Shadow for a 2003 residency, she elaborated on the blanket-stack motif. Crow's Shadow is near Pendleton, Oregon, where the famous wool blankets originate. They have become an important part of Native gift economy: heirloom pieces are given at milestone events such as powwows, graduation ceremonies, weddings, and funerals. In *Blankets* (see fig. 37, p. 51 ; p. 88), a forest of blankets, rising like conifers, fills the left half of the composition. The stacks shift in scale and perspective: some large, some small, some drawn in outline, others with each blanket delineated. A central stack, photo transferred, overlays the composition in shades of faded brown and sepia. The polyvalence of the blanket appealed to Watt: its meaning is not fixed or static; it is shaped in time through storytelling and ritual. The blanket's multiple meanings register in the lithograph through palimpsest and repetition.

Star Quilt (p. 87) relates to a large 2003 wool blanket wall piece, *In the Garden (Corn, Beans, Squash)*. In the late nineteenth century, the buffalo robes used by Plains tribes vanished along with buffalo herds, necessitating the turn to quilts for bed and body coverings. Women from Dakota or

FIG. 5. PAUL KLEE (Swiss, 1879–1940), *Letter Ghost (Geist eines Briefes)*, 1937; pigmented paste on newspaper, 13 × 19⅛ in. (33 × 48.6 cm); Purchase. The Museum of Modern Art, New York, NY, U.S.A. © 2021 Artists Rights Society (ARS), New York. Digital Image © The Museum of Modern Art/Licensed by SCALA/Art Resource, NY.

FIG. 6. *Letter Ghost*, 2003; lithograph on Rives BFK tan, 13 × 18 in. (33 × 45.7 cm).

Ojibwe tribes adopted quilting techniques from the wives of Christian missionaries, and acquired cloth and steel needles from trading posts. The star-patterned quilt, so closely identified with Plains Indian culture, was a creative syncretism of forms and materials introduced by colonizers with motifs drawn from Native symbolism.[15] In Watt's interpretation, the diamonds loosen from the rigid geometries of conventional patterns, winding in a serpentine path across the composition—a visual metaphor for the creative adaptation of time-honored motifs by contemporary artists.

Envelopes, like blankets, cover and contain. *Letter Ghost* (fig. 6; p. 86) portrays an envelope with a vertical stripe of deeper red, hinting at hidden histories and private correspondence. People receive news of major life events through letters or announcements: weddings, births, graduations, holidays. A small circle on the envelope with puckered edges indicates a navel or omphalos—a motif

related to the 2002 lithograph. *Letter Ghost* pays homage to Paul Klee's *Letter Ghost (Geist eines Briefes)* (fig. 5), which figures the flaps of an envelope as a spectral being, a disembodied spirit traveling from one person to another.

The three-color lithograph *Braid* (fig. 8; p. 89) anticipated a textile of the same name, one of the largest pieces in her 2004 series of wall works (fig. 7). The Möbius strip, like the circle, has no beginning or end: it represents life cycles on an infinite loop. The size and ambition of the wall piece—composed of hundreds of small diamond-shaped wool snippets sewn into a figure eight symbol—encouraged Watt to solicit help from her friends and social network. She put out a call and invited friends to sewing circles in her home studio. Watt appreciated the storytelling and sense of community that flowed naturally from the group gathered around a project. This experience sparked what would become an important part of Watt's practice: the sewing circle as "social

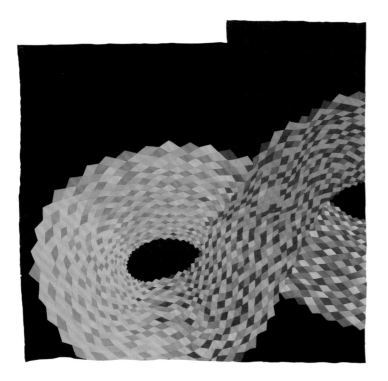
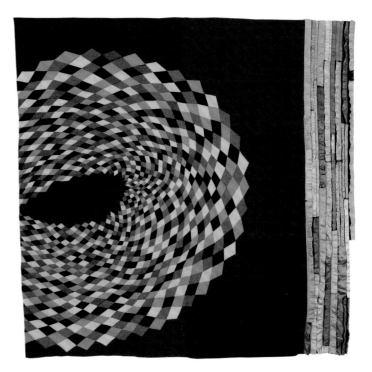

FIG. 7. *Braid*, 2004; reclaimed wool blankets, satin bindings, thread; 128 × 259 in. (325.1 × 658.9 cm). Museum purchase from the Eiteljorg Contemporary Art Fellowship. Eiteljorg Museum of American Indians and Western Art, Indianapolis, Indiana.

FIG. 8. *Braid*, 2003; lithograph on Rives BFK grey, 14½ × 29 in. (36.8 × 73.7 cm).

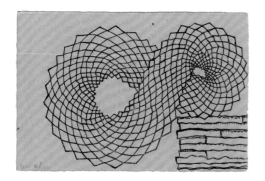

FIG. 9. Gocco prints, dates and editions variable, approx. 4 × 6 in. (10.2 × 15.2 cm) each. Courtesy of Marie Watt Studio.

sculpture," in the sense used by the German artist Joseph Beuys, in which the events themselves are as meaningful as the finished product.

Prints had a role to play in the affective gift economy of the sewing circle. A sign at the circles announced, "I will trade you a print for your time" (fig. 53, p. 169). In exchange for joining a sewing circle, Watt gave participants a small, signed, limited-edition Gocco print (fig. 9). Invented in Japan in the late 1970s, the Gocco printing system allowed Watt to make modestly sized, multicolor screenprints. The Gocco prints, operating outside the commercial economy of galleries and dealers, memorialized the sewing circles and their importance to Watt's evolving practice. "Watching my friends with their heads down, hands busy, stories flowing," she recalled, "I learned once again the importance of community."

THE TAMARIND INSTITUTE

In 1960, the artist June Wayne founded the Tamarind Lithography Workshop in Los Angeles, a premier print atelier that contributed to the revival of fine art lithography in the United States. Ten years later it relocated to Albuquerque and became the Tamarind Institute, affiliated with the University of New Mexico. The rich Native culture of the Southwest led to collaborations with Fritz Scholder (Luiseño), T. C. Cannon (Caddo/Kiowa), and Jaune Quick-to-See Smith (Salish-Kootenai), among others, over the course of the 1970s.[16]

The 2006 exhibition and publication *Migrations: New Directions in Native American Art* grew out of "Conduit to the Mainstream," the 2001 symposium at Crow's Shadow that was critical to Watt's early career trajectory. Marjorie Devon, director of the Tamarind Institute, attended the symposium and came away inspired to use the institute's resources to help

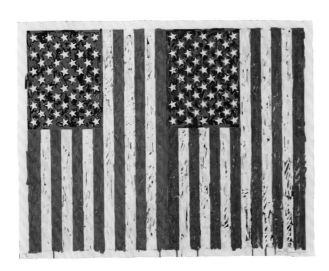

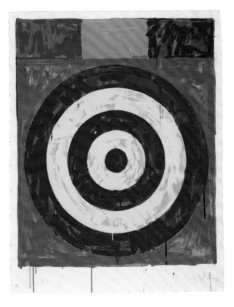

FIG. 10. **JASPER JOHNS** (American, b. 1930), *Flags I*, 1973; screenprint, edition 51/65, 27⅜ × 35⅜ in. (69.5 × 89.9 cm). Collection of Jordan D. Schnitzer © 2021 Jasper Johns / Licensed by VAGA at Artists Rights Society (ARS), NY.

FIG. 11. **JASPER JOHNS** (American, b. 1930), *Target*, 1974; screenprint, edition 44/70, 35 × 27½ in. (88.9 × 69.9 cm). Collection of Jordan D. Schnitzer © 2021 Jasper Johns / Licensed by VAGA at Artists Rights Society (ARS), NY.

cultivate emerging Native talent. Devon and Tamarind staff developed the idea of a traveling group exhibition featuring lithographs by Native artists that would be editioned at Tamarind or Crow's Shadow. They put out a call for nominations of tribally affiliated artists who had not yet had a major museum exhibition.

A panel that included Jaune Quick-to-See-Smith and the Museum of Modern Art curator Deborah Wye reviewed nominees and selected six artists: Steven Deo (Creek/Euchee), Tom Jones (Ho-Chunk), Larry McNeil (Tlingit/Nisga'a), Ryan Lee Smith (Cherokee), Star Wallowing Bull (Ojibwe/Arapaho), and Marie Watt. Half the selected artists collaborated with master printers at Crow's Shadow and the other half at Tamarind. Watt opted to work at Tamarind, where she editioned *Transit, Receive*, and *Three Ladders* (pp. 91, 96, 97 and fig. 38, p. 51) in collaboration with the master printer Bill Lagattuta and the senior printers Deborah Chaney and Jim Teskey.[17] In these prints she elaborated on a "flag"

concept first realized as a large-scale wall piece titled *Flag* (2003) as well as an etching of the same name executed at the Oregon College of Art and Craft (p. 90). By calling the etching and wall piece "Flag," Watt effectively collapsed two central Jasper Johns motifs—the flag and the target—made famous in the series of paintings and prints from the fifties and sixties (figs. 10 and 11).

Watt shares Johns's interest in "things that the mind already knows," such as the elemental shape of the circle, the central form in *Transit* and *Receive*. Such a universal symbol might be, Watt suggests, the basis for a flag uniting all people in a symbol of shared humanity. "As one of the first drawn images in most cultures," Watt noted, "it's inherited memory. Then there is the sewing circle and the Native American medicine wheel. . . . It is also shield-like . . . and an anchor to family and knowledge."[18] Watt also associated the circle with the storytelling circles her mother initiated in the Seattle area as part of her work as an

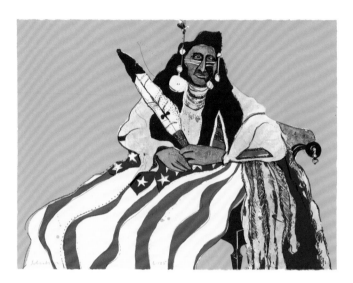

FIG. 12. FRITZ SCHOLDER (Luiseño, 1937–2005), *Bicentennial Indian*, 1975; color lithograph on wove paper, 22⅜ × 29¾ in. (56.83 × 75.57 cm); National Gallery of Art, Washington, Corcoran Collection (Gift of Lorillard Tobacco Company), 2015.19.2595. © Estate of Fritz Scholder

Indian Education specialist. Circles can expand or contract based on the number of participants, and the form implies equality among the participants. The flag partakes of Jolene Rickard's call for "sovereignty" as a critical framework for interpreting Indigenous visual culture, while conjuring the ironic use of the symbol in lithographs such as Fritz Scholder's *Bicentennial Indian* from 1975 (fig. 12).

While printers worked on *Transit* and *Receive*, Watt drew directly on a limestone block to create the design for *Three Ladders*, which brings together the artist's central motifs: the ladder, the star quilt pattern, and the blanket stack. Each motif rises from a curved, banded ground that suggests the concentric circles of the flag/target. Three is a significant number in Seneca cosmology (the Three Sisters, for example), and the lithograph further alludes to the Seneca Creation Story. In the story, a sacred tree tears a hole in the clouds of Sky World, through which Sky Woman falls. Birds and animals help her

settle on Turtle Island (the continental landmass of the Americas) and form the earth. In honor of this original association, the Haudenosaunee consider animals their "first teachers," identifying specific animals with certain clans—Watt, for example, belongs to the Turtle Clan of the Seneca Nation.

DWELLINGS

In 2005, Watt returned to Crow's Shadow, where she and Janzen editioned a suite of subtle, evocative prints that blur distinctions of foreground and background, abstraction and figuration. The palette is largely limited to two colors and the composition to one or two elements, a restraint that gives the prints an elemental quality. They conjure the multiple senses of "dwelling"—a place to live (a dwelling), or the act of thinking about something (to dwell on/upon).

Watt elected to work in woodcut, the oldest medium in the Western print tradition, dating to the

early fourteenth century. Woodcuts require the artist to dexterously cut away the surface of a woodblock except the design to be printed, which stands in relief. As a living, organic material, each block of wood contains variations in the grain, pliability, and response to carving. The artist must be especially sensitive to its character to avoid splitting or splintering the wood. Once the block is carved, the printer inks it and transfers the design to paper, either manually or with the aid of a press.

Instead of gouging the block with a knife, the traditional woodcutting technique, Watt employed a sewing roulette wheel, an instrument with multiple teeth used to transfer patterns onto fabric or to make perforations. When applied to fine-grained Shina plywood, the wheel registered dotted incisions on the surface, creating a stitch-like pattern that tied the woodcuts to Watt's work in textiles. *Mend* (p. 101) makes this association explicit, with the allover use of the roulette wheel to convey a sense of stitched fabric, with a mending patch at the lower right.

Often the stippling effect is more suggestive than descriptive. In *Ladder* (p. 103), for example, the irregular dotted lines might be sheets of rain, an element that bridges earth and sky, set against darker, cloud-like shapes. *Lodge* (p. 99) represents the corner of a longhouse—symbol of the Haudenosaunee confederacy—with a Y-forked wooden pole braced diagonally against the A-framed roof. The roulette wheel created a speckled column rising through the corner frame and cascading down the roof's pitched slope: a mingling of smoke and rain, perhaps, as firepits are a characteristic feature of the longhouse.

The title *Door* (p. 105) is another evocation of the thresholds, gateways, and portals that recur in Watt's work (the Seneca, as the westernmost of the Six Nations confederacy, are known as the "Keepers of the Western Door"). *Door* incorporates the block's wood grain into the composition, emphasizing the

material character of the medium. The pattern and texture of the grain define the two stacks of blankets, which stand silhouetted against the dream-catcher coils of the darker brown background.

Watt would revisit the style and motifs of her 2005 woodcuts six years later during a 2011 residency at Crow's Shadow, when she and Janzen collaborated on a suite of four woodcuts of similar size: *Camp, Tether, Plow, Vest* (pp. 114–19). *Tether*'s attenuated simplicity depends on the yellow dotted lines set against a field of chartreuse: a curtain of rain or a ladder that binds sky and ground. *Plow* has a topographical quality, a view as if seen from the sky of a furrowed field. From the print studio, Watt spied a blue tarp covering a woodpile outside the print-room window and chose to isolate the shape for *Camp*. The 2005 and 2011 woodcuts—with their one-word titles, limited palette, and reduced elements—share a poetic austerity while exploring thematic ideas around shelter, coverings, and dwellings.

BLANKET STORIES

The blanket motif visible in Watt's early prints— *Omphalos* (2002), *Blankets* (2003) and *Three Ladders* (2005), for example—anticipated a body of sculptural work that has since achieved widespread acclaim. From 2003 to 2005, the Smithsonian's National Museum of the American Indian mounted *Continuum: 12 Artists*, a series of installations pairing contemporary Native artists. The curator, Truman Lowe—whom Watt had met at the 2001 "Conduit to the Mainstream" symposium at Crow's Shadow— invited Watt to participate; she was the youngest artist among a cohort that included Rick Bartow, Harry Fonseca (Maidu/Nisenan, Portuguese, Hawaiian), Jaune Quick-to-See-Smith, and Kay WalkingStick.

Watt's contribution, *Continuum: Blanket Stories,* showcased sculptures of stacked blankets on plinths

of wood or stone. While ancient columns were priapic monuments to military victory and imperial power, Watt reorients the meaning of monuments through the soft and malleable wool, gathering associations with home and hearth, collective memories and storytelling, and the dignity of the everyday. Stacked blankets might represent unity in difference, with the variable colors, textures, and patterns of each individual blanket contributing, like the rungs of a ladder, to the overall structure (Watt titled one of her sculptures *Blanket: Ladder*). They are also reminders of the fraught history of cross-cultural trade in the United States, dating back to the arrival of the first European settlers and missionaries. White traders exchanged wool blankets, manufactured in English or French mills, for highly prized pelts, skins, or hides. Native women made the new medium their own, adorning and embellishing the blankets with dyes, mother-of-pearl buttons, silk ribbons, or elk's teeth. Cherished blankets continue to be handed down as heirlooms.[19]

Iterations of *Blanket Stories* have traveled all over the country and around the globe (fig. 13). Two 2007 lithographs published by the Tamarind Institute—*Blanket Stories: Continuum (Book I)* and *Blanket Stories: Continuum (Book I/III)* (pp. 110, 111) —developed directly out of those traveling exhibitions. Watt had invited visitors to share their "blanket stories" in comment books handcrafted by her friend Roberta Lavadour and then transcribed parts of the entries using a marker on glassine. The text, once photographed, could be transferred to the lithographic plate, a text-tapestry of words and memories inked in shades of pink, green, and ochre.

Watt served as an amanuensis, a vessel for channeling the stories of others, an approach that subverts the modernist claim to art as an exclusively personal form of self-disclosure. Watt weaves in a chorus of voices united by a common bond with an

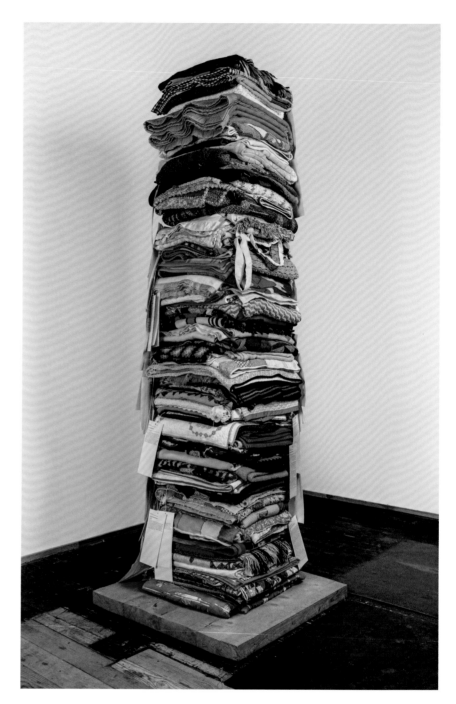

FIG. 13. *Blanket Stories: Great Grandmother, Pandemic, Daybreak,* 2021; reclaimed blankets, manila tags, cedar, 108 × 38¼ × 40 in. (274.3 × 97.2 × 101.6 cm).

everyday item, the blanket, that contains intimate histories and associations. Watt's "voice" is in the handwriting, in the personal character of her script as she records reminiscences from unidentified sources (see fig. 52, p. 168): "I had a blanket from my second birthday. It has different colors. It has pink, blue, orange and red stripes. It is beautiful." "Before I was born, my grandmother made a special blanket . . . I love sleeping with it. Whenever I don't sleep with it, I don't have a good night's sleep. I love it."

Jo-ann Archibald (also known as Q'um Q'um Xiiem) has theorized Indigenous storywork as a form of meaning-making passed down from Elders as "ways to help people think, feel, and 'be' through the power of stories." Archibald outlined seven principles related to Indigenous storywork: respect, responsibility, reciprocity, reverence, holism, interrelatedness, and synergy. She compared these principles to the strands of a cedar basket that "have distinct shape in themselves, but when they are combined to create story meaning, they are transformed into new designs, and also create the background, which shows the beauty of the designs."[20] Archibald might be describing the effect of Watt's *Blanket Stories* lithographs, which give form to "storywork" as woven strands of interrelatedness, mutual respect, and reciprocity. In both lithographs, the nexus of vertical and horizontal lines, interwoven and overlapping, create the silhouettes of blanket stacks: a new kind of monument to humility rather than power, respect rather than dominance, the community rather than the individual.

LANDMARKS

Watt continued her partnership with the Tamarind Institute in 2013 as part of the ambitious initiative *LandMarks: Indigenous Australian Artists and Native American Artists Explore Connections to the Land*, supported by the National Endowment for the Arts. Watt joined fellow artists Chris Pappan (Kaw/Osage/Cheyenne River Sioux), Jewel Shaw (Cree/Metis), and Dyani Reynolds White Hawk (Sicangu Lakota), in traveling to the Yirrkala community of northern Australia to collaborate with Aboriginal artists. The Yirrkala community, a creative and cultural epicenter for Aboriginal art, hosted the US and Canadian artists for dialogue and workshops exploring the theme of communion with the land across Indigenous cultures.

In Australia, Watt made a series of unique etchings (pp. 122, 123) as a way to process themes and ideas. She became aware that the diamond motif she frequently employed was the sign (*miny'tji*) of the Madarrpa clan of the Yirritja moiety, for whom it represented the metamorphosis of an ancestor into a saltwater crocodile. The diamond-shaped pattern of the crocodile's serrated back belonged to the clan's sacred inheritance; it appears, for example, on bark paintings made by the clan's members. Watt's etchings evolved into the lithograph *Landmark: A Thousand Names*, which in turn relates to the large textile piece *East Meets West Summit* (figs. 15 and 14).

Preoccupied throughout her career with themes of shelter and dwelling, Watt dedicated her *Landmark* prints to various Indigenous built environments: Mississippi mounds, ancient Anasazi cliff dwellings, and the Seneca longhouse. A visit to the Laumeier Sculpture Park in St. Louis—which boasts works by Anthony Caro, Niki de Saint Phalle, and Donald Judd among others—inspired *Mound Builder* and *Landmark: Mound Builder* (figs. 16 and 17). The contemporary practice of land art has precontact precedents in Indigenous cultures. Near St. Louis, the people of the ancient Mississippian culture built vast ceremonial mounds, aesthetic and

logistical achievements to rival any contemporary earthwork. In the lithograph, the mounds' meandering outlines press up against a plaid pattern, suggesting the tense coexistence between natural Indigenous forms and the checkerboard grid systems applied by colonial settlers.

For *Landmark: Skywalker,* Watt upended the traditional form of the Seneca longhouse to create a vertical "skyscraper." The title converges pop culture mythology—Luke Skywalker of *Star Wars* fame—with the "skywalkers" of the Haudenosaunee, the structural ironworkers who raised and riveted the steel beams that armature modern city skylines.[21] (In the soft-ground etching *Portrait with Chair Caning [Part II]* [p. 131], the rope-edged perimeter circumscribes an I-shaped figure stamped in black across the lap of the chair. The *I* suggests the first-person singular, while also alluding to the steel I beam, another homage to the predominantly Mohawk skywalkers.) The inverted longhouses rise against a backdrop of free-floating shapes that suggest the early "sky cities" of the Ancestral Puebloans in the southwestern United States.

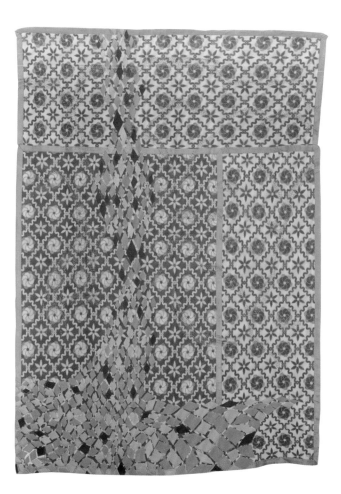

FIG. 14. *East Meets West Summit,* 2014; reclaimed wool blankets, embroidery floss, thread; 121 × 87 in. (307.3 × 221 cm).

TRANSPORTATION OBJECTS

Recently, Watt's prints have become more figurative and explicit in their themes of protest rooted in Indigenous thought and experience. While on a Smithsonian Artist Research Fellowship at the National Museum of the American Indian, Watt came across an archival photograph of a First Nations, Quamichan, potlatch held off Vancouver Island, British Columbia, in 1913 (fig. 18). The Coast Salish people of the Northwest held potlatches (the word, meaning "to give," comes from the Nuu-chahnulth language) as gift-giving ceremonies or festivals. In the Coast Salish economy, wealth was measured by how much a family could give away, not by how

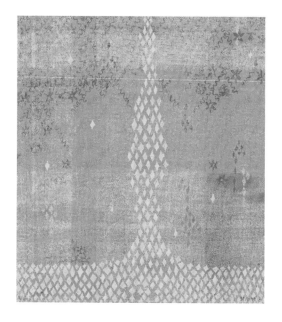

FIG. 15. *Landmark: A Thousand Names,* 2013; lithograph on newsprint grey Somerset velvet, 11 × 10 in. (28 × 25.5 cm).

FIG. 16. *Mound Builder*, 2014; reclaimed wool blankets, thread, and embroidery floss; 96½ × 80 in. (245.1 × 203.2 cm).

FIG. 17. *Landmark: Mound Builder*, 2013; lithograph on newsprint grey Somerset satin; 11 × 10 in. (28 × 25.5 cm).

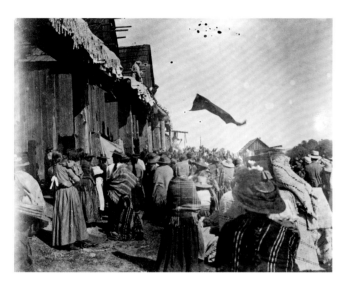

FIG. 18. REVEREND TATE, Quamichan Potlatch, 1913. Coast Salish. Image PN 1500. Courtesy of the Royal BC Museum and Archives.

much it could hoard or accumulate. Blankets were common gifts—so common, in fact, that folded and stacked blankets might touch the ceiling of a longhouse.

The etching inspired by the photograph, *Witness (Quamichan Potlatch, 1913)* (p. 135)—made with Julia D'Amario at a 2014 Sitka Center residency—is a kind of manifesto-in-miniature: a powerful statement intimately scaled at 7 by 8 inches. The host family, standing on the rooftop of a longhouse, casts a blanket through the air to the guests gathered below: a vision of "ecstatic giving," in Watt's words. The sooty charcoal-gray of the scene, achieved through aquatint, contrasts with the vivid red of the blanket suspended between earth and sky. We stand amid the crowd, gathered in an act of collective witness to a moment of exuberant generosity, the ceremony's collective energy concentrated in the blanket's flap and furl.

In reclaiming a photograph taken by a white missionary, Watt gives witness through her etching to an Indigenous ceremony that operated simultaneously as an act of civil disobedience. At the time the original photograph was taken, potlatches were outlawed by the US and Canadian governments. Watt's print enacts what Nancy Marie Mithlo has called "engaged history," a reclaiming of the past (as written or pictured by colonizers) by Indigenous artists as a form of aesthetic and social intervention.[22] Watt considered the act of civil disobedience to resonate with current social movements such as Black Lives Matter and the Standing Rock protests, and she included herself and her daughters in the large 2015 blanket piece *Witness* (fig. 19). "As witnesses," Watt wrote, "we all have responsibilities to be active agents, too, in creating change. For me [the potlatch photograph] is about resilience and perseverance and connectedness."[23]

On the same research trip, Watt discovered that archivists had labeled cradleboards, a traditional baby carrier, as "transportation objects"—a phrase

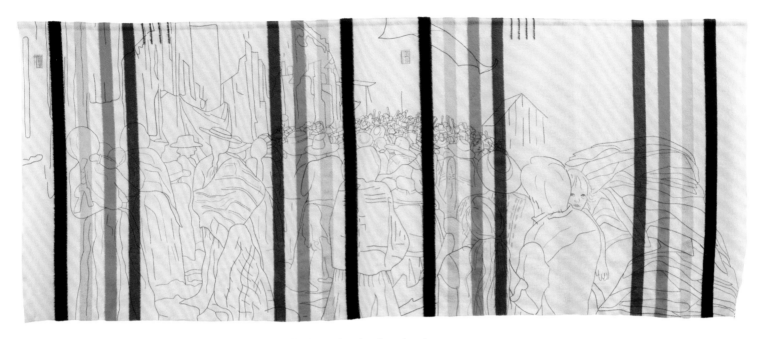

FIG. 19. *Witness*, 2015; reclaimed wool blanket, embroidery floss, thread, 71 × 180½ in. (180.3 × 458.5 cm). Jordan Schnitzer Museum of Art, University of Oregon.

redolent with meaning for Watt. "I have come to think of blankets as transportation objects," she observed, "both physically and metaphorically." Blankets are transportable, moving through time as well as space. In *Transportation Object (Sunset)* (p. 134), Watt focused on the blanket as a stark shape carved out from a field of red, lozenge-shaped marks. Art, in this sense, could be considered a transportation object, spanning time and space in its ability to transport viewers. Prints, even more than paintings or sculptures, circulate in multiple impressions, finding diverse audiences in far-flung locations.

Watt's father worked as an engineer for Boeing, and images of flight and the cosmos suffuse her work. The softground etching *Artifact* (fig. 21 and p. 133) relates to the fabric sampler *Seven Sisters (Shadow Plaid)* (fig. 20 and p. 132) and the larger fabric piece *Trek (Pleiades)*. The Pleiades is a star cluster named for the Seven Sisters of Greek mythology, the daughters of the Titan Atlas and the sea nymph Pleione. Watt merged the Greek myth with the latter-day interstellar mythology of *Star Trek*, resisting the tendency to memorialize Native culture as artifacts in natural history and anthropological museums rather than treat it as a vital contemporary force.

Watt combined this futurism with traditional craft that answers to her self-described proto-feminism. Watt and D'Amario employed a specific softground etching technique to use the fabric sampler as the basis for the print. Invented in the mid-eighteenth century, the tallow-based, pliable softground allows the artist to transfer patterns onto the plate from unconventional materials such as corduroy, lace, gauze, or other textured fabrics. When the fabric and the plate are run together through the press, the fabric's surface pattern imprints on the softground, which is etched when the plate is submerged in the acid bath. This technique denied the signature

FIG. 20. *Seven Sisters (Shadow Plaid)*, 2016; reclaimed wool blanket, embroidery floss, thread, 16¾ × 18 in. (42.6 × 45.7 cm). University of San Diego, David W. May Collection. A2019-3-1.

FIG. 21. *Artifact*, 2014, softground etching on Hahnemühle warm white, 17 × 17 in. (43.2 × 43.2 cm).

"hand" of the artist, bringing the print closer to the anonymity of historical women's work, as referenced by Miriam Schapiro in her *Anonymous Was a Woman* series of softground etchings (fig. 22) made with embroidered antimacassars and doilies.

Issues of craft and gender structure *Portrait with Chair Caning (Part I)* (p. 130), editioned during the same 2014 Sitka residency, which operates on multiple levels of allusion. Its form and title invoke Pablo Picasso's *Still Life with Chair Caning* from 1912 (fig. 23), a signal work in the development of modernism that challenged the boundaries between art and craft, high and low culture, handmade and mass-produced objects—strategies that Watt carries on today. The print also carries personal resonance. Watt paid homage to a grandfather who went blind "as a result of a bad batch of moonshine," the artist recalled, and "who later became an expert at chair-caning." Chair caning, like sewing, is a hand-craft that requires manual dexterity to thread the

cane material across the chair in a warp and weft of vertical, horizontal, and diagonal strips.

Watt wanted the print to "evoke the complexity of my West," as she put it. On her father's side, she hails from Wyoming ranchers and educators, and Watt remembered her conflicting allegiances when watching Western movies as a child: she didn't know whether to root for the cowboys or the Indians. Perhaps to resolve this tension, Watt appropriated the shape of the lasso from an image of the comic-book hero Wonder Woman. In alluding to Wonder Woman (a fixture of Watt's youth in the Lynda Carter television version), she subtly re-gendered the lasso from its associations with the rugged cowboy to a female superhero. Wonder Woman belonged to an all-female society of Amazonian warriors—a reference, for Watt, to Seneca matrilineal culture, and another instance of her blending of pop culture mythology with Seneca tradition.

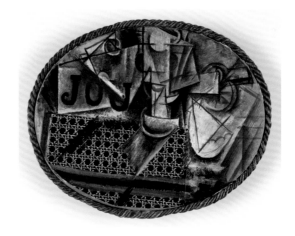

FIG. 22. MIRIAM SCHAPIRO (American, 1923–2015), *Anonymous Was a Woman IV*, 1977; softground etching in blue on Arches paper, 18⅛ × 23¾ in. (46 × 60.3 cm). Gift of the Artist, National Gallery of Art, Washington 1979.9.5 © 2021 Estate of Miriam Schapiro / Artists Rights Society (ARS), New York.

FIG. 23. PABLO PICASSO (Spanish, 1881–1973), *Still-life with Chair Caning*, *Spring 1912*; oil on canvas, 11⅜ × 14⁹/₁₆ in. (29 × 37 cm). MP36. © 2021 Estate of Pablo Picasso / Artists Rights Society (ARS), New York; Photo: Mathieu Rabeau © RMN–Grand Palais / Art Resource, NY.

COMPANION SPECIES

In October 2016, Watt joined Julia D'Amario for a collaboration at the Smith College Print Workshop. (It was a homecoming for D'Amario, who graduated from Smith in 1982.) They developed *Companion Species (Words)* and *Companion Species (Mother)* (fig. 25 and p. 137; p. 140), prints from a body of work exploring themes of human-animal kinship.

In 2003, the scholar Donna J. Haraway published *The Companion Species Manifesto: Dogs, People, and Significant Otherness*, which argued for thinking of humans and canines as interdependent and coevolutionary. This approach rejected the biblical injunction for humans to exercise "dominion over the fish of the sea, and over the fowl of the air, and over the cattle" (Genesis 1:26), a hierarchical logic sanctioning human exceptionalism and conquest. Haraway asked instead, "How might an ethics and politics committed to the flourishing of significant otherness be learned from taking dog-human relationships seriously?"[24] That would entail treating animals in general, and dogs specifically, as "significant others" with their own needs and capacities, rather than as a means to an end.

For Watt, animal-human relations might be re-enchanted through recourse to ancient myths. According to legend, an Etruscan she-wolf rescued the infant twin brothers Romulus and Remus (sons of the god Mars and future founders of Rome) after they had been left to drown in the Tiber. She nursed them to health until they were adopted by a local shepherd. The famous sculpture of the Capitoline Wolf struck Watt for its emphasis on the she-wolf's emaciated torso, embossed ribs, and harrowed expression (fig. 24). The sculpture conveyed to Watt the self-abnegating demands of maternal obligation. "Mother," in this sense, is a placeholder for the ethical obligation to protect, nurture, and sustain life, even at one's own expense.

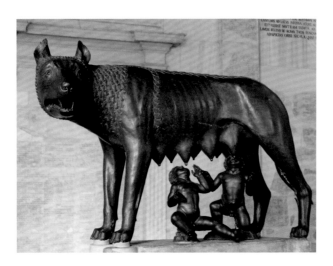

FIG. 24. Capitoline Wolf, 5th century BCE or medieval; bronze, 30 × 45 in. (76.2 × 114.3 cm). Capitoline Museums, Rome. © Vanni Archive / Art Resource, NY.

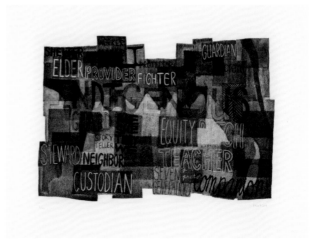

FIG. 25. *Companion Species (Words)*, 2017; softground etching, aquatint, drypoint, on medium-weight, smooth, warm white Hahnemühle, 16½ × 22¼ in. (41.9 × 56.5 cm).

The silhouette of the Capitoline Wolf's legs and udders, in profile, is visible in both etchings made during the Smith College workshop. It appears over the patchworked squares of *Companion Species (Words)* (fig. 25), related to the fabric piece, *Companion Species (Fortress)* (fig. 26). Watt and D'Amario ran the small blanket construction through the press, transferred it onto a softground plate, and etched it, then Watt further worked the plate with drypoint and burnishing. A constellation of bold nouns appears, in uppercase letters, associated with notions of protection and stewardship: *Elder, Provider, Fighter, Guardian, Teacher, Custodian. INDIGENOUS* is the largest word, crossing the upper third of the composition, implying indigeneity as the conceptual framework for the call to protect and nurture the natural environment.

Watt carried on the *Companion Species* theme for her fifth Crow's Shadow residency in 2017, which coincided with Frank Janzen's retirement. They honored their long-standing partnership with a pair of four-color woodcuts, *Companion Species (Anthem)* and *Companion Species (What's Going On)* (pp. 145, 144), each greater in scale and complexity than previous editions.

"Mother, mother" is the opening invocation of Marvin Gaye's "What's Going On," the title track from his classic 1971 album. Gaye's album—which assumed the perspective of a soldier returning home from Vietnam and confronting the country's widespread social unrest—spoke to the efflorescence in the early seventies of protest movements: antiwar, feminism, Black Power, environmentalism, and the American Indian movement. A lattice of words and phrases from the title track fills *Companion Species (Anthem)* in a polyphony of shared appeal and exhortation. In *Companion Species (What's Going On)*, the earthen colors suggest the use of army fatigues or camouflage

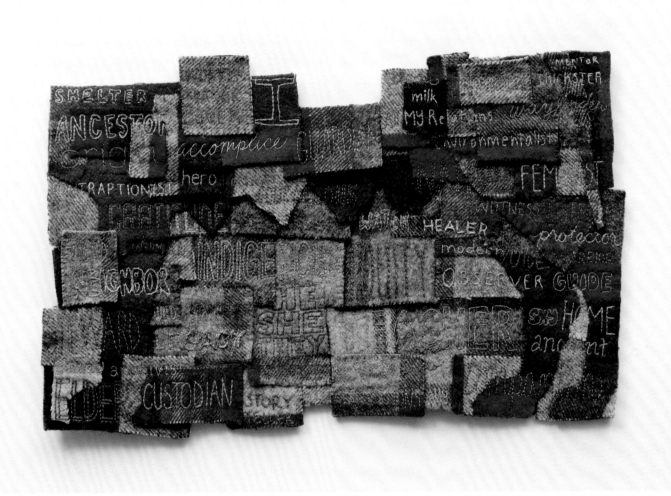

FIG. 26. *Companion Species (Fortress)*, 2017; reclaimed wool blanket, embroidery floss, thread, 11 × 17¼ in. (27.9 × 43.8 cm); Collection of Smith College, Northampton, Massachusetts.

FIG. 27. JOHN SINGER SARGENT (American, 1856–1925), *Asher Wertheimer*, 1989; oil on canvas, 58 × 38½ in. (147.3 × 97.8 cm). Tate Galleries. Presented by the widow and family of Asher Wertheimer in accordance with his wishes, 1922. Photo: Tate (with detail).

to cover and protect while dissolving the human body into the natural surroundings. Interspersed throughout both woodcuts, like a series of water-falls, is the pink, drooping shape of a dog's tongue. John Singer Sargent's 1898 portrait of the art dealer Asher Wertheimer standing next to his black poodle, Noble (fig. 27), inspired the motif, which reminded Watt of her own tongue, reinforcing a sense of her interrelatedness with dogs as embodied beings.

The large-scale fabric piece *Companion Species (Speech Bubble)* (fig. 28) led to the diptych *Companion Species (Malleable / Brittle),* created in collaboration with Julia D'Amario during an early 2021 Sitka residency (pp. 146–47). The megaphone-shaped speech bubble is the visual equivalent of a shout, an outward-expanding cry or call for an ethics of relat-edness based on Seneca principles and the lyrics of "What's Going On." Watt has found that Gaye's song is as relevant today as it was in 1971. His call to broth-ers, sisters, fathers, and mothers invites an awareness

of relationality based on kinship and mutual aid that is consistent, in Watt's view, with Indigenous beliefs.

Artists and scholars have theorized Indigenous knowledge as a vital, if still largely neglected, resource for confronting social and environmental challenges today.[25] Watt has referred to the Seneca principle of Seven Generations, for example: the conviction that equitable and mindful action today should secure a sustainable world seven genera-tions into the future. The *Companion Species* series models ways of thinking beyond the binaries— human and animal, culture and nature, individual and collective—that have set humanity on a path to social inequity and ecological destruction. They offer alternative ways of knowing embedded in Seneca tra-ditions of storytelling, community, proto-feminism, and environmental stewardship.

In a further evolution of her practice, Watt has recently brought her participatory sewing circles and printmaking together. In collaboration with the

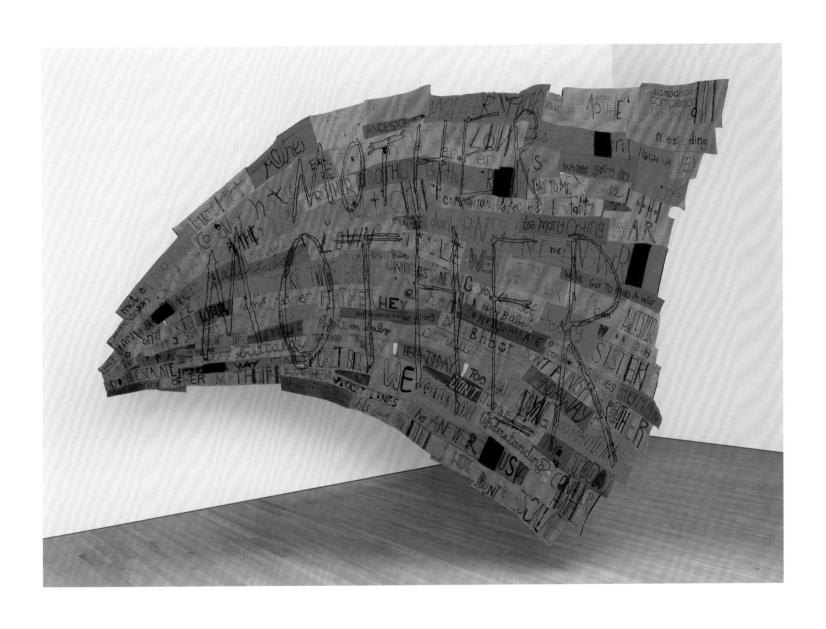

FIG. 28. *Companion Species (Speech Bubble)*, 2019; reclaimed wool
blankets, embroidery floss, and thread, 136 × 198½ in. (345 ×
504.2 cm); Crystal Bridges Museum of American Art, Bentonville,
Arkansas. Photography by Edward C. Robinson III.

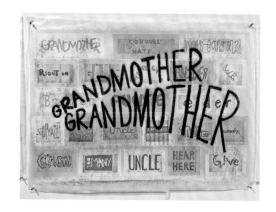

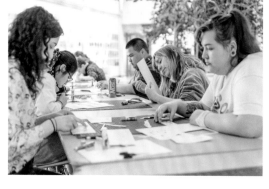

FIG. 29. Portland Community College workshop, 2019, and subsequent collaboration with Mullowney Printing. Upper right: *Companion Species (Passage)*, 2021 (detail of pp. 150–51).

printer Kathy Kuehn, she has convened what might be called "printing circles" where participants— Portland Community College students, friends, or community members—create small pressure prints or stratographs (fig. 29), which Watt collages to generate a large matrix. She is working with Mullowney Printing in Portland to produce tapestry-like editions based on this collaborative process: her most monumental and ambitious print-based project to date (pp. 150–51).

Woven throughout her career, Watt's prints give form to identity, personal or collective, as a vulnerable carapace shaped by memories, myths, and complex histories. As "transportation objects," the prints travel through time and space like blankets or letters, carriers of hidden meanings and enduring mysteries, catalysts for new ways of thinking, being, and relating based on the seven principles of Indigenous storywork: respect, responsibility, reciprocity, reverence, holism, interrelatedness, and synergy. They answer the call by the United States poet laureate Joy Harjo (Muscogee/Creek)—whose words Watt has begun incorporating into her work— to give "thanks for the story, for all parts of the story / because it was by the light of those challenges we knew / ourselves."

NOTES

The author wishes to thank Marie Watt, Frank Janzen, and Julia D'Amario for generously sharing their time, insight, and knowledge.

1 Jolene Rickard, "Visualizing Sovereignty in the Time of Biometric Sensors," *South Atlantic Quarterly* 110, no. 2 (2011): 465–86.

2 On "survivance" as a concept in Native American studies, see *Survivance: Narratives of Native Presence,* ed. Gerald Vizenor (Lincoln: Nebraska University Press, 2008).

3 heather ahtone and Rebecca J. Dobkins, "The Emergence of Indigenous Printmaking in North America," in *Crow's Shadow Institute of the Arts at 25* (Seattle: University of Washington Press, 2017), 32.

4 Quoted in Rebecca J. Dobkins, *Marie Watt: Lodge* (Salem, OR: Hallie Ford Museum of Art, Willamette University, 2012), 24.

5 For more on this print see John Paul Rangel, "Mapping Indigenous Space and Place," in *Making History: IAIA Museum of Contemporary Native Arts: Institute of American Indian Arts,* ed. Nancy Marie Mithlo (Albuquerque: University of New Mexico Press, 2020), 57–58.

6 Stephen Lewandowski, "Diohe'ko, the Three Sisters in Seneca Life: Implications for a Native Agriculture in the Finger Lakes Region of New York State," *Agriculture and Human Values* 4 (1987): 76–93.

7 Quoted in Janet Catherine Berlo, "Back to the Blanket: Marie Watt and the Visual Language of Intercultural Encounter," in *Into the Fray: The Eiteljorg Fellowship for Native American Fine Art,* ed. James H. Nottage (Indianapolis: Eiteljorg Museum of American Indians and Western Art; Seattle: University of Washington Press, 2005), 114–15.

8 Berlo, "Back to the Blanket," 114.

9 Philip Jenkins, *Dream Catchers: How Mainstream America Discovered Native Spirituality* (Oxford and New York: Oxford University Press, 2004).

10 For the history of Crow's Shadow, see Prudence F. Roberts, "Crow's Shadow Institute of the Arts at 25: A History," in *Crow's Shadow Institute of the Arts at 25,* 10–29. See also Gerald McMaster, "Crow's Shadow: Art and Community" in *Migrations: New Directions in Native American Art,* ed. Marjorie Devon (Albuquerque: University of New Mexico Press, 2006), 17–26.

11 Alex V. Cipolle, "Increasing Exposure for Native Artists," *New York Times,* March 15, 2019.

12 Quoted in Dobkins, *Lodge,* 32.

13 "Marie Watt," in *Indelible Ink: Native Women, Printmaking & Collaboration* (Albuquerque: University of New Mexico Art Museum, 2020), 30, https://issuu.com/unmartmuseum/docs /online_magazine__1_.

14 Conversation with the author.

15 Colette A. Hyman, *Dakota Women's Work: Creativity, Culture, and Exile* (St. Paul: Minnesota Historical Society Press, 2012).

16 For more on Tamarind's collaborations with Native artists, see Kathleen Stewart Howe, "A Quiet Commitment: Tamarind and Native American Artists," in *Migrations,* 27–38.

17 For more on Watt's work for the Tamarind series, see the chapter "Marie Watt" in *Migrations,* 116–25.

18 Quoted in Cynthia Barber, "Feeling the Pulse," *Printmaking Today* 15, nos. 2–3 (Summer–Autumn 2006), 24.

19 See Berlo, "Back to the Blanket," 111–21; see also Linda Tesner, *Marie Watt Blanket Stories: Receiving* (Portland, OR: Ronna and Eric Hoffman Gallery of Contemporary Art, Lewis & Clark College, 2005).

20 Jo-ann Archibald (Q'um Q'um Xiiem), *Indigenous Storywork: Educating the Heart, Mind, Body, and Spirit* (Vancouver, BC: UBC Press, 2008).

21 Jim Ransenberger, *High Steel: The Daring Men Who Built the World's Greatest Skyline* (New York: HarperCollins, 2004).

22 Nancy Marie Mithlo, *Knowing Native Arts* (Lincoln: University of Nebraska Press, 2020), 61.

23 Quoted in Elizabeth Anne Bilyeu, *Witness: Themes of Social Justice in Contemporary Printmaking and Photography: From the Collections of Jordan D. Schnitzer and His Family Foundation* (Portland, OR: Jordan Schnitzer Family Foundation in association with Hallie Ford Museum of Art, Willamette University, Salem, OR, 2018), 22.

24 Donna J. Haraway, *The Companion Species Manifesto: Dogs, People, and Significant Otherness* (Chicago: Prickly Paradigm Press, 2003), 3.

25 See, for example, Jessica L. Horton, "Indigenous Artists Against the Anthropocene," *Art Journal* 76, no. 2 (2017): 48–69.

ONÖNDOWA'GA:' YAGÖ:GWEH /
MARIE WATT / SENECA WOMAN

JOLENE RICKARD (SKARÙ·RĘʔ / TUSCARORA)

ART IS ANTICIPATORY. We don't plan for the compulsion to make art; we respond to it. Some would argue that the process of making art is not something that Indigenous peoples were engaged with historically. That might seem inflammatory to suggest, and that is not my intent. I argue that the creation of art is in the process, and through the centuries there are different end results. The Kanien'kehá:ka (Mohawk) artist and curator Tom Hill and the Skarù·rę? (Tuscarora) artist and historian Rick Hill grappled with this question in 1994 parallel to the opening of the National Museum of the American Indian (NMAI).[1] They ultimately put forth the idea of "expressive culture" to accommodate the breadth of creative actions that have taken place among Indigenous communities for millennia.[2] Old-school ideas from the field of anthropology relegated Indigenous creative processes as resulting in utilitarian objects. We've seen the migration of such objects in museum collections from being defined anthropologically to being identified as art. If we take up "process" and not finished objects as the fundamental role of art making, Indigenous peoples—like all peoples of the world—were deeply involved with the observational translation of their experiences into expressive gestures and forms, recognized in modernity as art. How does this relate to the artist Marie Watt? It calls into question how the philosophy and political ideas in Indigenous art are critiqued across epistemological and political borders, in particular during a time of hypercapitalism and neoliberalism.

The question of how Indigenous art is located within a global cultural milieu flattens the political and cultural autonomy of recognizing Indigenous nationhood.[3] Marie Watt and other leading Indigenous artists continue to be read through an ethnographic hegemonic or neocolonial lens because of the obscuring absence of recognition of Indigenous nations—not simply ethnographic history—as forming a basis for locating their artistic vision. Is the geopolitical space of nation a relic of the twentieth century? Economically, it might be, but culturally, nation classifications are part of art-world categories of identification. Recently, the Swiss curator Carin Kuoni, in *Forces of Art,* repositions the neutrality of nation by using "colonial nations"; the field of Native American and Indigenous Studies

FIG. 30. *Companion Species (Tree and Stone)*, 2021. Detail of fig. 39, p. 52.

43

disseminates the use of "settler-state"; and the first world/third world pejorative binary has been amended to "majority world countries" by the artist Shahidul Alam's intent to replace "third-world countries."[4] But even within this more nuanced positionality, there remains an ambiguous space for Indigenous artists' agency and sovereignty.

The default setting in artists' biographies indicates country of origin and current residence. By mapping artists' identities in this way, volumes of assumptions are made about what influences the artist. If the normative setting to critique Indigenous art is American cultural and political space influenced by Indigenous cosmology and history, does it serve Indigenous futurity? How can Marie Watt's Onöndowa'ga:' (Seneca) heritage be understood in this flattening terrain? Does this work address specific Hodinöhsö:ni' (Haudenosaunee) responsibilities to the next seven generations or "ever coming faces"? Why does any of this matter? Since there really isn't such a thing as a "pure" culture, the condition of Indigenous futurity is an entangled space within global hegemony. But within our communities, there is a resurgence of Hodinöhsö:ni' thinking. Indigenous peoples have been incorrectly folded into the American imaginary as a minoritized group when we are actually separate nations, each with its own worldview.

The Hodinöhsö:ni' are a confederacy of six nations, whose governmental formation is described as an extended longhouse with the "elder brothers" Onöndowa'ga:', "Keepers of the Western Door," and Kanien'kehá:ka (Mohawk), "Keepers of the Eastern Door," along with the Onǫda'géga' (Onondaga) as the "Central Fire," flanked by the "younger brothers," Onyota'a:ká: (Oneida), Gayogohó:nǫ (Cayuga), and Skarù:re? (Tuscarora). This worldview is not informed by American settler or arrivant philosophies. The Hodinöhsö:ni' worldview is constructed within the episodic narrative of the "Earth Grasper," or Creation Story; the journey of the Peacemaker in the Great Law; and the good word, or Gaiwi:yoh, as part of the prophecy of Handsome Lake.[5] This cosmology and philosophy are deeply rooted in the geology, ecology, and location of the ancestral homelands of the Hodinöhsö:ni'. Specifically, the Onöndowa'ga:' have two distinct governmental structures: the Tonawanda Band of Seneca, who practice a traditional form of governance based on the Great Law and Gaiwi:yoh, and the Seneca Nation of Indians, who are incorporated with an elective system wherein some citizens observe the Longhouse way of life and Gaiwi:yoh.

The Hodinöhsö:ni' reject settler assertions of colonial dominance, and nowhere is this more present than in current Onöndowa'ga:' assertions of sovereignty. Hodinöhsö:ni' political and customary practices transcend the formation of the United States by thousands of years but value the "nation to nation" acknowledgment based on treaties, in particular, the Canandaigua Treaty of 1794.[6] And according to legal records, the United States made treaties with the Hodinöhsö:ni', recognizing them as politically and culturally autonomous, not as minoritized populations.[7] We are often reminded by our leaders that "treaties are made with nations."[8] Evidence of a renewed Hodinöhsö:ni' recognition of "place," and specifically Onöndowa'ga:' expressions as a sovereign nation, is the proliferation of bilingual (Onöndowa'ga:' and English) territorial border signs (fig. 31). As noted by Joe Heath, an attorney for the Onǫda'géga' Nation: "The signs, although just a little step, [are] important to [the tribe] to preserve their sovereignty . . . their language. The symbolism is important."[9] Art is also part of marking the sovereign cultural and political space of Indigeneity in 2021.

Marie Watt, armed with an MFA from Yale, an AFA from the Institute of American Indian Art,

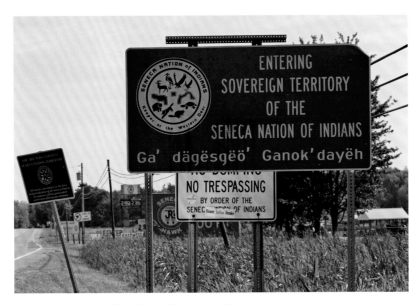

FIG. 31. Bilingual (English and Onöndowa'ga:') border sign.
© Photo by Jolene Rickard, 2018.

experience at Crow's Shadow Institute for the Arts and Sitka Center for Art and Ecology, artist residencies at the Smithsonian's National Museum of the American Indian, and many other arts opportunities, is making influential art.[10] By her own account, her work resides at the intersection of art and life.[11] Her interviews are peppered with comments about the role her family plays in her process and with reflections on pop culture and political actions as evidence of the desire to contextualize her own work in the zeitgeist. Marie's mother grew up in the Cattaraugus territories, which are part of the Seneca Nation of Indians; her father's heritage is European. Marie's subjectivity as an Onöndowa'ga:', Turtle Clan, woman with German and Scottish heritage instigates reflection on what her art anticipates. She questions, "Who am I and what does it mean to be a German/Scot/Seneca in the twentieth century?"[12] In her youth, she defined herself as a combination of both her parents' heritages, compelling her to use a cowboy/Indian binary.[13] Today, Marie's

Onöndowa'ga:' identity is central, yet it is enriched by her father's German-Scottish heritage. From a Hodinöhsö:ni' perspective, Marie is Onöndowa'ga:', because the inheritance of identity comes through the mother's side. (In fact, a critical aspect of the field of anthropology was developed based on observations of lineal Hodinöhsö:ni' practices described as kinship systems.[14]) In Hodinöhsö:ni' nations, the phrase commonly expressed is "you are what your mother is." This does not mean that the recognition of lineal descent as coming from your mother or as modeled in the Creation Story by Sky Woman, the "mother" of us all, negates the role of the father. Rather, it is about a balance of power and responsibility deeply rooted in Hodinöhsö:ni' governance and societal order.

Marie's maternal lineage reflects how rapidly things change. Both her maternal grandparents were from Cattaraugus and fluent Onöndowa'ga:' speakers. Marie's mother, Romayne, grew up at Cattaraugus and fondly recalls that the Seneca

FIG. 32. Dave and Romayne Watt at the *No Reservations* installation at the Aldrich Contemporary Art Museum, Ridgefield, Connecticut, 2006.

FIG. 33. L to R: Marie's grandmother, Hus'do Maxine Clark Maybee; Marie; Marie's mother, Romayne; and Marie's children, Evelyn and Maxine, Cattaraugus Territory.

name of her mother, Maxine Clark Maybee, was Hus'do.[15] Throughout Hodinöhsö:ni' territories, within Romayne's generation the Seneca language ceased to be spoken in the home, and the meaning of her grandmother's name was forgotten. Although she moved to the Pacific Northwest in 1962, from every indication Romayne continues to live as an Onöndowa'ga:' woman. Her lifelong dedication to empowering young Indigenous people in urban spaces, the affirmative attitude as an Indigenous woman she instilled in Marie, and her creation of an extended network of family beyond her ancestral homeland demonstrate these observations. Marie has often referred to her parents, who frequently assist her with installations, as "roadies" (fig. 32). But it's more than a casual proclamation. The desire to continue to build a relationship with one's parents, intergenerationally, is central to our communities. Romayne grew up in an Onöndowa'ga:' world and passed on foundational Hodinöhsö:ni' knowledge to her family by example. Marie acknowledges

this connection with humor, but it reveals deep taproots to her Onöndowa'ga:' matrilineal heritage (fig. 33).

Marie's recognition of her father's heritage pushes at the boundaries of Hodinöhsö:ni' teachings formed since the fall of Sky Woman from Sky World, initiating the beginning of this world on Turtle Island (also known as the Americas).[16] Her "process" of art making doesn't begin with her education or time spent in the studio or at the printing press, but with her family. Marie is true to her understanding of her experience and the relationship between how we live and the art we make; her standpoint reflects a critical shift for Indigenous peoples in the twenty-first century.

Throughout Indigenous spaces, often referred to as "Indian Country," a dynamic change is unfolding. Once degraded as sites of loss and victimization, reservations now described by the Hodinöhsö:ni' as "nation territories" are dynamic, regenerative cultural and political spaces. But settler

governments enacted forced removal of Indigenous youth during the boarding-school era (late 1800s to 1960s) and continued the disruption of families with urban relocation programs in the mid-twentieth century, driving many away from their traditional territories. The field of Native American and Indigenous Studies has adopted the terminology of diaspora to describe the forced displacement and elected movement of Indigenous peoples from our homelands, therefore making Marie part of an Onöndowa'ga:' diaspora. What does that mean in the context of contemporary art and analysis? Artists in their most expansive reach are commenting on their own reflections about society. What are the levels of cultural legibility as it relates to Indigenous artists and our art? Powerful art has the ability to transcend ideological and political borders, but can it reveal multiple epistemological, philosophical, and cultural formations? Or what the Onöndowa'ga:' historian John Mohawk-kéhe[17] often referred to as autochthonous centers or "indigenous to a place"?[18]

The philosopher Kyle Whyte (Potawatomi) recognizes that "Indigenous Environmental Studies and Sciences (IESS) is an emerging field that centers Indigenous historical heritages, living intellectual traditions, research approaches, education practices, and political advocacy to investigate how humans can live respectfully within dynamic ecosystems."[19] Within the field of Native American and Indigenous Studies, the combination of Indigenous knowledge, or IK, is informed by many Indigenous teachings, including Hodinöhsö:ni' customary practices like the "Original Instructions," which acknowledge earth's life force and human reciprocal responsibilities to all sentient beings.[20] For Mohawk-kéhe, the reciprocity of the Original Instructions is enacted within a Hodinöhsö:ni' cultural and political center and is "indigenous to place." Artists like Marie encourage us to expand our notion of "cultural centers" where

their work becomes a new site of reciprocity and reflection on the Original Instructions.

Hodinöhsö:ni' knowledge keepers use the term Original Instructions to refer to the beginning story, or Creation Story. When Sky Holder finished creating human beings, he returned to Sky World, and "he left them with a set of directions about how he intended life on this earth to exist." These Original Instructions enacted the ceremony of burning tobacco to communicate with Sky Holder to give thanks, as well as listing our responsibilities to "beautify the earth by cultivating it . . . that the orb of light [Sun] will continue to give pleasure to the mind." When the Hodinöhsö:ni' became lax in these duties, we were visited by the Peacemaker, who brought the *Gayanashagowa*, or the "Great Law of Peace."[21] The story of the Peacemaker's journey through the Hodinöhsö:ni' homelands is based in actual places on the land, not imagined spaces.

So what happens when an artist like Marie is detached from the physical place of her Onöndowa'ga:' ancestors but connected through her mother's memory and lived experience? How do we read her art? What is it telling us about the concepts and experiences she is negotiating? It's important to acknowledge that Marie's experience as a diasporic citizen of the Onöndowa'ga:' Nation is more common than that of Indigenous peoples living within their nation territories. The assumption that one has to live within territory to have a legitimate claim to represent this experience has been eclipsed by the prevalence of working and living outside the communities. The Seneca Nation of Indians currently has an enrollment population of nearly eight thousand citizens with over half living off territory.[22] If we consider John Mohawk-kéhe's "indigenous to a place" as critical in understanding Hodinöhsö:ni' thinking, what changes when we are no longer rooted in ancestral homelands?

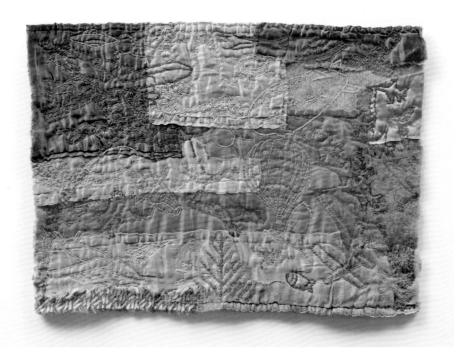

FIG. 34. *Parable: Sky Dome, First Teachers, and Relations*, 2015; reclaimed wool blankets, satin binding, thread, embroidery floss, 9½ × 13¼ in. (24.1 × 33.7 cm); Private collection.

This realization calls for a shift in how Indigenous cultures and art are understood. The awareness that Indigenous communities are multilayered should be part of a critical analysis of how art is read. Within Hodinöhsö:ni' frameworks, the phrase "someone stepped out of the circle" can indicate that they moved away physically from their kinship relationships or people, or that they married or partnered outside the communities, or that they have abandoned what is understood as a "traditional" way of life, or longhouse teachings. But the Hodinöhsö:ni' are a welcoming people and maintain that anyone who "steps outside of the circle" can return; they are always connected. Stepping out does not mean that they are not Hodinöhsö:ni' but indicates that they are on a different path from those who continue to engage with the Original Instructions. It is a shared understanding within Hodinöhsö:ni' nations that we have been together for millennia and continue to make choices to reimagine our cultures collectively. What is the

twenty-first-century role of Indigenous art that is informed by Indigenous heritage but not exclusive or responsible to the ongoing transmission of the Original Instructions? There is a dynamic tension between the accepted norm of artists' agency as individuals and the ongoing formation of Indigenous cultures. Indigenous artists are often asked what makes their art Indigenous, and many insist that it is "Indigenous art" because they made it and are themselves Indigenous. I argue that there is more at stake in considering the positionality of the artist in relationship to what is Indigenous about their work. This example indicates how delicate the balance is for the future of Indigenous people. There is little concern that Indigenous peoples will cease to exist as discrete populations, but it is the relationship to the Original Instructions, or traditional knowledge, that is challenged if we no longer are thinking together or, as John Mohawk-kéhe describes it, "thinking in Indian."[23] Marie's work is part of this continuum and indicates the necessity to remap the physical and

FIG. 35. Quilt made from Canandaigua Treaty annuity cloth by Onöndowa'ga:' women.

conceptual borders of our Hodinöhsö:ni' nations. She invests considerable time in evaluating her relationship to the Onöndowa'ga:' community and homeland. She does the work to remain connected and is responsible to and part of an ongoing reimaging of a Hodinöhsö:ni' future.

Marie's complicated subjectivity often resonates with various pulse points in Hodinöhsö:ni' space, like a ping or an evocative echo that affirms the resilience of the original teachings or marks the impact of settler violence and decolonial love. Her insight about blankets, seen in works such as *Witness (Quamichan Potlatch, 1913)* (2014, p. 135) and *Parable: Sky Dome, First Teachers, and Relations* (2015, fig. 34), has received critical analysis parsing out the practice of "place-based knowledge" as part of Marie's acknowledgment of her Northwest Coast homeland. Although some critics have suggested that blanket culture is ubiquitous among Indigenous peoples, thereby transcending the specific history of Indigenous cultures that have "blanket honoring"

traditions, I prefer to think about Marie's work as part of an ongoing transformation of an "honoring" practice.[24] Is it possible that her interest in the tactile or materiality is an attempt to close the gap between her mother's Onöndowa'ga:' embodied experience and an inherited memory? Her prints made with black walnut dye, sculptures configured from corn husks, beads marking contact history, stitched fibers, reclaimed wool, and woven cane are physical or ontological reminders that transcend fixed boundaries in time and place.[25] Her relationship to blankets, reclaimed wool, and quilts spans Turtle Island. Her use of cotton recalls quilts made by the Onöndowa'ga:' women and their use of annuity goods (fig. 35). The distribution of annuity cloth was guaranteed in the Treaty of Canandaigua of 1794, Article VI—"The United States now deliver to the Six Nations, and the Indians of the other nations residing among and united with them, a quantity of goods of the value . . ."—and it continues to be practiced today. At Cattaraugus, Marie's aunt Joann-kéhe

49

FIG. 36. Eagle staff bearer, Clayton Logan (Onöndowa'ga:') leads the march to acknowledge the Canandaigua Treaty of 1794 made between the United States and the Six Nations, or Haudenosaunee Confederacy. L to R: Chief Sam George (Gayogǫhó:nǫ') carrying the Hiawatha wampum belt, Chief Ken Jonathan (Onöndowa'ga:') and Chief Tom Jonathan (Skarù·rę?) carrying the 1794 Canandaigua Treaty Belt (George Washington Belt).
© Photo by Jolene Rickard, 2018.

used to pick up Romayne's family share of annuity cloth at the Nation's clerk office, the same office that carefully manages federal enrollment within their community. The receipt of this cloth is confirmation of the ongoing treaty relationship between the United States and the Hodinöhsö:ni' Confederacy (fig. 36).

The stories of the Hodinöhsö:ni', according to John Mohawk-kéhe, "tend to change over time to accommodate changes which take place in peoples' experiences because they are stories which tell people how things got to be the way they are and therefore are a lens on peoples' lived realities."[26] I have learned to pay attention to what artists are thinking about and placing in their work. In the early 1990s, very few people in Hodinöhsö:ni' territories were focused on the Creation Story; instead, the Great Law and the journey of the Peacemaker were in the air. The embers from a confederacy-wide civil war over gas, gaming, and cigarettes had just cooled. At that time, I was conducting interviews

with Hodinöhsö:ni' artists and recognized that a number of them were now interested in and making work about Sky Woman. Sky Woman's "fall" from Sky World is meant to remind us that life is a series of changes or transformations. The reimagining of Sky Woman at that time was also an indicator about the need to decolonize a patriarchal imbalance and rematriate.

In lithographs such as *Blankets* (2003, fig. 37; p. 88), as well as in sculptures, Marie directly addresses the physical stacking of blankets. But is there also an intended linkage between grounded and less overt spaces? In a number of works, Marie makes visual connections between the earth and the sky, as in the early lithograph *Three Ladders* (2005, fig. 38). It's her exploration with materials and themes that relate directly to the Hodinöhsö:ni'— corn husks, black ash basket splints, and cosmological figures—that pushes me to wonder if that impulse embodies an underlying ordering structure. The worldview of the Hodinöhsö:ni' as articulated

FIG. 37. *Blankets*, 2003; lithograph on Rives BFK grey, 19¾ × 25¾ in. (50.2 cm × 65.4 cm).

FIG. 38. *Three Ladders*, 2005; lithograph with chine collé on natural Sekishu white Somerset satin, 12 × 18 in. (30.5 × 45.7 cm).

through the Creation, or Earth Grasper, Story is formed around a central idea or "teaching" that our world is in a constant state of transformation.[27] The spatial shift from the upper or Sky World to earth is embodied in the fall of Sky Woman. The connection between the worlds isn't severed; rather, Sky Woman's fall linked Sky World to the beginning of a human space on earth. This expanded space of a continued relationship to the physicality of earth is balanced with an ephemeral "Sky World."

Recalled in oral recitations, the worldview of the Hodinöhsö:ni' has been realized in quill and moose hair tufting, tattooed on the body, etched into the rims of pottery, and carved in bone and stone. Perhaps the most ubiquitous visualization of this concept is the iconic mark of the double curve. Its base is often set on hatched, slanted lines depicting water, earth, and wind. The double curve forms an opening or portal to the upper world, sometimes punctuated with a solid circle referencing the Elder

Brother, Sun, or "the maker of all things," that permeates a Hodinöhsö:ni' universe.

This symbol of a double curve also references another concept within the Hodinöhsö:ni' mind or philosophy. When Sky Woman fell to earth in the embrace of Ga'ha'syendiet'ha, the Fire Dragon or Comet, she was pregnant with a daughter, who later gave birth to the twins Sapling and Flint, the first male humans. The twins represent a dynamic tension within us. This tension has been interpreted as good versus evil, but that is an understanding influenced by Christian ideals. The Hodinöhsö:ni' aren't invested in an opposition of good versus evil but instead express the tension through the qualities suggested by the twins' names: Sapling, or Oda'ë:ni:h (young tree poles), and Flint, or Otä:gwë'da' (brittle).[28] These central figures in the Earth Grasper, or Creation, Story have been interpreted by John Mohawk-kéhe as representing states of mind: Flint having a "brittle" or fixed mind, not

FIG. 39. *Companion Species (Tree and Stone)*, 2021; reclaimed wool blankets, embroidery floss, thread, 10½ × 22½ in. (26.7 × 57.2 cm).

flexible, and Sapling having a supple mind, like a young tree. This interpretation leads to an understanding that if humans possess both states of mind, when we act in a destructive or hurtful way, as Flint sometimes does with Sapling, it's because of the way we think and the choices we make, not because we are essentially good or bad.

Marie's work *Companion Species (Tree and Stone)* (2021, fig. 39) brings together the artist's affinity with reclaimed wool, a call to revisit Hodinöhsö:ni' cosmology, and the use of text as an expedient political strategy. Not only does this piece have a complicated tactical hierarchy but it sets up multiple binaries. The overt, dominant scrawl of *SAPLING* and *FLINT* immediately is recognizable as the names of the first male humans, Sky Woman's grandsons. The physical layering in both the fabric version and the related etching (2021, fig. 41) amplifies the entangled relationship of the twin brothers with each other and with other family members: their grandmother, Sky Woman; their father, Turtle Man; and their uncle, the Guardian of Sky World. The conflict between Sapling and Flint shaped Hodinöhsö:ni' cosmology, but the relationships between each of these archetypal figures offer instruction on how intrapersonal socialization became a structure for gendered relationships, governance, and kinship with beings other than human. Marie's gestural interpretation of the struggle between these forces also contemporizes the perspective shared by John Mohawk-kéhe on the Creation narrative: "Our story . . . was frozen at the beginning of the [twentieth] century before such matters acquired the contemporary level of complexity."[29] The multiple interpretations of *Companion Species (Tree and Stone, Benevolent / Trickster,* and *Malleable / Brittle)* (figs. 39–41) call our attention to a foundational moment in establishing a Hodinöhsö:ni' worldview. Is this work a symbolic call for a time of renewal? Are the banner-like, red, layered slashes

FIG. 40. *Companion Species (Benevolent / Trickster)*, 2021; softground etching, 16½ × 21½ in. (41.9 × 54.6 cm) each.

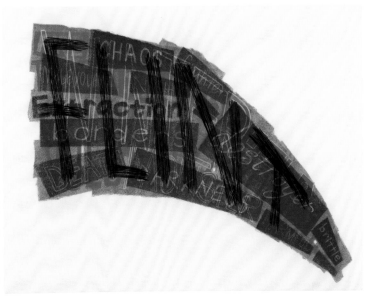

FIG. 41. *Companion Species (Malleable / Brittle)*, 2021; softground etching, 16½ × 21½ in. (41.9 × 54.6 cm) each.

an embodiment of the womb yet reimagined or a literal reference to a "companion species," like a wolf? Hints of Indigenous cultural priorities such as *water*, *root*, *tree*, *adaptive* are balanced or juxtaposed with human struggles—*extraction*, *chaos*, and *brittle*. The artist has the expectation that we will know or be driven to investigate the Myth of Earth Grasper,[30] while making the work legible enough that we can grasp a dynamic tension between these opposing forces without requiring deep cultural knowledge. Her use of color is multivalent: red can refer to its racialized use in "red man" or the sacred use of red and black on Hadu'wi false faces (now considered taboo seen outside a Medicine or ceremonial context).[31] The title, *Companion Species,* opens the door to reflecting on cyclical relationships—the entangled relationship of Sapling and Flint since the beginning of Hodinöhsö:ni' existence. Perhaps this work leads us to reflect on the contemporary circumstance of Indigenous ways of being as transformational in a world insisting on fixed boundaries and a linear mapping of time and space. Marie Watt's art draws on the cultural memories of her mother, Romayne Maybee-Watt and her family, as she finds new ways of making Indigenous community while extending the geopolitical and cultural boundary of Hodinöhsö:ni' place. Perhaps another way of thinking about this transformation is that Marie Watt, of the Onöndowa'ga:' "Keepers of the Western Door," has just pushed that door farther west.

NOTES

1 Throughout this essay, I am using the names and spellings that are now in use in Hodinöhsö:ni' communities. *Haudenosaunee* is the Onondaga spelling, and since Marie is Seneca or Onöndowa'ga:', I am using the Onöndowa'ga:' spelling of *Hodinöhsö:ni'*. When referencing other Hodinöhsö:ni' nations, I am using their own spelling and terminology. The Onöndowa'ga:' refer to themselves as "Great Hill People." See Phyliss Eileen Wms. Bardeau, *Definitive Seneca: It's in the Word* (Salamanca, NY: Seneca-Iroquois National Museum, 2011).

2 See Richard W. Hill Sr. and Tom Hill, eds., *Creation's Journey: Native American Identity and Belief* (Washington, DC: Smithsonian Institution Press in association with the National Museum of the American Indian, Smithsonian Institution, 1994).

3 For an in-depth analysis of the intersection between global Indigenous art, sovereignty, and nationhood, see Jolene Rickard, "The Emergence of Global Indigenous Art," in *Sakahán: International Indigenous Art*, Greg Hill and Candace Hopkins, eds. (Ottawa: National Gallery of Canada, 2013), 53–60.

4 See Carin Kuoni et al., eds., *Forces of Art: Perspectives from a Changing World* (Amsterdam: Valíz, 2020), 11.

5 As part of the decolonization of knowledge, it becomes increasingly important to understand multiple worldviews. Interest in Hodinöhsö:ni' artists requires a basic understanding of our worldview. For a firm basis for understanding the beginnings and ongoing reimaging of Hodinöhsö:ni' realities, see Paul Kayanesenh Williams, *Kayanerenkó:wa: The Great Law of Peace* (Winnipeg: University of Manitoba Press, 2018); John Mohawk, *Iroquois Creation Story: John Arthur Gibson and J.N.B. Hewitt's Myth of the Earth Grasper* (Buffalo, NY: Mohawk Publications, 2005); Jacob E. Thomas, *Teachings from the Longhouse* (Toronto: Stoddart, 1994); and Bardeau, *Definitive Seneca*, 201, 213–15, on the good word and Handsome Lake.

6 To understand the treaty relationship between the United States and Hodinöhsö:ni', see Oren (Jaogquisho) Lyons, "The Canandaigua Treaty: A View from the Six Nations," in *Treaty of Canandaigua 1794: 200 Years of Treaty Relations Between the Iroquois Confederacy and the United States,* ed. G. Peter Jemison and Anna M. Schein (Santa Fe, NM: Clear Light Publishers, 2000), 67–76.

7 G. Peter Jemison, "Sovereignty and Treaty Rights: We Remember," in Jemison and Schein, *Treaty of Canandaigua*, 149–62.

8 Additionally, it is significant to note that the Onöndowa'ga:' expressed allyship with the BIPOC and LGBTQ communities in June 2021 by raising a Pride flag at Cattaraugus as a statement of solidarity, https://sni.org/news-announcements/2021/06 /presidential-update-61121/, accessed June 16, 2021.

9 David Figura, "Bilingual Road Signs: Growing Trend on State Roads Crossing Indian Lands," NYUP.com, https://www.newyorkupstate .com/news/2016/10/bilingual_road_signs_growing_trend_on _state_roads_crossing_indian_land.html, October 25, 2016, updated January 2, 2010, accessed June 13, 2021.

10 For a biographical snapshot of Watt's education and professionalization, see Rebecca J. Dobkins, "Cradle: v. to nourish, nurture, support, take hold," in *Marie Watt: Lodge* (Salem, OR: Hallie Ford Museum of Art, Willamette University, 2012), 23–37.

11 See Derrick Cartwright's "Call-and-Response: A Dialogue with Marie Watt," in this catalogue.

12 Dobkins, *Lodge*, 24.

13 Also contributing to her cowboy/Indian identity is that her father's grandparents homesteaded land in Wyoming, where her father grew up and where they were ranchers and educators.

14 Lewis Henry Morgan (American) founded a scientific branch of anthropology based on exposure to Seneca kinship systems. See

Thomas R. Trautmann, *Lewis Henry Morgan and the Invention of Kinship* (Berkeley: University of California Press, 1987).

15 The use of an Onöndowa'ga:' name is a precious cultural gift today within Hodinöhsö:ni' families. The trace of the language within our communities is a testament to the enduring strength of our culture.

16 See Williams, *Kayanerenkó:wa*, 27–28: "The most complete recital of the Creation story was provided by Skaniatariio John Arthur Gibson, and transcribed by J. N. B. Hewitt at the end of the nineteenth century . . . in the Haudenosaunee story of creation, a woman fell from the Sky World to earth."

17 In Skarù:rę? (Tuscarora), *kéhe* after a name indicates that this person is deceased.

18 For an expanded discussion on the recentering of Hodinöhsö:ni' philosophy, see John C. Mohawk and Yvonne Dion-Buffalo, "Thoughts from an Autochthonous Center: Postmodernism and Cultural Studies," in *Thinking in Indian: A John Mohawk Reader* (Golden, CO: Fulcrum, 2010), 232–39.

19 Kyle Whyte, "Critical Investigations of Resilience : A Brief Introduction to Indigenous Environmental Studies & Sciences," *Daedalus* 147, no. 2 (Spring 2018): 136–47.

20 In *The Clay We Are Made Of: Haudenosaunee Land Tenure on the Grand River* (Winnipeg: University of Manitoba Press, 2017), 22–23, Susan M. Hill discusses the Original Instructions and the Creation Story. She references Mohawk's *Iroquois Creation Story* depicting the words of Sky Holder: "[I say] that indeed this earth is alive, be it known, so therefrom I took up earth by which I made all the things I have planted and I have finished living bodies, so that is the reason all they are severally alive and that in their bodies severally they will die, that earth they will become again, not as to their lives" (22). She describes Sky Holder's role: "Skyholder (also the Creator) within our languages, Shonkwaya'tihson, which means 'he completed our bodies'"; and his instructions (23).

21 Williams, *Kayanerenkó:wa,* 148–51.

22 Seneca Nation website, https://sni.org/culture/, accessed June 12, 2021.

23 Mohawk provided a perspective on what is distinct about Hodinöhsö:ni' responsibilities in *Thinking in Indian*: "[t]he Creator's law is the real natural order. Just as the Father Spirit combines with Mother Earth to form life, as all living things in the natural order tend to form groups of families, so do extended families form nations. The nations, as seen by traditional peoples, are groups of families whose dedication is to the betterment of life for the future generations" (3).

24 For multiple examples of the role of fiber and blanket arts within contemporary Indigenous culture, see Jill Ahlberg Yohe, Teri Greeves, Laura Silver, and Kaywin Feldman, *Hearts of Our People: Native Women Artists* (Minneapolis: Minneapolis Institute of Art in association with the University of Washington Press, 2019).

25 There are centuries-old reciprocal relationships among Hodinöhsö:ni' nations. The Clinton-Sullivan genocidal campaign of 1794 ravaged the cornfields of the Hodinöhsö:ni', and the Skarù·rę? helped to reseed the fields with the white corn sometimes referred to as Tuscarora white corn.

26 John C. Mohawk, "A View from Turtle Island: Chapters in Iroquois Mythology, History and Culture" (PhD diss., State University of New York at Buffalo, 1994), 93.

27 Marie noted that her mother was unfamiliar with the term "Earth Grasper." I observed that Mohawk reintroduced this translation in 2005 in *Iroquois Creation Story*. Email correspondence with the author, August 2, 2021.

28 According to the linguist Phyllis Eileen Wms. Bardeau in *Definitive Seneca* (see note 1), in the oral tradition, "Otä:gwë'da' is the creator of obstacles, fear and the dark side of humanity and Oda'ë:ni:h is only identified as young tree poles," 181, 355.

29 For an updated analysis of the Hodinöhsö:ni' Creation Story, see Mohawk, *Iroquois Creation Story*.

30 The use of the word *myth* is considered pejorative in Indigenous communities today, and the term *story* is preferred. J. N. B. Hewitt's translation of the Hodinöhsö:ni' Creation Story is more in the spirit of Gregory J. Cajete's (Tewa, Santa Clara Pueblo) interpretation of myth. According to Cajete, "The evolution of human consciousness has generally been marked by transformations of the guiding myths that a given society holds. In a sense, mythic stories trace the journey of a people through different stages of their consciousness as well as through the times and places in which they have lived." "Children, Myth and Storytelling: An Indigenous Perspective," *Global Studies of Childhood* 7, no. 2 (June 2017): 113–30, https://doi.org/10.1177/2043610617703832.

31 The Grand Council of the Hodinöhsö:ni' have officially forbidden the representational use of the False Face masks, or *Sagojowéhgowa:* ("he defends or protects them; the Great Defender") in Seneca. In *Kayanerenkó:wa*, Kayanesenh Paul Williams describes False Faces, or Hadu'wi, as dwelling at the world's rim: "a being our Creator encountered in the early days of the world. A powerful figure, Hadu'wi may symbolize all the elements of the natural world over which humans have no control. His alliance with us, arranged by the Creator, is invoked by the medicine society whose members wear the wooden masks bearing his image, and maintained by the tobacco burned for him" (46).

WORKS IN THE EXHIBITION

Untitled (Corn Husk Study—Parting), 1996
Engraving with gouge
10⅞ × 9⅞ in. (27.6 × 25.1 cm)

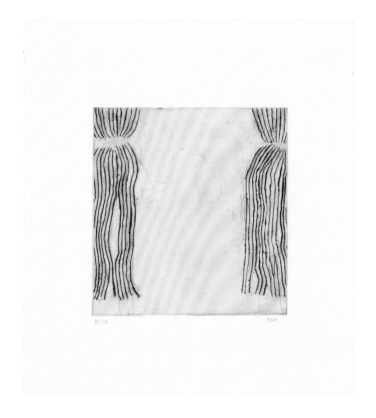

Untitled (Corn Husk Study—Alone), 1996
Engraving with gouge
9¾ × 10¾ in. (24.8 × 27.3 cm)

Untitled (Corn Husk Study—Pair), 1996
Engraving with gouge
10 × 10¾ in. (25.4 × 27.3 cm)

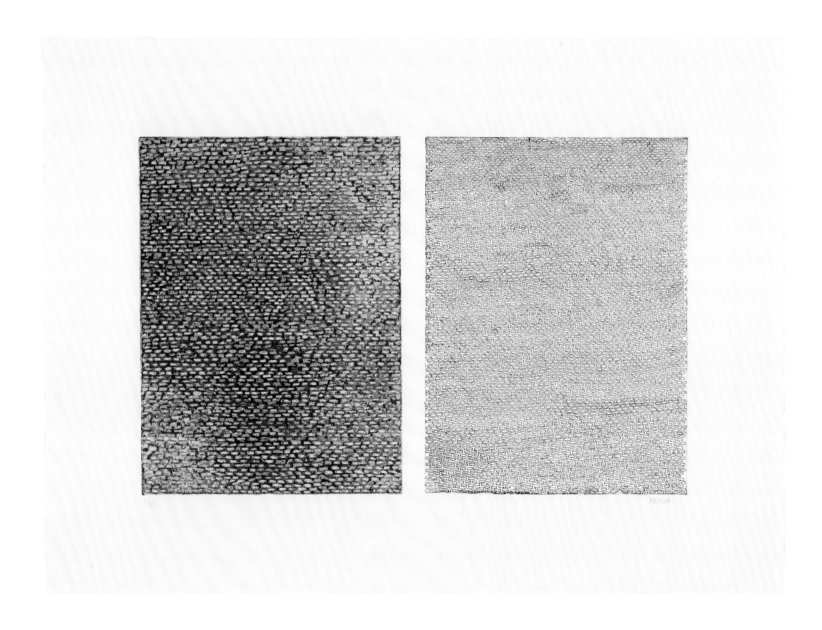

Untitled (Corn, lozenge, brick study), c. 1998
Softground etching and hardground etching
18¼ × 25¼ in. (46.4 × 64.1 cm)

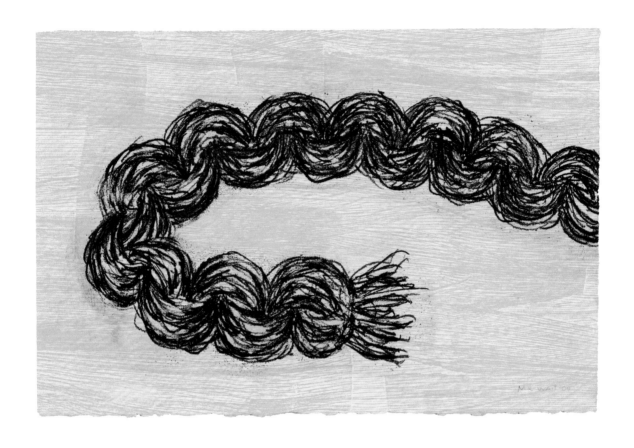

Untitled, 2000
Softground etching
7¾ × 11½ in. (19.7 × 29.2 cm)

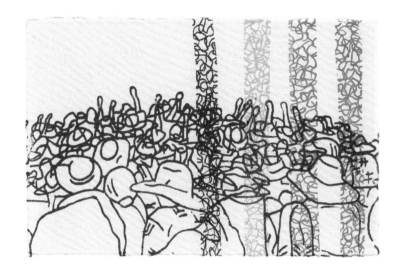

399/425 MKW

Selection of untitled Gocco prints, approximately 4 × 6 in.
(10.2 × 15.2 cm) each; edition size variable. Print Collection, University
of San Diego.

Watt made her first Gocco print in 2002. Since then she has offered
signed, limited-edition Gocco prints to participants at her
sewing circles.

Blanket Relative, 2002
Aquatint and drypoint
17½ × 18½ in. (44.5 × 47 cm)

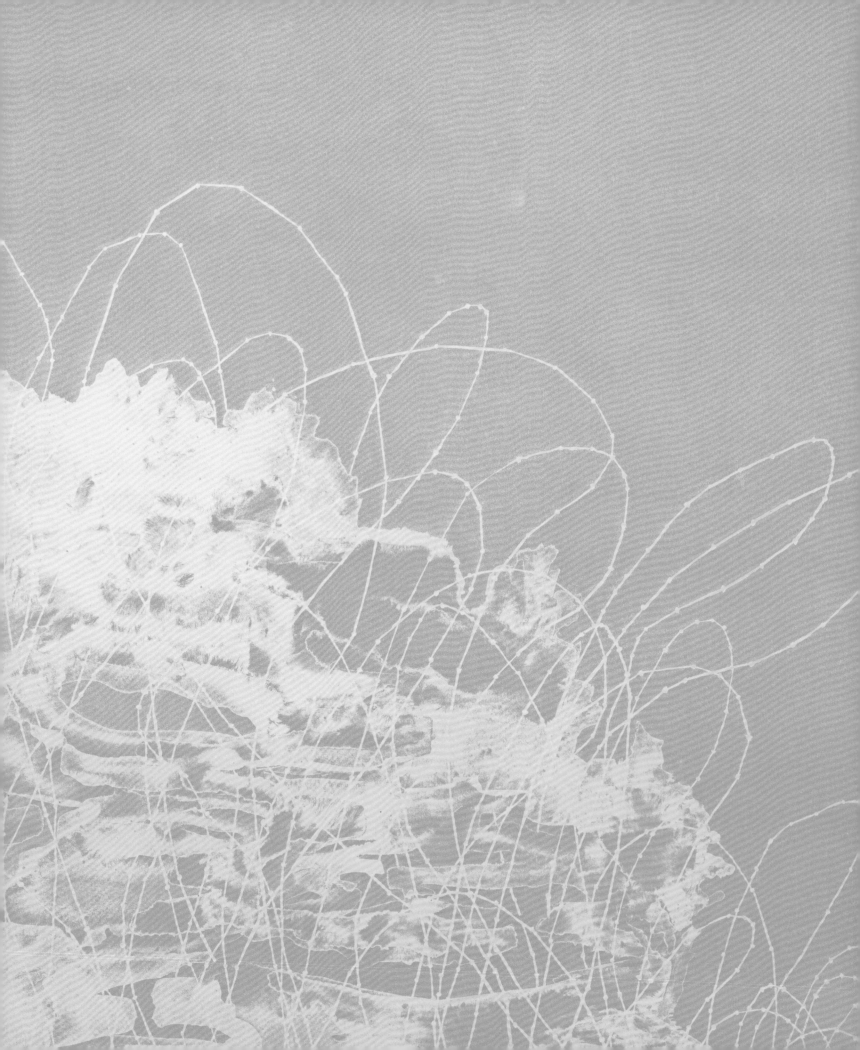

Proposal (Variation), 2002
Color spitbite, sugar lift, and aquatint
Image and sheet: 17½ × 18 in. (44.5 × 45.7 cm)

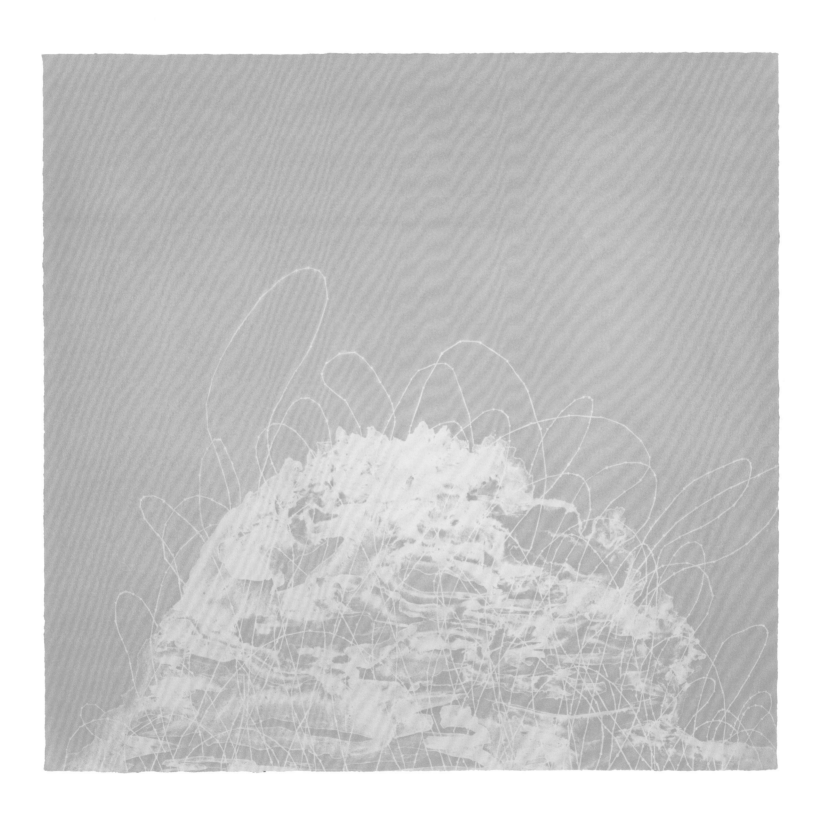

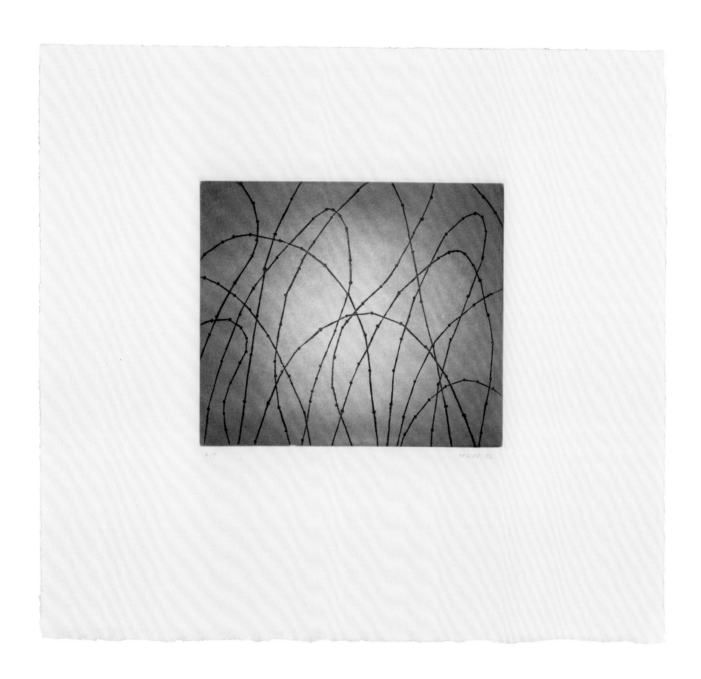

Gate, 2002
Spitbite, sugar lift, and aquatint
11 × 12 in. (27.9 × 30.5 cm)

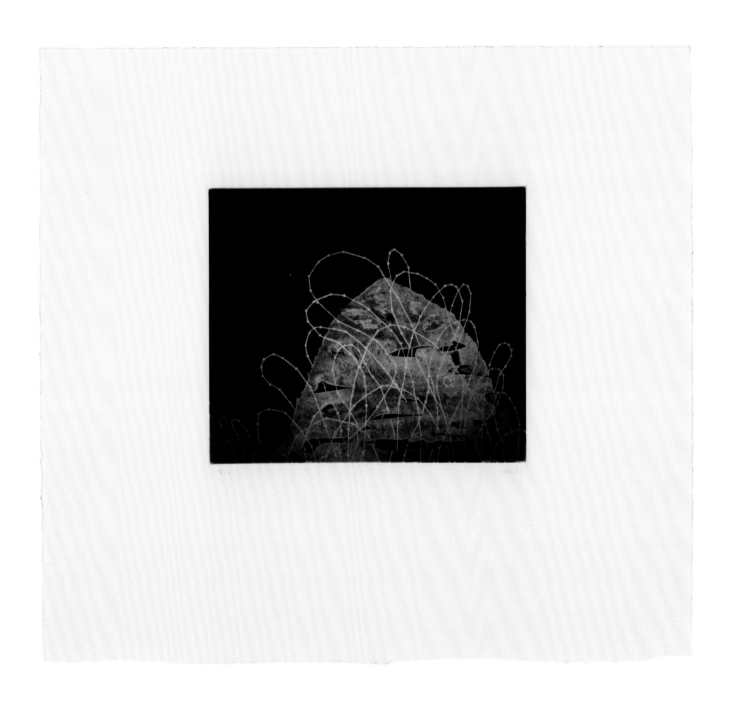

Untitled, 2002
Spitbite and whiteground aquatint
11 x 12 in. (27.9 x 30.5 cm)

Three Rocks, 2002
Hardground etching and stippling on Hahnemühle bright white
11 x 12 in. (27.9 x 30.5 cm)

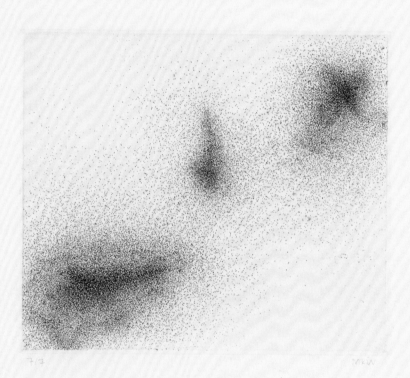

7/7 MKW

Cloud/Dust, 2002
Hardground etching and stippling on Rives BFK cream
17¼ × 17¼ in. (43.8 × 43.8 cm)

Curtain, 2002
Color spitbite and aquatint
13 × 10 in. (33 × 25.4 cm)

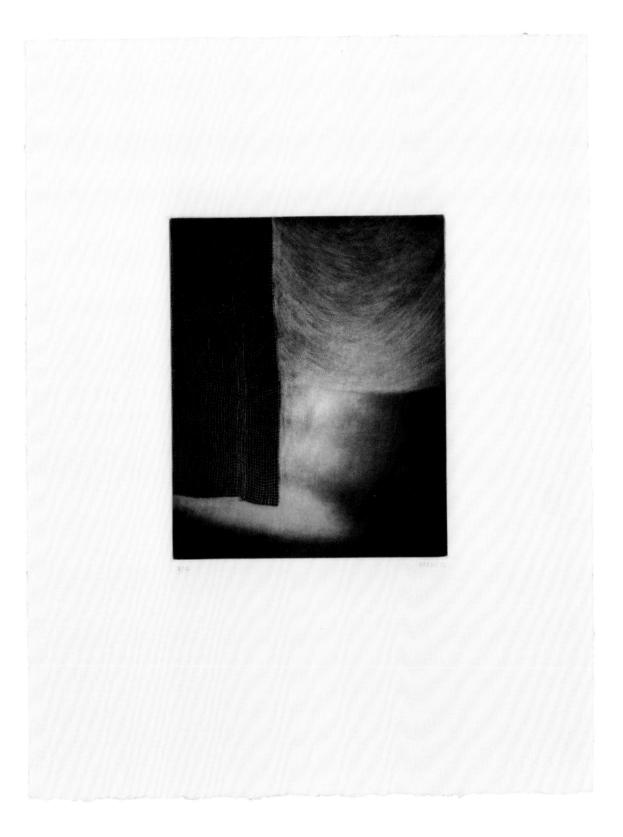

Proposal, 2002
Whiteground, aquatint, and sugar lift
11 × 12 in. (27.9 × 30.5 cm)

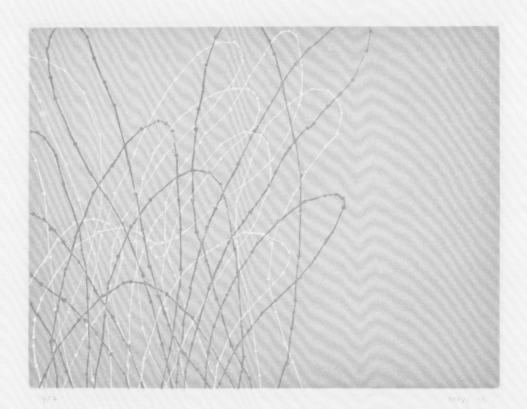

7/7 MKW '02

Portal, 2002
Lithograph on Rives BFK grey
17½ × 18 in. (44.5 × 45.7 cm)
Print Collection, University of San Diego

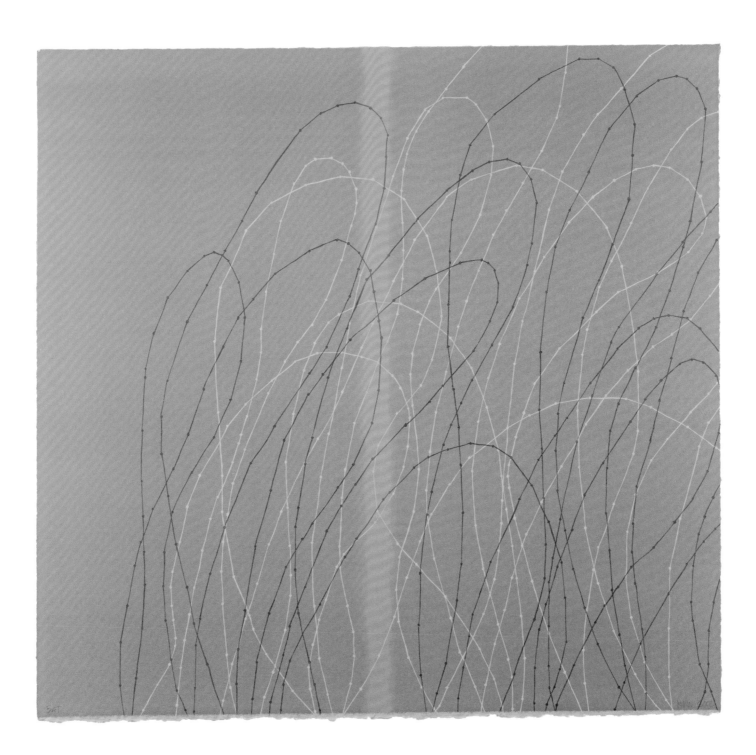

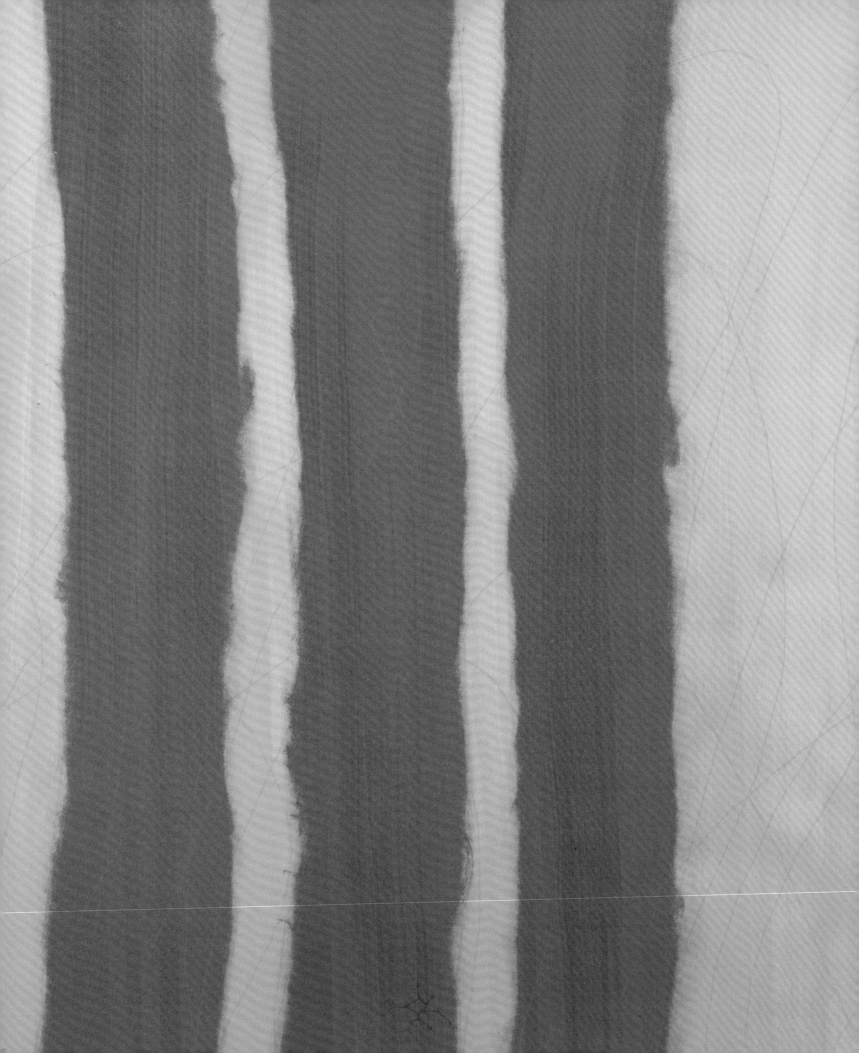

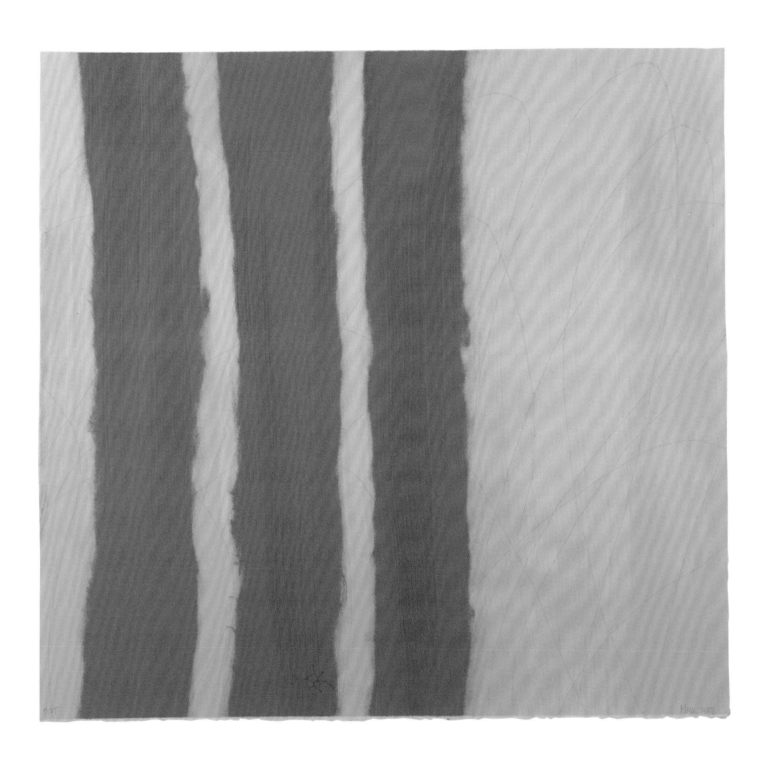

Omphalos, 2002
Lithograph on Rives BFK grey
17½ × 18 in. (44.5 × 45.7 cm)
Print Collection, University of San Diego

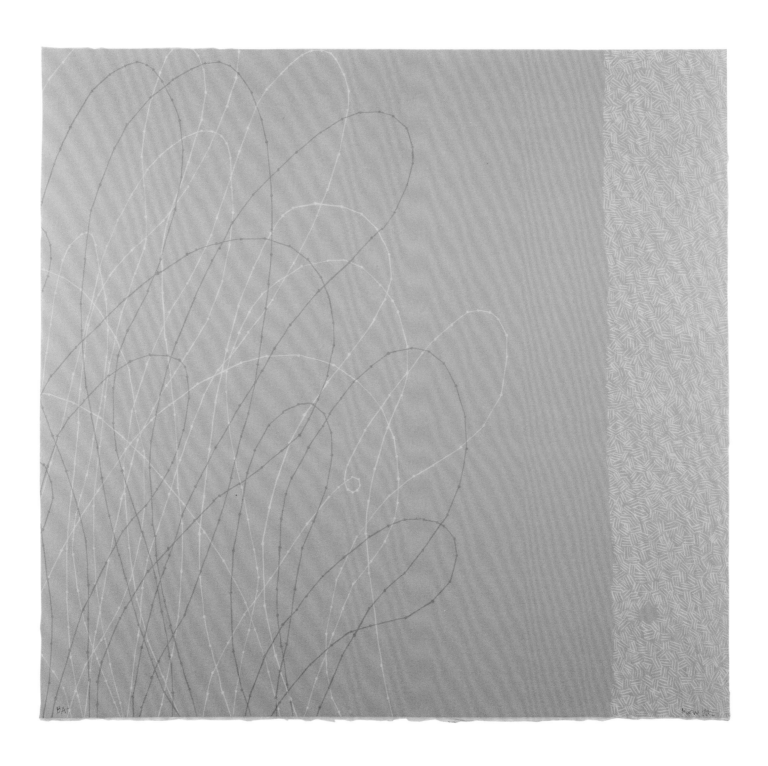

Guardian, 2002
Lithograph on Rives BFK grey
17½ × 18 in. (44.5 × 45.7 cm)
Print Collection, University of San Diego

Sanctuary, 2002
Lithograph on Rives BFK grey
17½ × 18 in. (44.5 × 45.7 cm)
Print Collection, University of San Diego

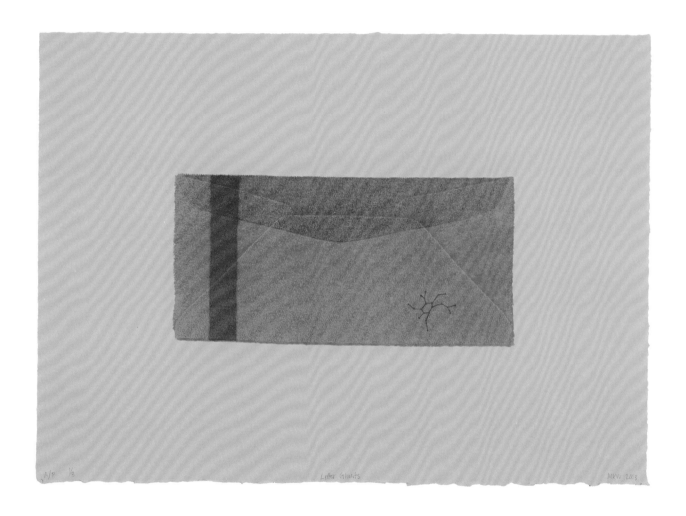

Letter Ghost, 2003
Lithograph on Rives BFK tan
13 × 18 in. (33 × 45.7 cm)

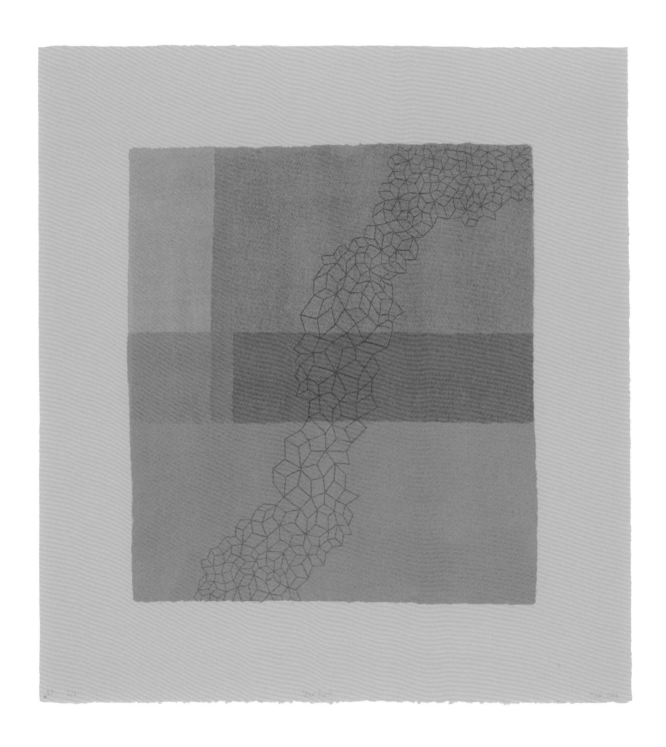

Star Quilt, 2003
Lithograph on Rives BFK tan
21¼ × 19 in. (54 × 48.3 cm)

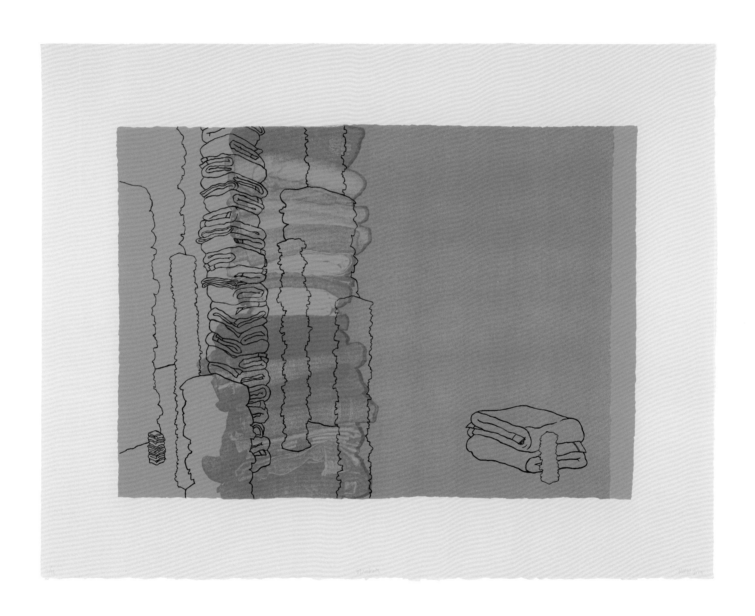

Blankets, 2003
Lithograph on Rives BFK grey
19¾ × 25¾ in. (50.2 × 65.4 cm)

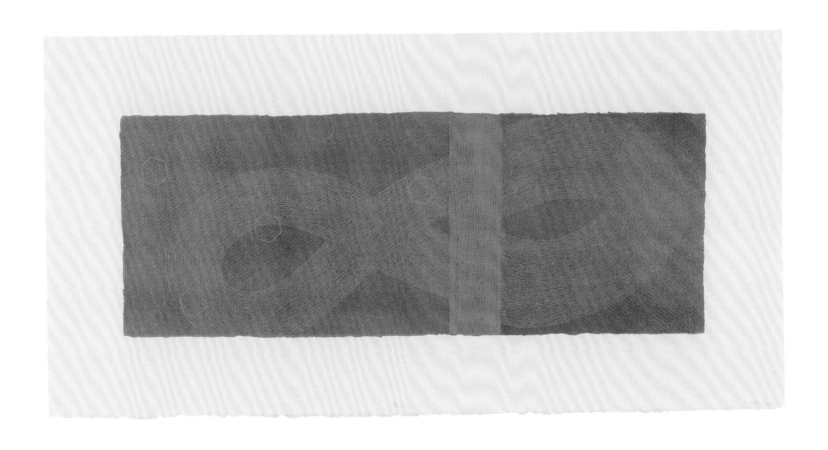

Braid, 2003
Lithograph on Rives BFK grey
14½ × 29 in. (36.8 × 73.7 cm)

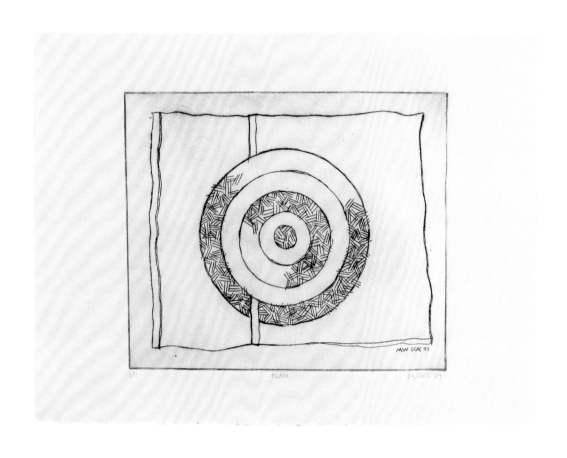

Flag, 2003
Etching
11 × 14¾ in. (27.9 × 37.5 cm)
Print Collection, Unversity of San Diego

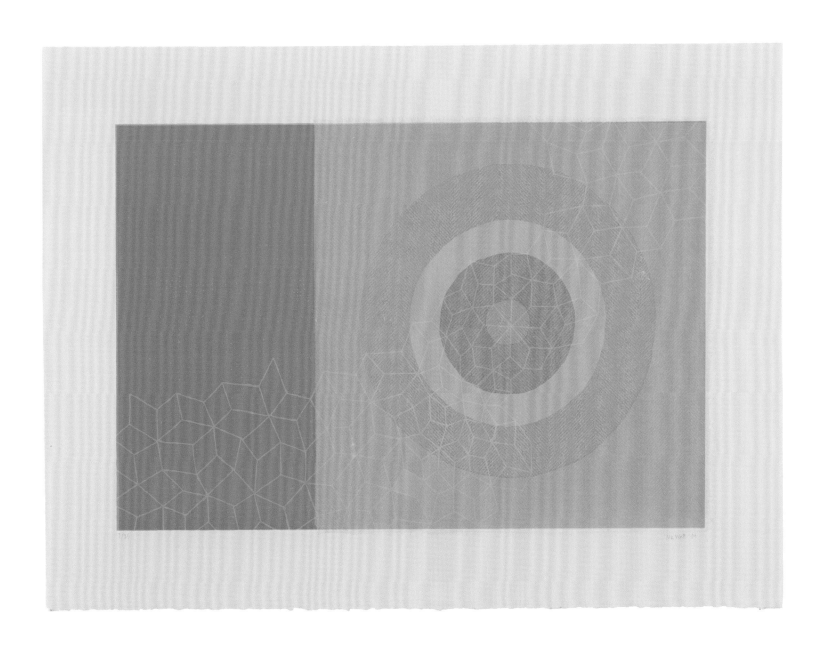

Transit, 2004
Lithograph with chine collé on Kizukishi chine collé and Rives BFK grey
22 × 30 in. (55.9 × 76.2 cm)

Threshold, 2006
Reclaimed wool blankets, satin binding, thread
123 × 119 in. (302.3 × 297.2 cm)

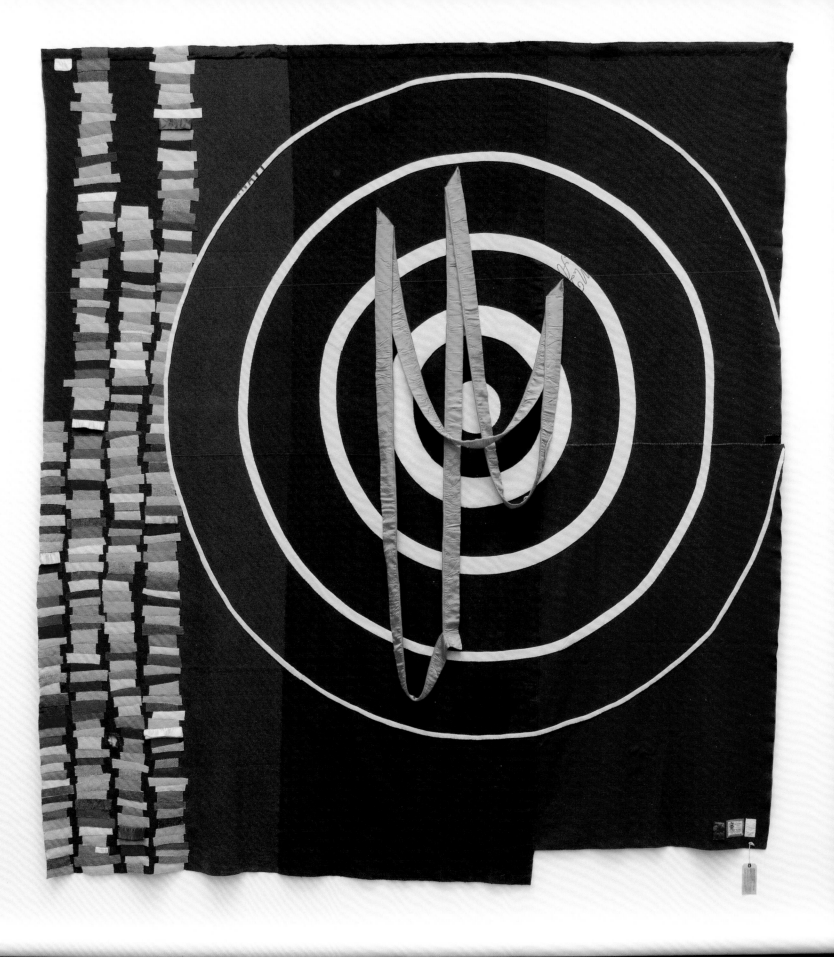

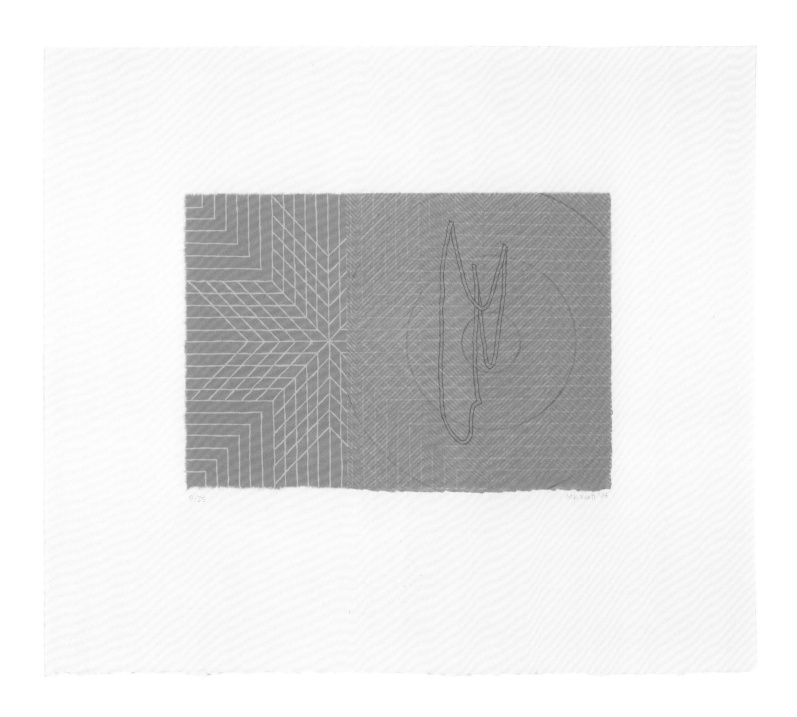

Receive, 2004
Lithograph on brown Yamato, off-white Rives BFK
17 x 20 in. (43.5 x 50.8 cm)

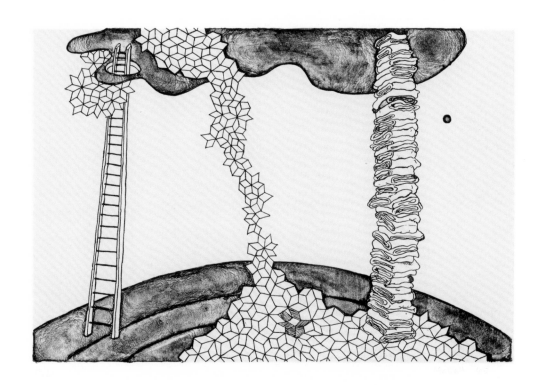

Three Ladders, 2005
Lithograph with chine collé on natural Sekishu white Somerset satin
12 × 18 in. (30.5 × 45.7 cm)

Lodge, 2005
Woodcut on Somerset satin white
16½ × 14 in. (41.9 × 35.6 cm)

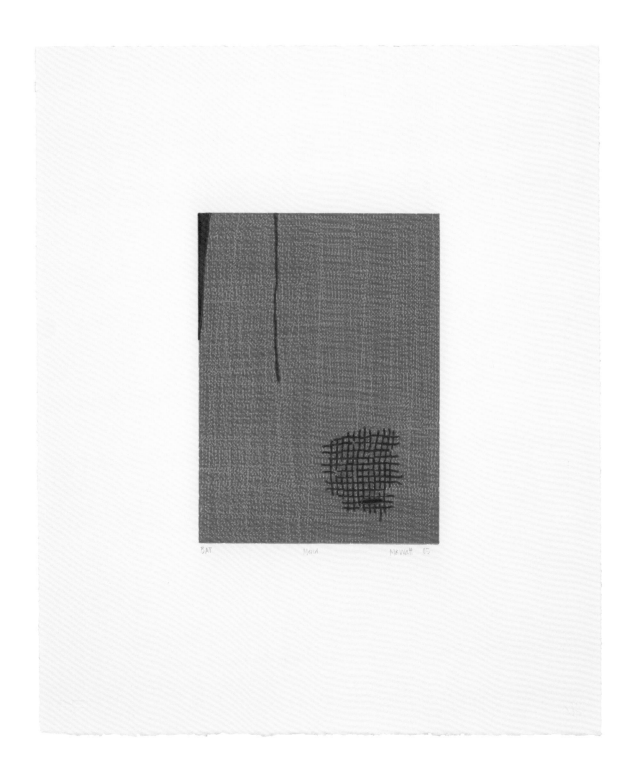

Mend, 2005
Woodcut on Somerset satin white
16½ × 14 in. (41.9 × 35.6 cm)

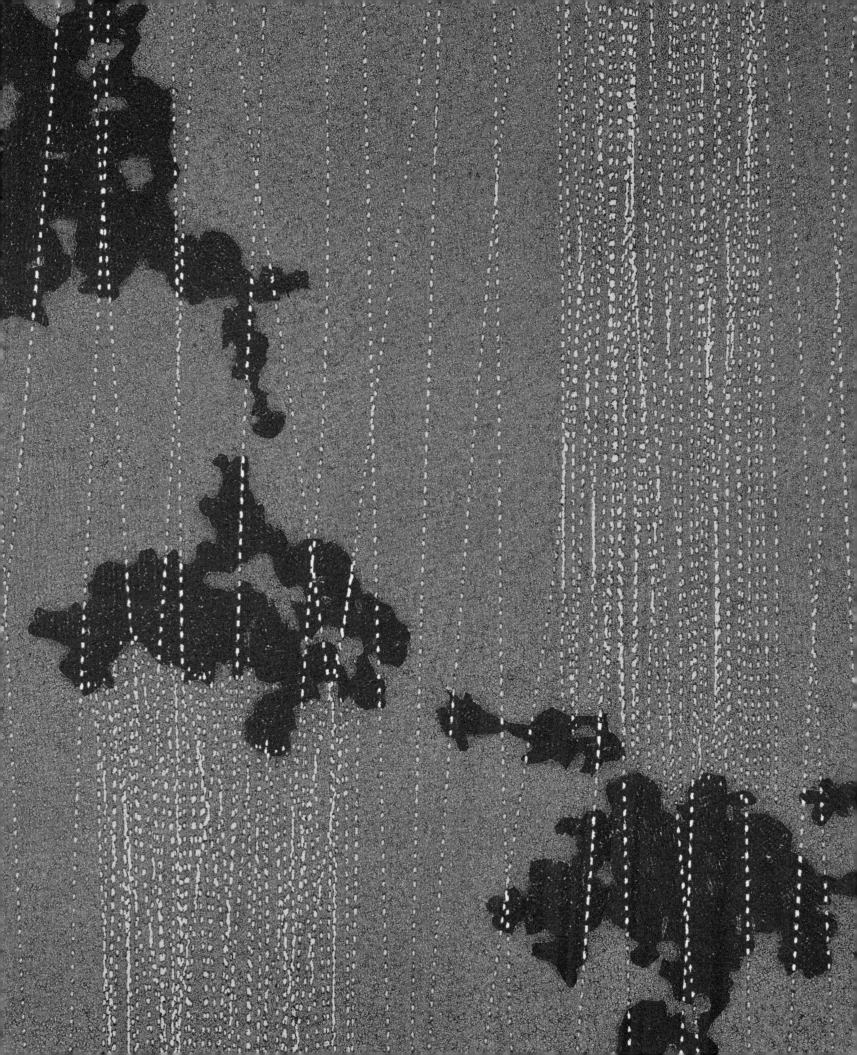

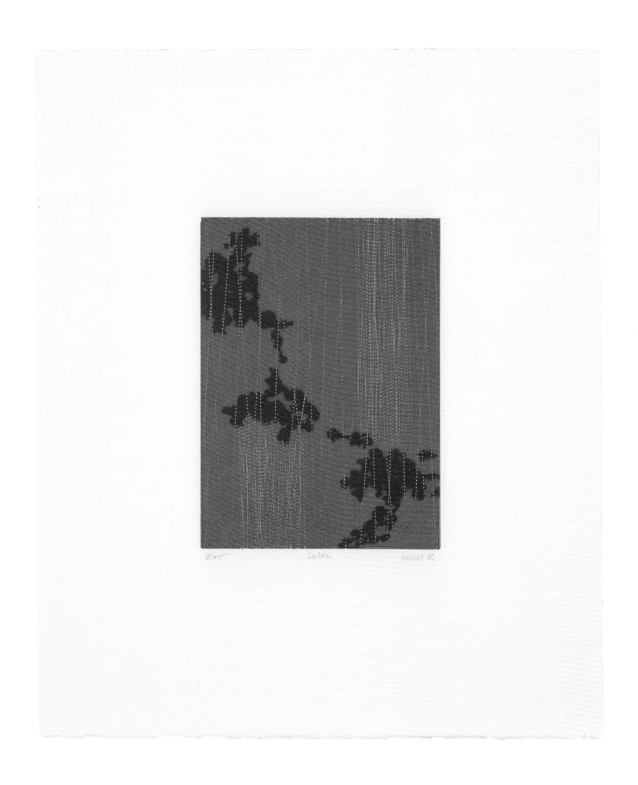

Ladder, 2005
Woodcut on Somerset satin white
16½ × 14 in. (41.9 × 35.6 cm)

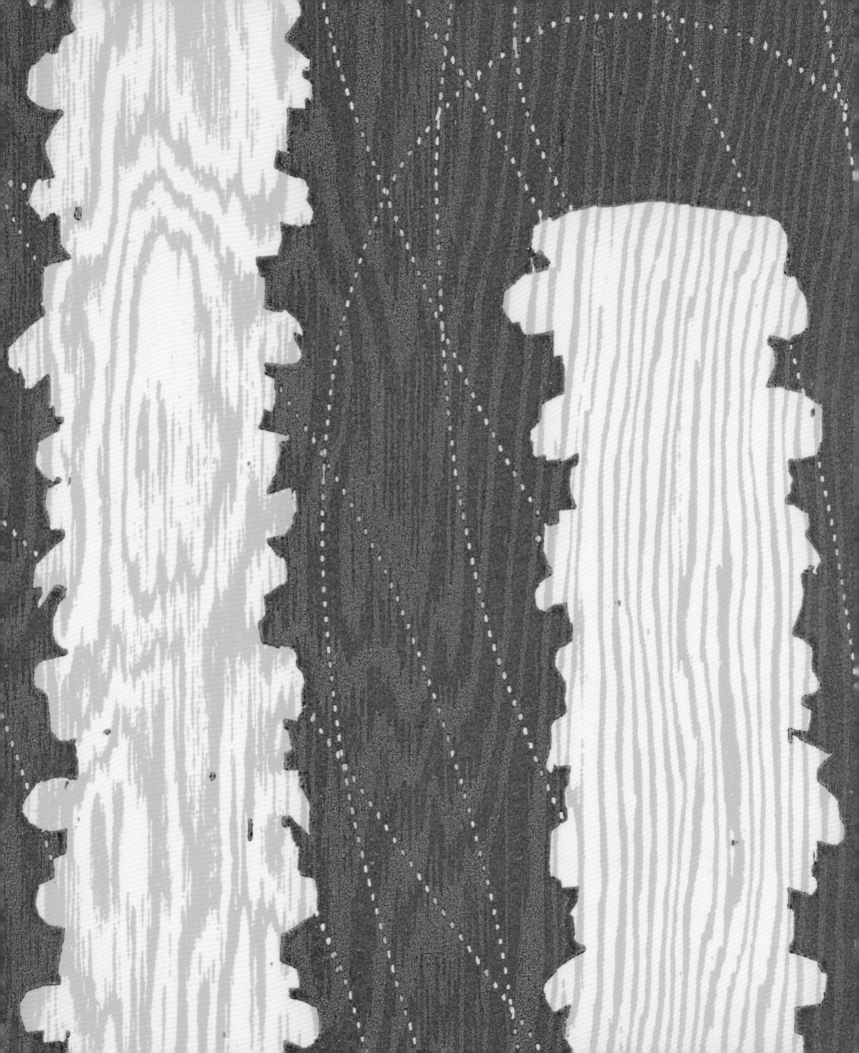

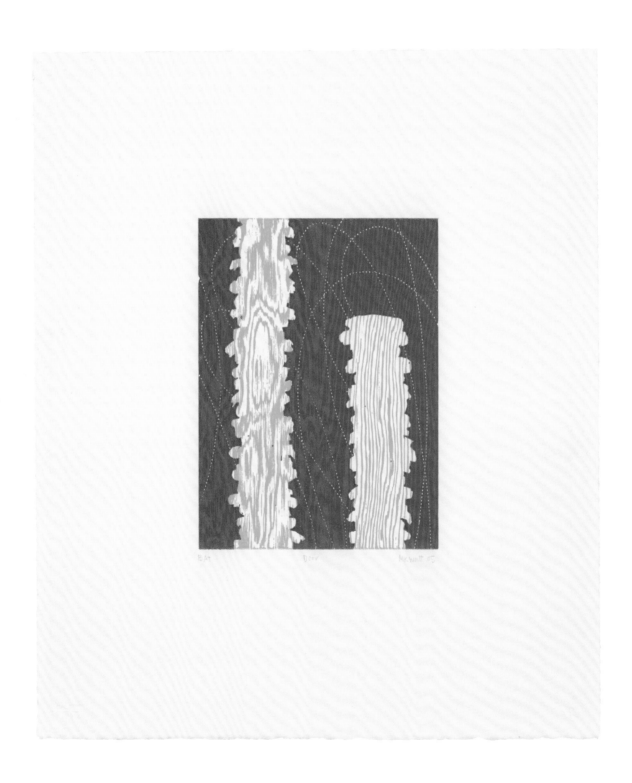

Door, 2005
Woodcut on Somerset satin white
16½ × 14 in. (41.9 × 35.6 cm)

Following pages:
Almanac: Glacier Park, Granny Beebe, and Satin Ledger, 2006
Bronze, reclaimed wool blankets, reclaimed red cedar
86 × 27 × 27 in. (218.4 × 68.6 × 68.6 cm)

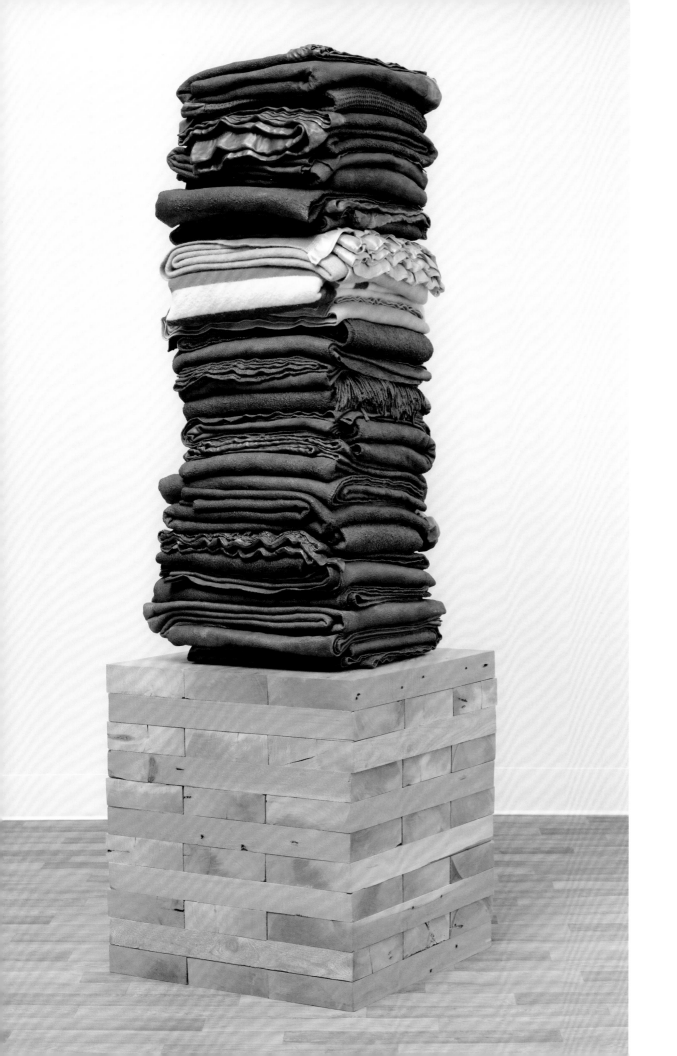

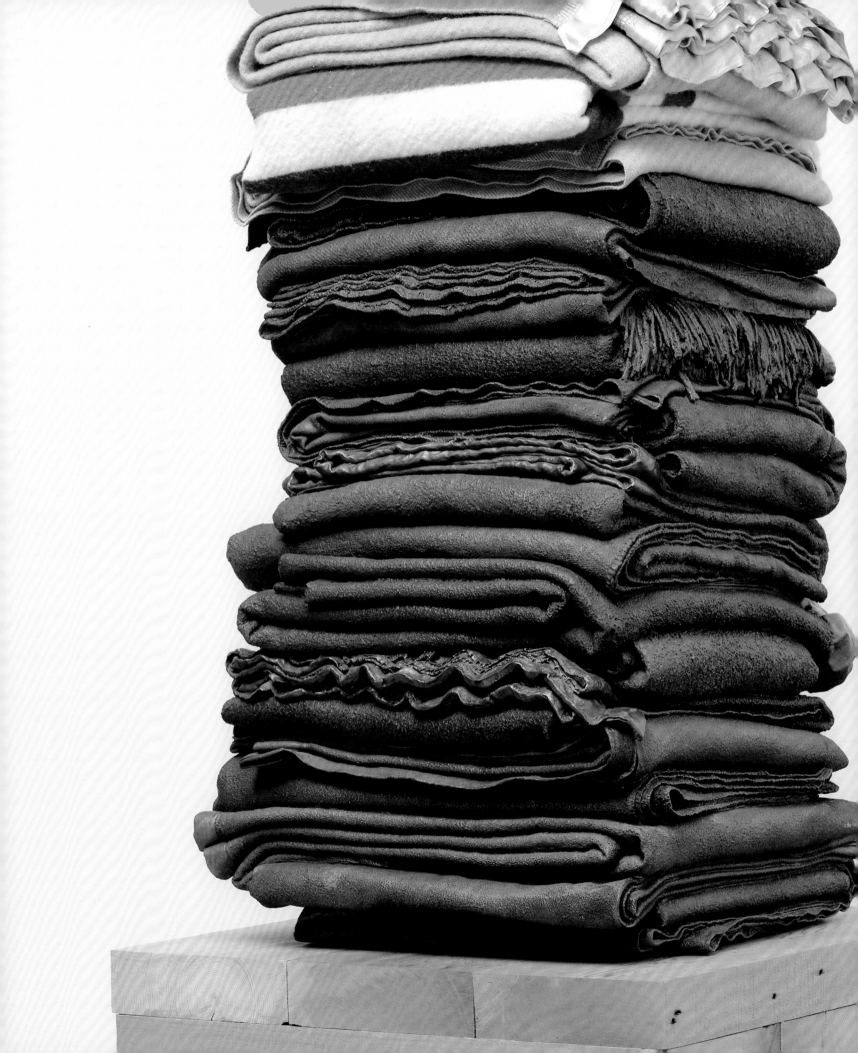

I had a blanket from my second birthday. It has different colors. It has pink, blue, orange,

I have a blanket I call my favorite Blankie. Its actually a large green sheet. I love it and I

friend Zoë. We have been friends for over 25 years. She stayed the night over at my house for t

into my house all those years ago. My blanket story is about my first blanket I call her Lola

My special blanket is pink with kittys dancing or doing something like that. I

a, my flying magic carpet, my police car, the house of my playmobils... I have today my l

sit on it thinking about the real importance of my problems.

I have a camels hair blanket my father got while in Africa in 1920.

square patterns on it and she used a lot of colors (red green, white, pink), I love sleeping with it

texture that made me feel happy to be at home on the couch waiting for mum's dinner.

I have blanket stories because I have a blanket named Pink Blank

mented garmet. that could not be salvaged... hold close those valuable items you wan

was made by my husband's grandmother from Ohio. It is made with remnants of mater

I love crawling under blanket

the summer of 2002. Me and my ex were in Crotona Park. We were outside all day

lay on was from her great great Grandmother and on that blanket is the first

reezy". It kept her warm in the winter. I (Frank) used to bug her and her freezy. I

her son did with her freezy. Maybe some day I will find it. I love blanket.

them by hand in different colors and with many textures.

actually a little cold last night I need to ask for a second blanket tonight.

have taken on a project of creating "cuddle blankets" an all inclusive term, for many kinds of quilts to be given to

ets are her legacy.

become a family heirloom. My parents have a green army blanket from internment camp that we

blanket was lost at the movie theater when I was seven or eight - maybe I was younger, actually be

remember what color it was or whether or not it was printed or solid. I do remember the satin

it was never replaced.

that my grandma gave me as a Christmas present when I was 10 years old. I sleep on it every night and

red stripes or should I say sections. It is beautiful. I keep it away in my closet so no one can't had it since I was born. I use it when I get scared and my friends aren't allowed to use it w

st time when we were 12 years old. She came with a bag full of blankets (5-7). She loves to ha with them. Her collection has grown over the years, but she still has 3 or 4 of the same ones she

My blanket now lives with my mom in Long Island. I miss her. (S

a lot of toys when I was younger, but I prefered always my blanket. It was my treasure ket kept with my toys and when I feel stress I put my blanket on the middle of my room

put it on a sheet as it is getting quite thin. I don't use it, but bring out to remind me of my dad. Before I was born, my grandmother made a special blanket. She gave it to me. She ma never I don't sleep with it, I don't have a good nights sleep. I love it.

love and protection. My favorite was a grey, black and white mohair blanket with a fabul

and I take it everywhere. Now she is old, but she used to be brand new eight years ago

covering it on my own rendered a smellie, torn and f

just had fun. The blanket she brought for

In memory of Catherine RoLon (Rivera) and her blanky she called loved. Now she (Cathy) is gone. I have no idea wh

I have so many memories about blankets. Back in my community people

time I have slept under a hospital blanket since I was in the hospital after being born ren who come to a local camp each summer. The project was started by a friend of ours who died of cancer n one is greeted with a blanket. Last year the women made 275. Our friend was Linda Karr. Blankete I embroidered a baby quilt for my first grandchild and hope it n se we were still living in Texas. I brought it there because movie theaters are usually so cold I used to hold between my forefinger and middle finger and rub. It was very soothing. My blan

work for the United Nations leaving my family, friends, and small town behind. I brought an old blanket n ink I will never quite look at it the same way now. I will recognize it as my foundation, my ground that ke razy people in this city) gets to me and makes me long for home. Grandmothers (and grandfathers, too g in that they are our replacement for the womb, so we are attached. The Irish, Welsh, Native Americans, a squirrel blanket. It was a comfort and dragged around after me. I said blue and white, but more often

Blanket Stories: Continuum (Book I), 2007
Lithograph with chine collé on natural Sekishu/white Arches Cover
22¼ × 30 in. (56.5 × 76.2 cm)

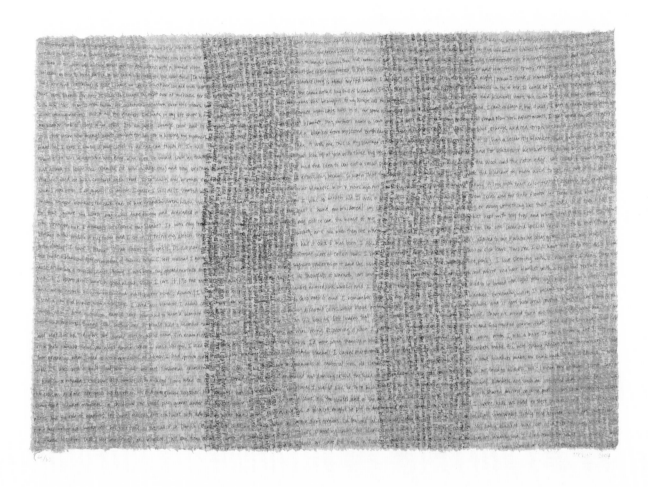

Blanket Stories: Continuum (Book I/Book III), 2007
Lithograph with chine collé on natural Sekishu/white Arches Cover
22¼ × 30 in. (56.5 × 76.2 cm)
Print Collection, University of San Diego

Loom: Betty Feves, Hilda Morris, and Amanda Snyder (off stage), 2009
Lithograph with light-blue Mulberry chine collé on Fabriano
Rosaspina cream
19½ × 14⅛ in. (49.5 × 35.9 cm)

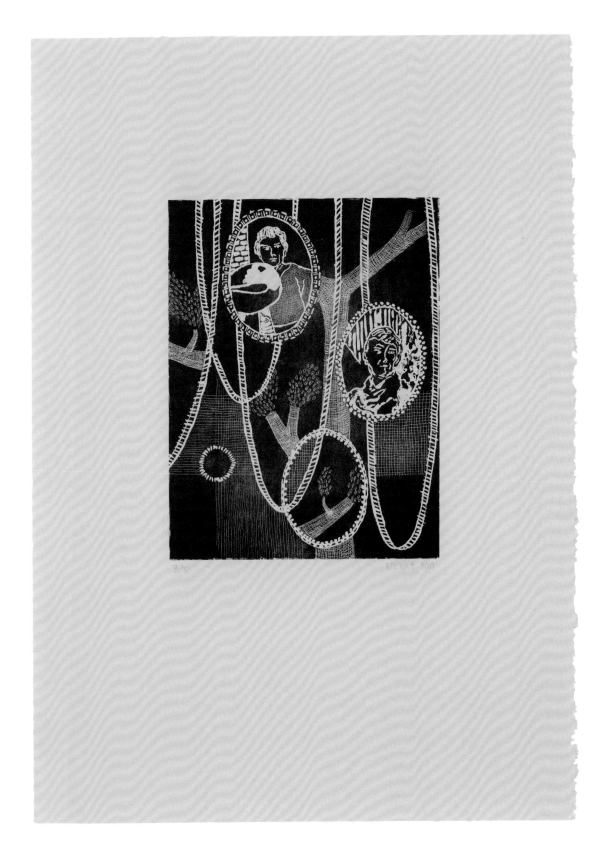

Tether, 2011
Woodcut on Somerset satin white
20¾ × 16 in. (52.7 × 40.6 cm)

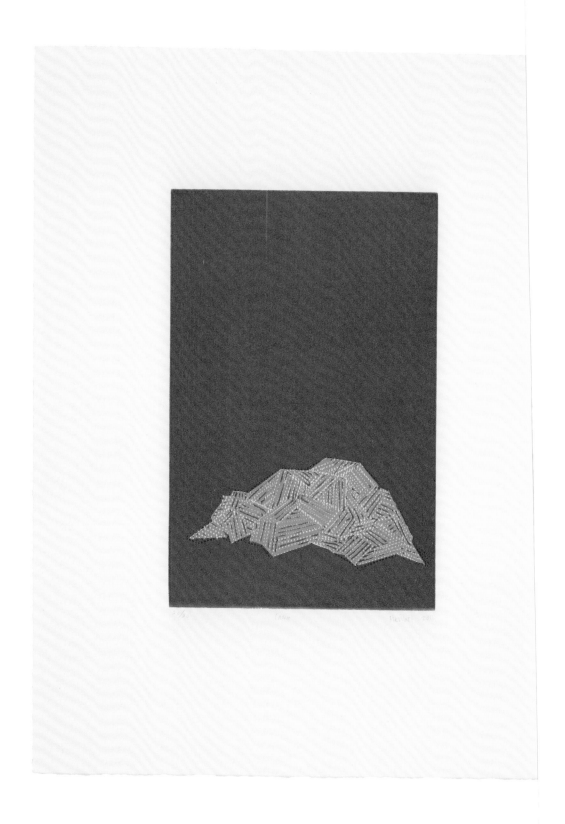

Camp, 2011
Woodcut on Somerset satin white
20¾ × 16 in. (52.7 × 40.6 cm)

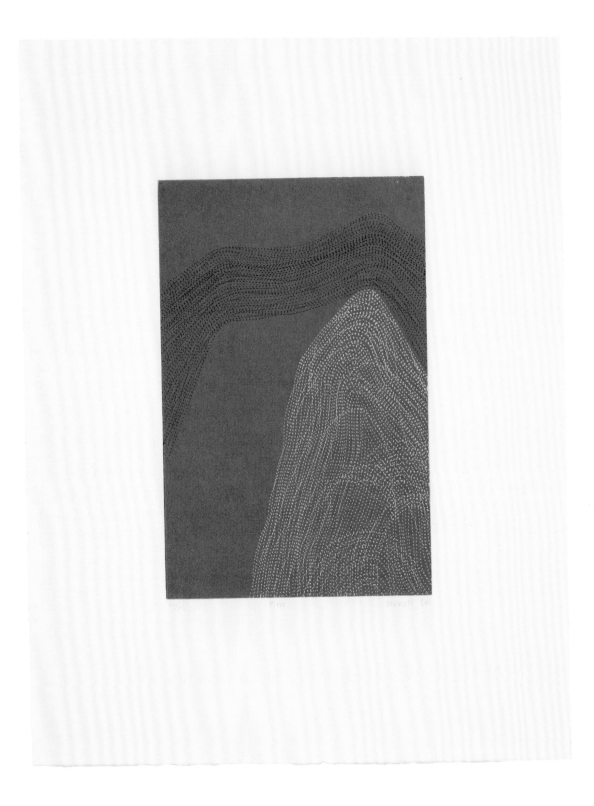

Plow, 2011
Woodcut on Somerset satin white
20¾ × 16 in. (52.7 × 40.6 cm)

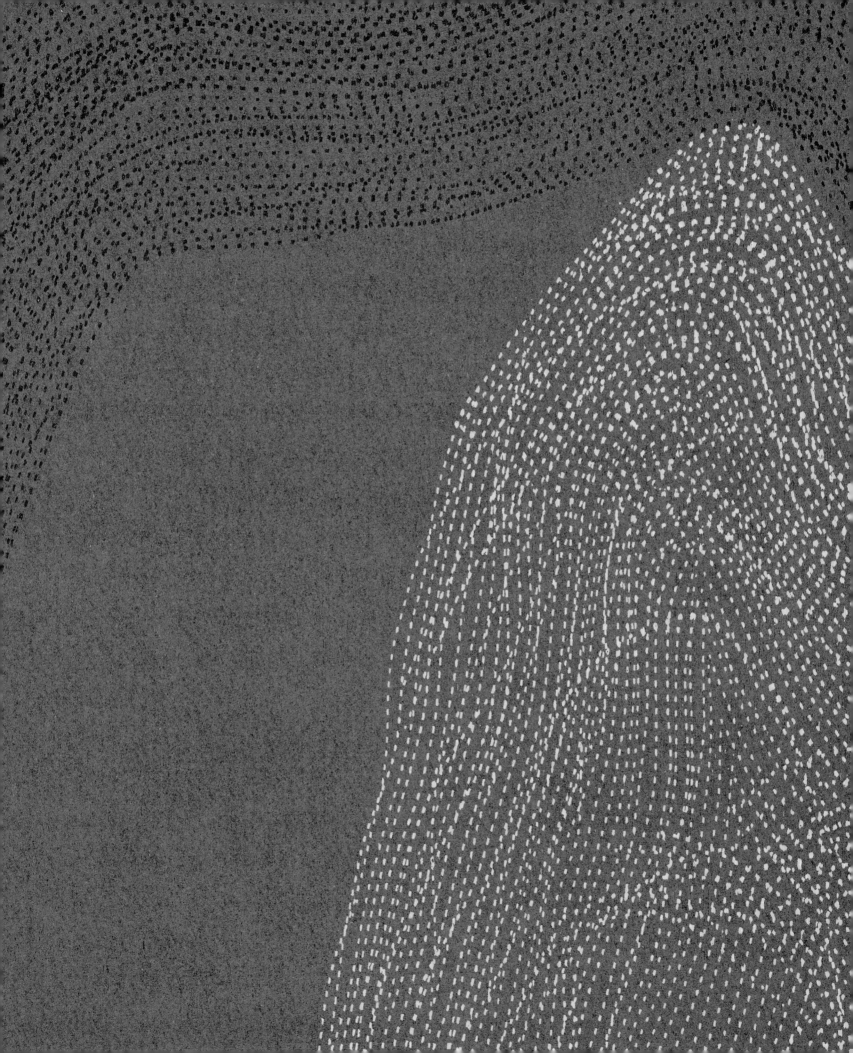

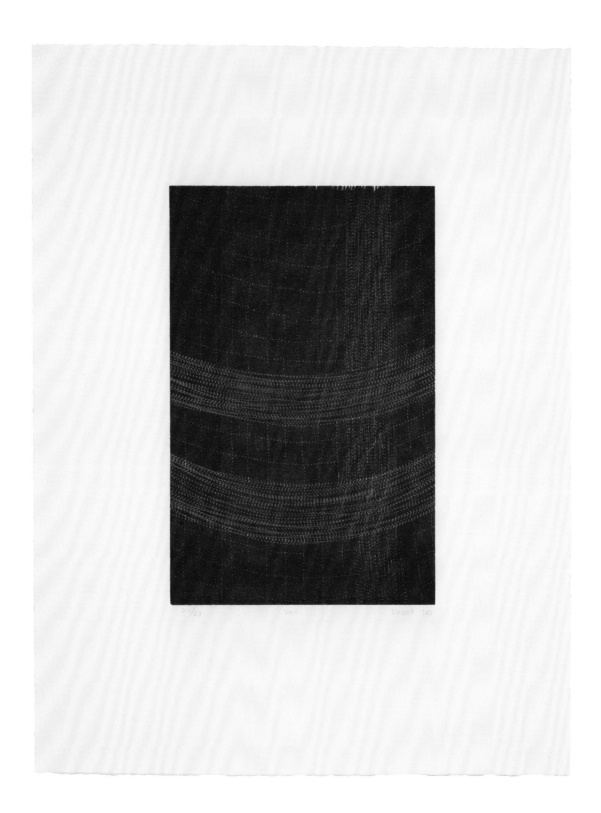

Vest, 2011
Woodcut on Somerset satin white
20¾ × 16 in. (52.7 × 40.6 cm)

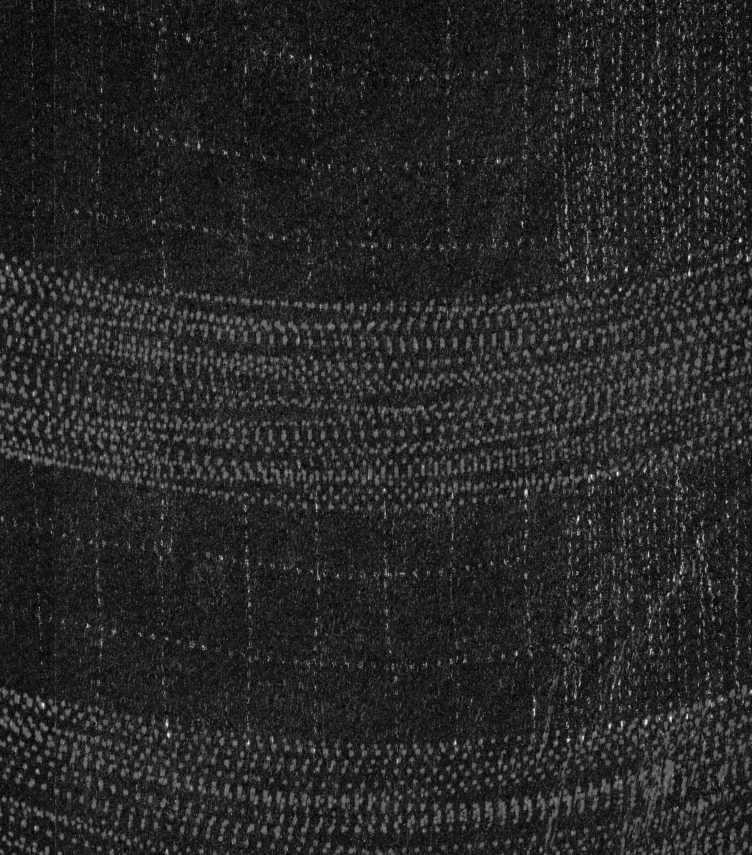

Cradle, 2011
Cast resin
16 × 17 × 8½ in. (40.6 × 43.2 × 47 cm)

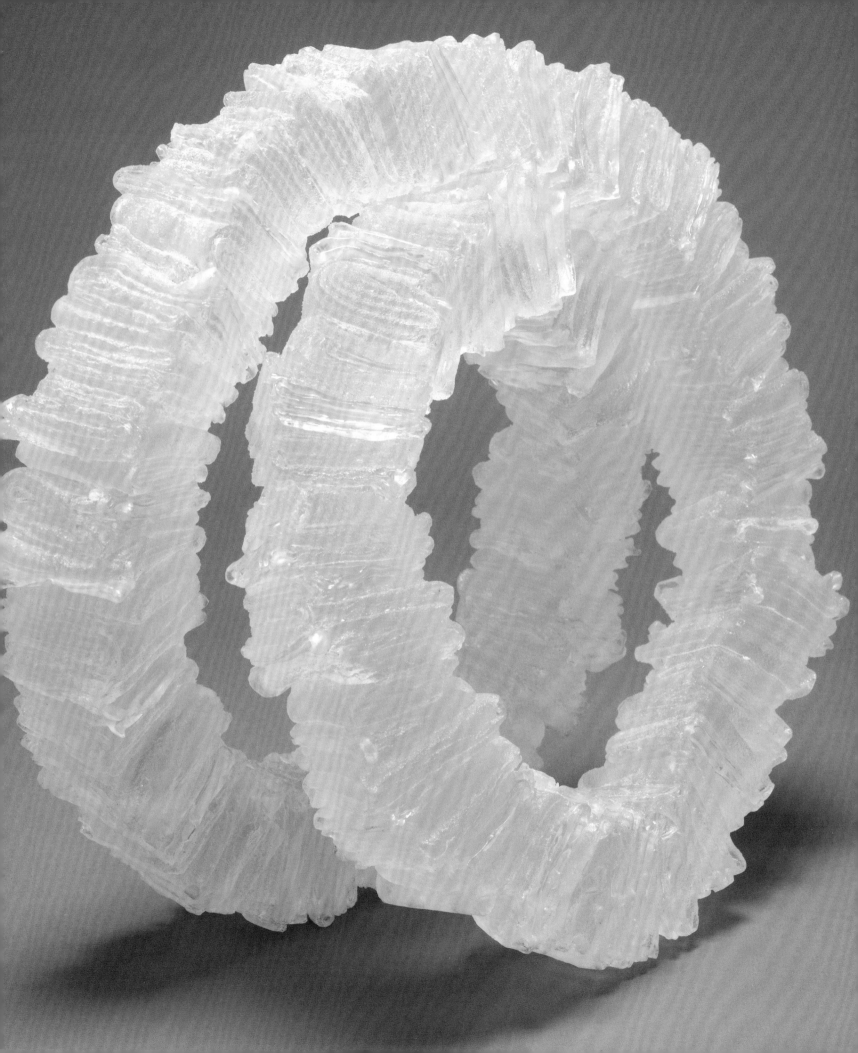

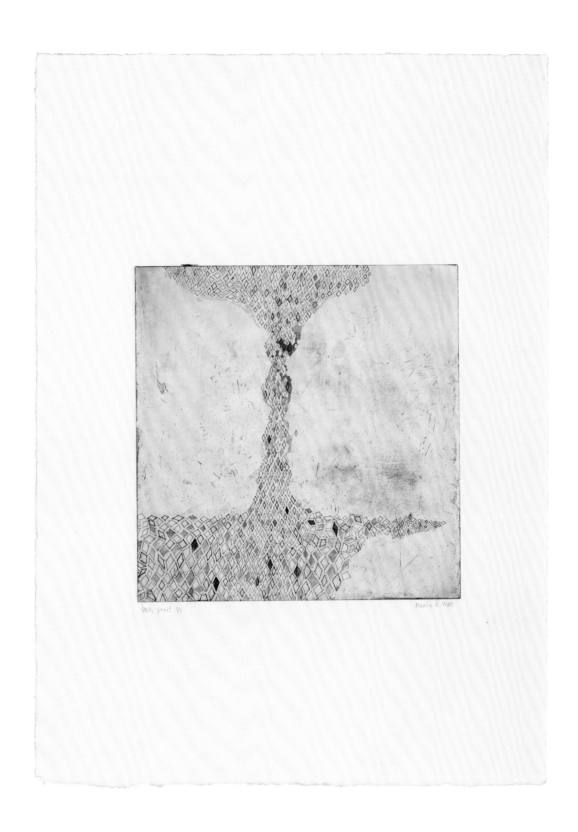

Landmark: Water/Sky (Summit), 2013
Etching
18¾ × 15½ in. (47.6 × 39.4 cm)

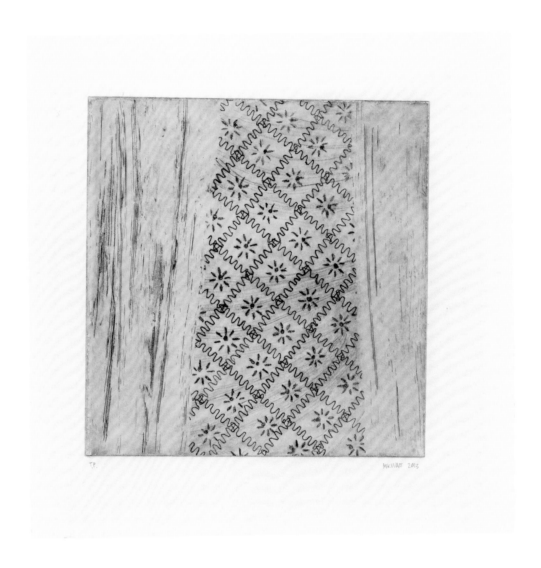

Landmark: Curtain (India Blanket), 2013
Etching
13¾ × 13¾ in. (34.9 × 34.9 cm)
Print Collection, Unversity of San Diego

Landmark: Skywalker, 2013
Lithograph on Somerset satin white
11 × 10 in. (28 × 25.5 cm)

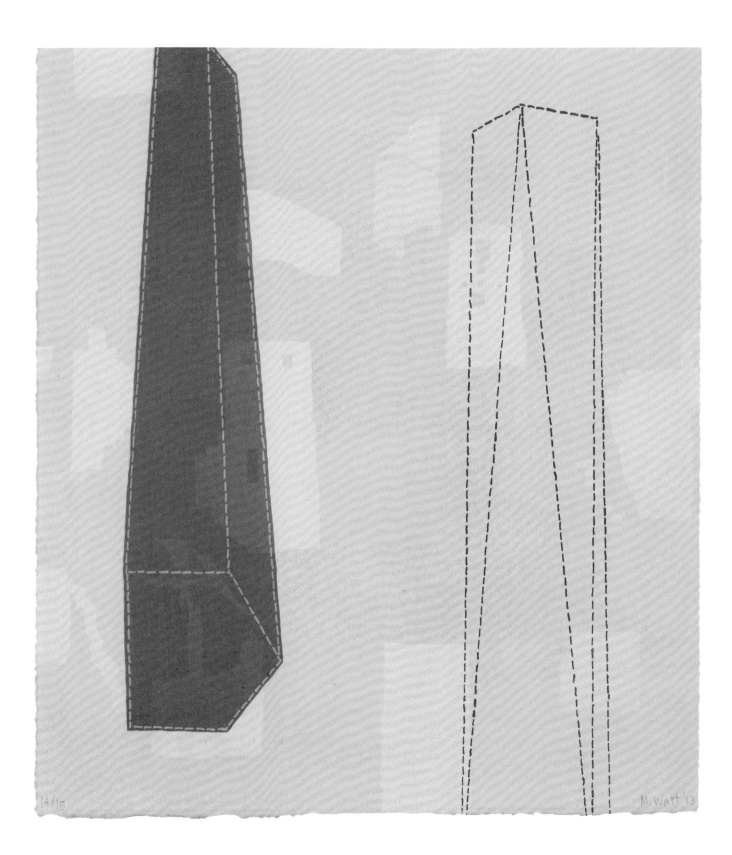

14/15 M. Watt '13

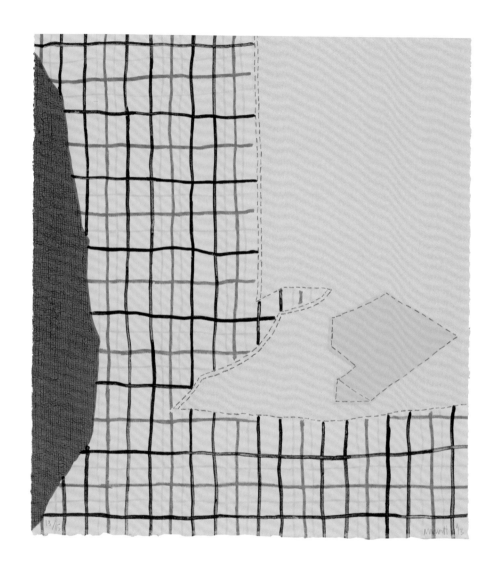

Landmark: Mound Builder, 2013
Lithograph on newsprint grey Somerset satin
11 × 10 in. (28 × 25.5 cm)

Mound Builder, 2014
Reclaimed wool blankets, thread, and embroidery floss
96½ × 87 in. (245.1 × 221 cm)

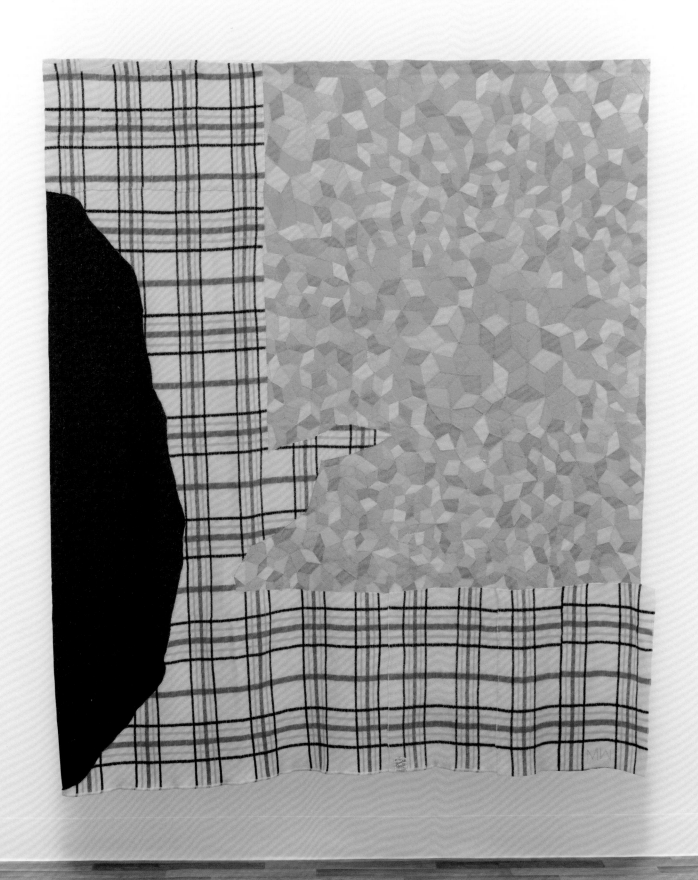

Landmark: A Thousand Names, 2013
Lithograph on newsprint grey Somerset velvet
11 × 10 in. (28 × 25.5 cm)

East Meets West Summit, 2014
Reclaimed wool blankets, embroidery floss, thread
121 × 87 in. (307.3 × 221 cm)

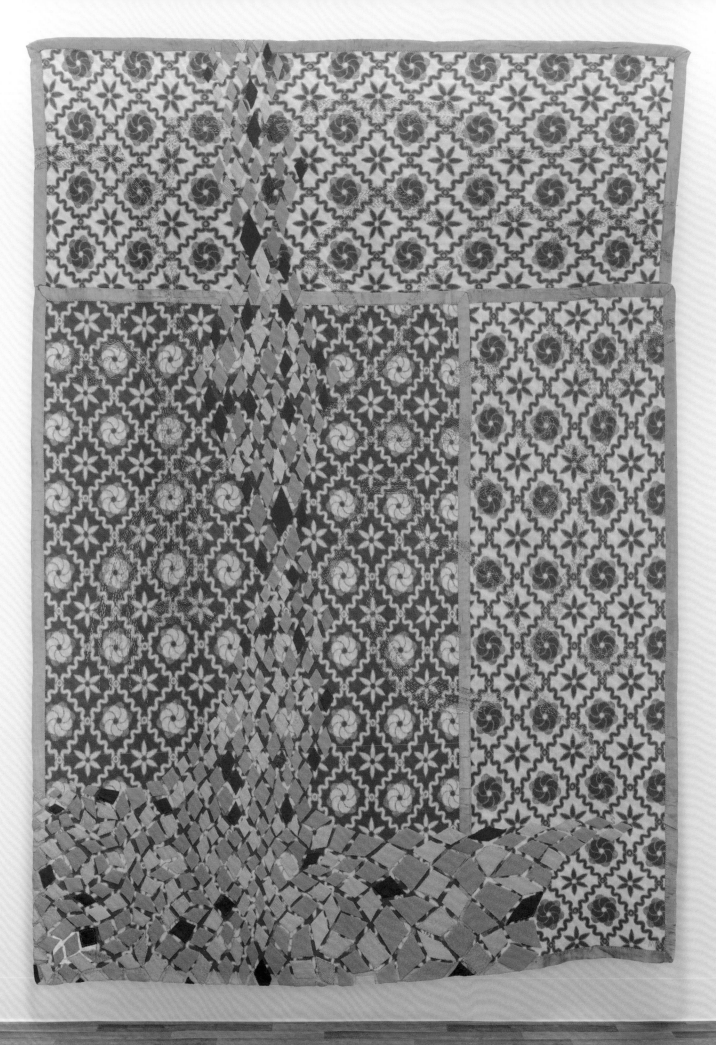

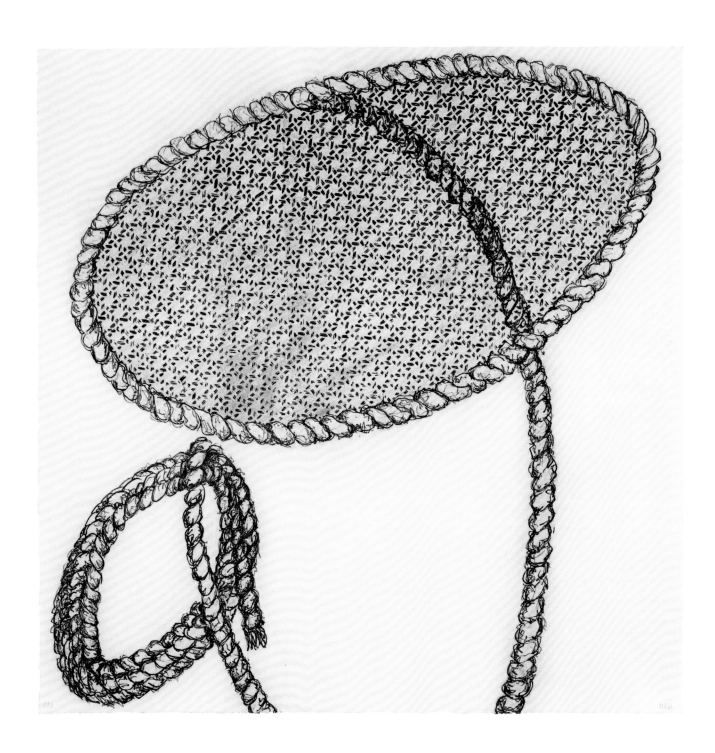

Portrait with Chair Caning (Part I), 2014
Softground etching on Hahnemühle warm white
18 x 18 in. (45.7 x 45.7 cm)

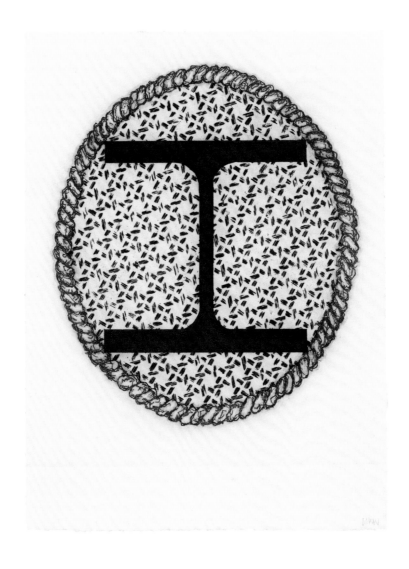

Portrait with Chair Caning (Part II), 2014
Softground etching and aquatint on Hahnemühle warm white
10 × 7½ in. (25.4 × 19 cm)

Seven Sisters (Shadow Plaid), 2016
Reclaimed wool blanket, embroidery floss, thread
16¾ × 18 in. (42.6 × 45.7 cm)
University of San Diego, David W. May Collection. A2019-3-1.

Artifact, 2014
Softground etching on Hahnemühle warm white
17 × 17 in. (43.2 × 43.2 cm)

Transportation Object (Sunset), 2014
Softground etching, sugar lift, and aquatint on Hahnemühle warm white
11 × 12 in. (27.9 × 30.5 cm)

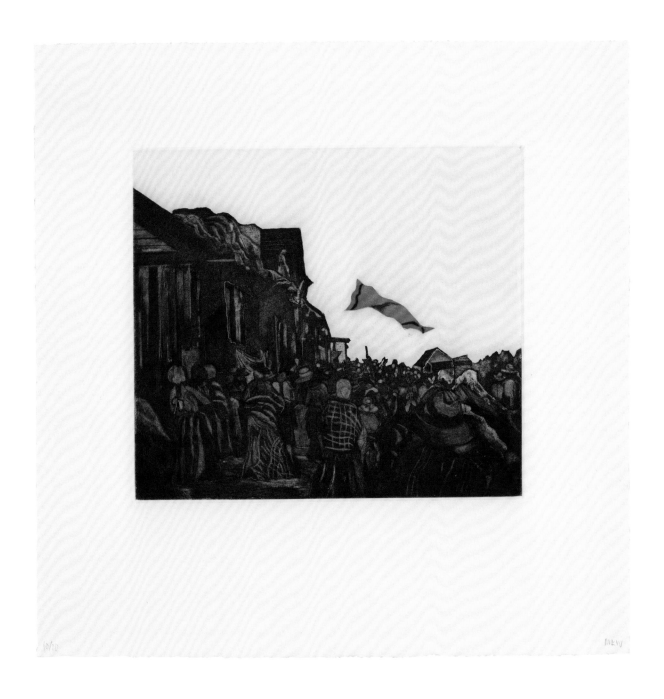

10/10 MEW

Witness (Quamichan Potlatch, 1913), 2014
Aquatint and whiteground etching on Hahnemühle warm white
12 × 12 in. (30.5 × 30.5 cm)

DER FIGHTER

GE

EQUITY

TEACH

SEVEN

GENERATION

proto
proto
proto
proto

AN

Companion Species (Words), 2017
Softground etching, aquatint, drypoint, on medium-weight, smooth,
warm white Hahnemühle
16½ × 22¼ in. (41.9 × 56.5 cm)

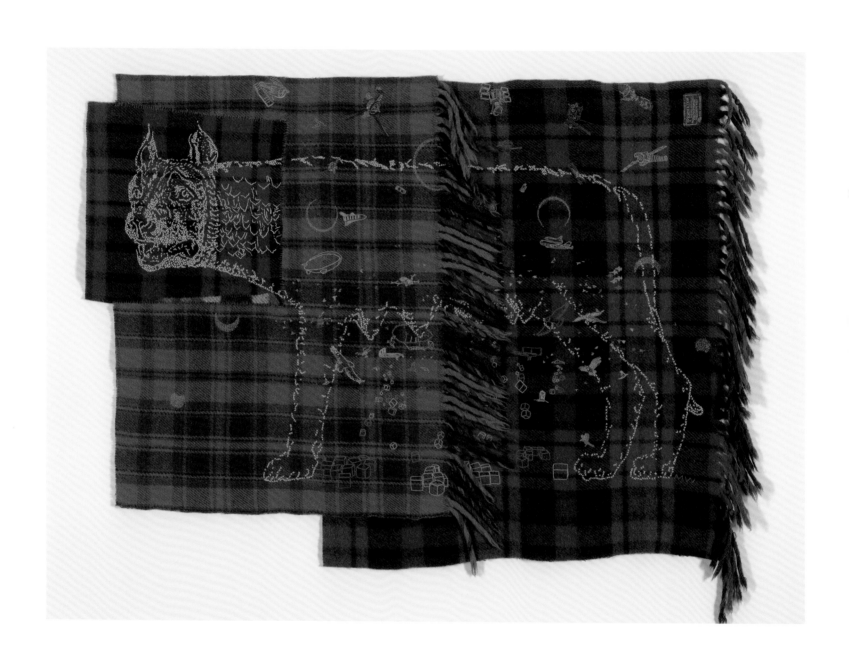

Companion Species (Cosmos), 2017
Reclaimed wool blanket, 24-karat gold-wrapped silk thread,
embroidery floss, thread
31 × 37 in. (78.7 × 94 cm)

Companion Species (Ancient One), edition 8/10, 2017
Cast bronze, reclaimed wool blanket (artist's grandmother's),
western walnut base
5 × 10¾ × 11⅛ in. (12.7 × 27.3 × 28.3 cm)

Companion Species (Mother), 2017
Softground etching, aquatint, drypoint, on medium-weight, smooth,
warm white Hahnemühle
16½ × 22¼ in. (41.9 × 56.5 cm)

Companion Species (Field), 2017
Reclaimed wool blankets, thread, embroidery floss
106 x 291 in. (269.2 x 739.1 cm)

Companion Species (Listening), 2017
Reclaimed wool blanket, embroidery floss
10½ × 35¾ in. (26.7 × 90.8 cm)

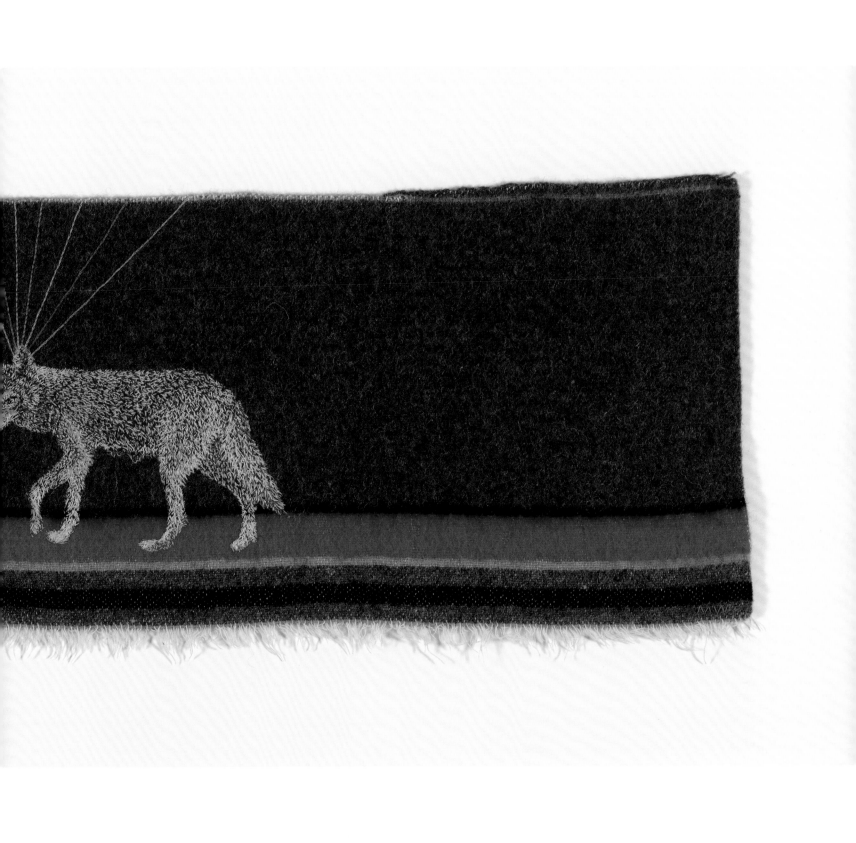

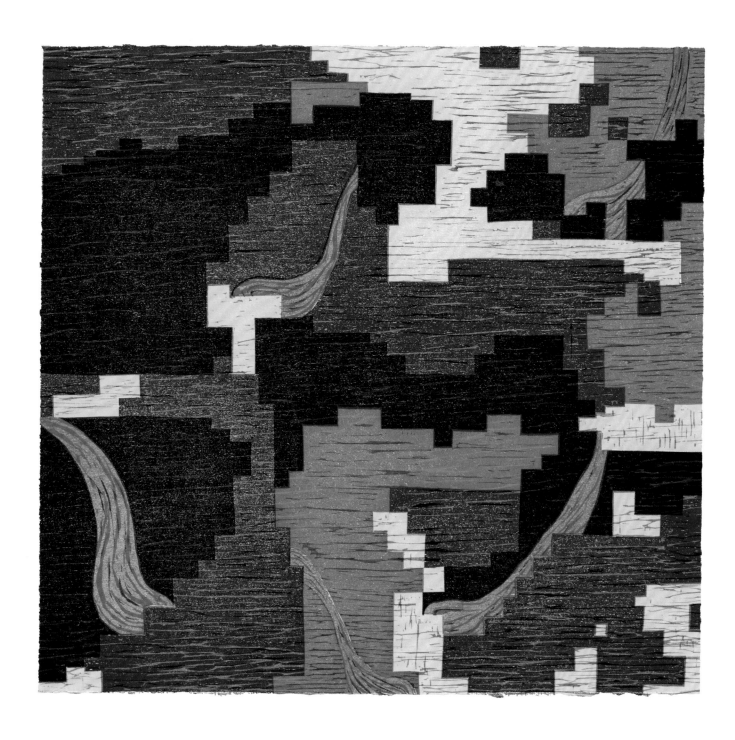

Companion Species (What's Going On), 2017
Woodcut on Somerset satin white
17½ × 18½ in. (44.5 × 47 cm)

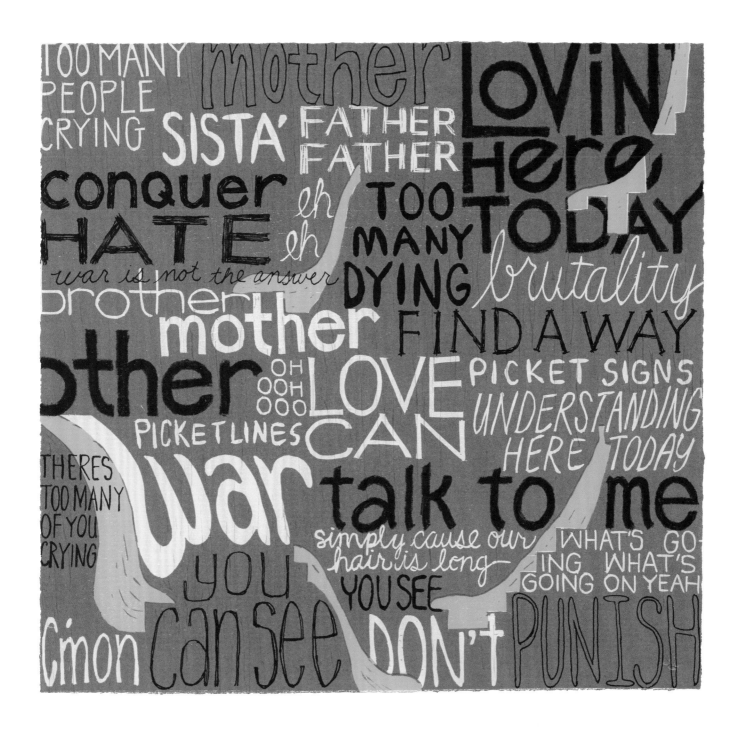

Companion Species (Anthem), 2017
Woodcut on Somerset satin white
17½ × 18½ in. (44.5 × 47 cm)

Companion Species (Malleable / Brittle), 2021
Softground etching
16½ × 21½ in. (41.9 × 54.6 cm) each

Companion Species (Rock Creek, Ancestor, What's Going On), 2021
Lithography and pressure print on Japanese kozo, collage, and backed
with Sekishu
30 × 91½ in. (76.2 × 232.4 cm)

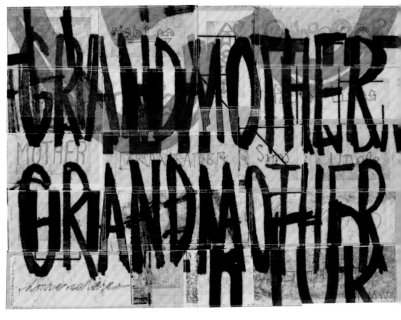

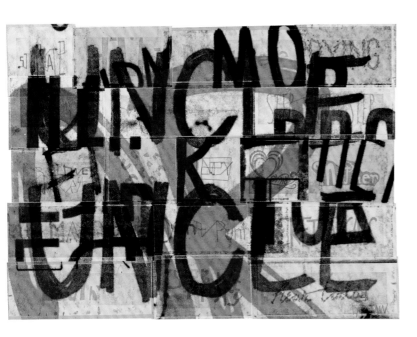

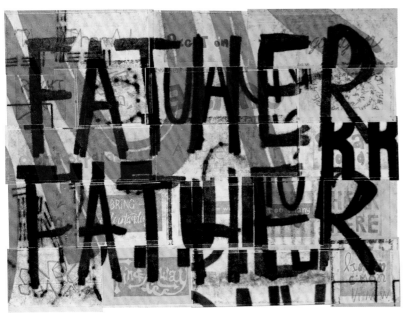

Companion Species (Passage), 2021
Pressure print on Japanese kozo, collage, and backed with Sekishu
72 × 96 in. (182.9 × 243.8 cm); each panel 23½ × 31½ in. (59.7 × 80 cm)

CALL-AND-RESPONSE
A DIALOGUE WITH MARIE WATT

DERRICK R. CARTWRIGHT

DERRICK R. CARTWRIGHT: How are you, Marie? How was New York?[1]

MARIE WATT: Good. I've just returned and now I'm quarantined in the house. Like everyone caught in this pandemic, I'm trying to figure out my life situation. It's funny, in my household everybody has established their own office and room except me—I'm on the bedroom floor, making it work somehow. Being in New York was strange and surreal, but also kind of lovely. The hotels were like ghost towns, although the place I was staying definitely got a little more crowded on the weekend. The travel part was actually fine. The flight to New York was nearly empty and, once there, I had to quarantine. I was tested in Portland before leaving and then stayed in the hotel for three days while waiting for another test result. There were contact tracers calling me and everything. After all of that, I got to work on-site.

CARTWRIGHT: This is a strange time. Yet, when I think about you and your career, it looks to be going really well. You've had major institutions acquiring works, and solo and group shows throughout the country. How do you feel about that?

WATT: I definitely feel grateful in this moment to have work as an artist. I appreciate the fact that I'm able to sustain this career full-time and support my family. Like everybody, when the virus first hit I wondered what was going to happen, and, honestly, I felt like I was on rocky ground. I applied for grants and for a PPP [Paycheck Protection Program] loan. In some way, that created a safety net. This offered stability as I prepared to open an October show at Marc Straus Gallery in New York. In an unexpected way, I had a concentrated presence on the East Coast—at the Whitney Museum of Art, Marc Straus Gallery, Loro Piana. It feels nice to be welcomed there, to be a part of that community and, as a result, to be new to some people's consciousness. More than anything, I am aware that so many artists and institutions are struggling as a result of the pandemic. I'm trying to figure out how do I and we as a community support this fragile and resilient ecosystem?

One of the things I have a lot of gratitude for is making new friendships under these circumstances—take the recent collaboration with Loro Piana as an example. Sustaining deep relationships in this moment of COVID is hard enough, but to be forging new relationships at this time is unusual, especially through an abundance of screen-facilitated connections. I'm also still trying to figure out how to use the Zoom format for presenting ideas. I've been in a couple of programs where I thought I was prepared and later felt, wow, that completely crashed and burned. At least these less-than-ideal circumstances encourage us to be more creative in the ways we connect.

CARTWRIGHT: The exhibition in San Diego will be the first one to focus solely on your activity as a printmaker. You've had other shows in which your prints are featured, but always in a secondary relationship to your sculptural practice, right? I'm wondering whether it was just a matter of time before somebody came along and said, "OK, Marie's done all this great print work. Let's investigate it."

WATT: It's true, nobody ever really picked up on that until now. The fact is, printmaking has been a consistent component of my practice, and, truthfully, it wasn't until you reached out that I thought of it as something I've always done but which hasn't received as much attention. Even though I haven't centered it, that doesn't mean it isn't important to my practice. Now that I've looked at your checklist for the exhibition, I'm asking myself, "How is it that printmaking has always been so integral and vital to my practice, but even I didn't recognize its significance?" This project invites me to think more about that history and the different ways I use prints in my work. I'm grateful for this opportunity.

CARTWRIGHT: Do you remember when you made your first print?

WATT: I do! I made my first print while I was a student at Willamette University, with Professor James Thompson. Because Willamette is a small liberal arts college, we were required to take classes in all disciplines. For the very first time in an academic setting I felt like, "Wow, I can take an art class!" I remember my first printmaking class fondly, in part because it's where I made my first artist-friend at Willamette, Matt Ferranto. He now teaches at Westchester Community College in New York, and we continue to be friends to this day. Somewhere I have a monotype of Matt working in the studio. It's a very austere image, almost completely black. At that time, Matt had really big, frizzy hair, and the image captures that part of his appearance.

CARTWRIGHT: Did you make prints while you were at Yale?

WATT: Yes, I studied printmaking with Professor Rochelle Feinstein. In 1994, it was her first year teaching at Yale and she was on a fast track to become the first tenured female professor in the department of Painting/Printmaking. This was an important milestone, but also seemed way behind the times. I had grown up in the West and moved to Connecticut from New Mexico, where I had finally found a community that I identified with at the Institute of American Indian Arts. New Mexico offered such a rich intersection of ethnicities and cultures, particularly Indigenous and Hispanic people. After being immersed in this diverse community, living in New Haven was a culture shock. At that time there wasn't a visible Indigenous community on campus. On top of that, the Yale School of Art felt a bit like an "old boys' club." I've gone back since,

FIG. 42. Marie on Zoom, December 2020.

and I'm happy to say things have changed and are still evolving.

Anyway, I took Feinstein's class early on in my MFA studies. Most people who graduate from the painting program at Yale have a degree in both painting and printmaking, so everybody's required to do this coursework. I was a work-study student, and my job was in the printshop. It was the perfect gig because I got to be in the shop at all hours. When I wasn't tidying up, cleaning, and opening or closing the studio, I was able to make my own prints. One of the things I loved most about that experience was being around my classmates, artists who shared a similar interest in printmaking. At Yale, there were a bunch of people I got to know better because of our time in the printshop: Gina Ruggeri, Jenny Dubnau, Simone DiLaura, Andrea Champlin, and Pedro Barbeito, to name a few. It's funny, I've never really made this direct connection between prints and

community before now. There is something similar about the printmaking studio and the sewing circles that I am invested in. It has to do with being in a place where your eyes are diverted and you're making your work and the stories just flow. In the print studio we're working side by side, time passes as plates are being processed, we're helping each other out, and connections are made. There's something special about those conditions.

CARTWRIGHT: It sounds like graduate school was the moment when you became comfortable in the print room. Has that comfort remained in other places where you've made prints since?

WATT: For sure. Actually, right after graduating from Yale, I moved to Portland and became a member of Inkling Studio. Inkling was a co-op print workshop which unfortunately no longer exists. It was run by

FIG. 43. *Untitled (Corn Husk Study—Pair)*, 1996; engraving with gouge, 10 × 10¾ in. (25.4 × 27.3 cm).

Liza Jones. Some of the prints I made during that period built upon projects I had started at Yale (fig. 43). The prints of corn husks that use a soft-ground technique, for example. I wanted the colors to relate to corn, because corn embodies our Seneca culture—nutritionally, spiritually, physically, meta-physically. The colors are reminiscent of the layers revealed when shucking corn: the sunny greens of the husk, the warm red-brown that is the corn silk, the milky yellow of the kernels converse with images of braids. I started to explore this project at Yale, but the prints never ended up becoming an edition. I made progress on them while at Inkling, but, still, it was something I never fully resolved. One of my downfalls is the patience required for editioning. So this is a variable edition.

CARTWRIGHT: When you had your MFA show at Yale, were there prints in it, or was it mostly a painting show?

WATT: I don't recall prints in it, but it also wasn't an exhibition of paintings. I worked with corn husks and created this giant "tapestry" in which husks were adhered together. It was about five feet wide and maybe eight feet tall. The form cascaded down, off the wall, and became a waterfall, which was the work's title, but it was really about corn and the nature of culture and land. If you hold a corn husk up to the light, there's this ridge and cellular structure that are fascinating. This led me to exper-iment with using husks sculpturally. I would soak the husks, making them malleable, and then create three-dimensional objects out of them. When a husk is dry, it becomes surprisingly fragile and, in a way, vulnerable. When it's wet, it's totally resilient and strong. I think that is a powerful metaphor, to hold vulnerability and resiliency within us.

At the same time, I found myself doing cumu-lative drawings of tiny cellular or lozenge-shaped marks, a form derived from looking at corn husks. I was making these marks using walnut ink and a

FIG. 44. "Conduit to the Mainstream" symposium at Crow's Shadow Institute
L to R:
Back row: Anthony Dieter, Joe Feddersen, Margaret Archuleta, James Lavadour, Laura Recht, Frank Janzen, Edgar Heap of Birds, Prudence Roberts, Joanna Bigfeather, James Luna.
Front row: Truman Lowe, Eileen Foti, Marjorie Devon, Dr. Rennard Strickland, Kay WalkingStick, Mari Andrews, Marie Watt.
Photo: Walters Photographers.

bamboo pen and repeating the gesture over and over and over again. My interest was in how the shape became almost topographical. In the end, it started to look architectural, but also resembled skin. As I am saying this, it strikes me that blankets are both those things, too. A blanket is a kind of husk, an outer layer, like a skin. So I look back now and can connect dots that I couldn't see at the very start. What began in New Haven, I am still pursuing here in Portland.

CARTWRIGHT: I want to ask about the relationship between the textiles and the prints you've made. Are these separate activities, or do they happen simultaneously?

WATT: What makes them separate is that, at some point, I was invited to step away from my studio in order to make prints collaboratively. I stopped printing at Inkling due to time constraints with teaching, but around this time I also started to work with master printers. A couple of years ago I bought my own Takach tabletop press, but I have yet to use it. I keep thinking that I'll carve out the time to make plates and proof them, but it hasn't happened yet. Two artists who I admire and have email-like-pen-pal friendships with are Alison Saar and Jaune Quick-to-See Smith. I know both of them have printing presses in their studios. I'm very curious to know how they integrate printmaking into their studio practice, beyond working with master printers.

CARTWRIGHT: Alison is such a marvelous sculptor who, like you, seems to move effortlessly between her three-dimensional practice and various printmaking efforts.[2] I don't want to put words in your mouth, but I wonder if one medium is primary for you?

WATT: No, they feed off each other. Sometimes a print will help manifest an idea, and then it may become something even more amplified in my studio as a sculpture. But at other times, something

may be happening in my studio and, as a way of understanding it further, I try making it into a print. It is omnidirectional. Does that make sense?

CARTWRIGHT: It does. I want to chase something you said a moment ago. You've had multiple opportunities to work with master printers throughout the country. How did the invitations to work in those places come about?

WATT: One thing that's really critical is to have a rapport with a printmaker. If there is a good fit, you often get the opportunity to come back together and expand on what's come before. I'm not usually the one deciding who gets invited to a printmaking residency, but I am always grateful to be asked. I think my first experience working with a master printer was at Sitka Center for Art and Ecology with Julia D'Amario, and later that year I printed with Frank Janzen at Crow's Shadow Institute of the Arts. Printing first with Julia better prepared me for making my first set of lithographs with Frank. That set of lithographs remains one of my favorites.

In my experience, the first week of the residency is spent working on the plates, doing technical tests and processing. The second week is absorbed with color trial proofing. One thing that's significant about my relationship with Crow's Shadow is that, prior to working with Frank, I was invited there for a symposium called "Conduit to the Mainstream" (fig. 44).[3] At that conference there were people from three leading print organizations in attendance: Eileen Foti, who was from the Center for Innovative Print and Paper at Rutgers; Marjorie Devon, who was the director of Tamarind Institute at the time; and Mari Andrews from Crown Point Press. Through that experience, I was introduced to Marjorie, and that was the catalyst for an invitation to print at Tamarind. There were also Indigenous artists and

curators at the symposium. Looking back now, I really see this symposium as my first opportunity to meet and interact with all these art luminaries who inspired me. I would be remiss if I didn't mention Jim Lavadour, the cofounder of Crow's Shadow Institute of the Arts located on the Confederated Tribes of the Umatilla Indian Reservation in the foothills of Oregon's Blue Mountains. Jim's belief in printmaking as a tool for agency for contemporary Native artists and his own example as a full-time working artist made me feel it was possible to build that path for myself, too. I consider Jim family and this friendship started with the "Conduit to the Mainstream" symposium.

"Conduit to the Mainstream" opened up many opportunities. Somewhere I have a photo of the participants, including Truman Lowe, who, after that gathering, included me in the *Continuum* exhibition that he curated at the Smithsonian National Museum of the American Indian, at the George Gustav Heye Center in New York City. At that time, I was still teaching art at Portland Community College and all of a sudden I had a golden letter from Truman and a compelling sabbatical application. I felt very lucky; that opportunity was well timed. That sabbatical year was a turning point for me in making my work full-time. After the show at NMAI, I dutifully went back to teaching but also had my first child, Maxine, who's now sixteen. After fulfilling the return-to-teaching commitment, I took a leave of absence to figure out whether I could sustain the studio practice on its own. That decision also allowed me some flexibility as a new mom.

CARTWRIGHT: Before we talk more about your experiences in academia, do you find that you make different kinds of prints in different environments?

WATT: Well, being in a new place necessarily results

FIG. 45. HELEN FRANKENTHALER (American, 1928–2011), *Japanese Maple*, 2005, 16-color ukiyo-e style woodcut, 26 × 38 in. (66 × 96.5 cm), edition 9/50; Collection of Jordan D. Schnitzer. © 2021 Helen Frankenthaler Foundation, Inc. / Artists Rights Society (ARS), New York / Pace Editions, Inc., New York.

in a different kind of print. I believe that access to new tools and materials yields different results, too. If a master printer, or an institution itself, has a specific thing that they're known for, then I think that channels the direction the prints might go in. At Crow's Shadow, Frank is a Tamarind Master Printer, which implies his specialty is in lithography, but he was also incredibly open to and interested in woodcuts, which we worked on together in my fourth residency. Part of this choice came from working with wood in the studio and thinking about how this material is blanket-like. At the time, I was also looking closely at Helen Frankenthaler's woodcuts, her block-cutting techniques, and the colors she achieved (fig. 45).

Color has always been important to me, and Frankenthaler deploys it so well. I can't quite fathom how the blocks came together to create certain colors, let alone atmospheric colors. There is something exquisitely lyrical and moody in her woodblock prints. As for working on woodblocks with Frank, I appreciated his great patience as it relates to multiple color drawdowns and figuring out color, minimal and complex, as in the print *Lodge* (p. 99). Because I have some background as a painter, there's a part of my work that feels painterly in terms of its color and textural selections. At the same time, there's also a mystery to understanding how color comes together in printmaking that is radically different from the way I work with blankets as found colors in my studio on a daily basis.

CARTWRIGHT: Do you arrive at residency opportunities with a sheaf of ideas and drawings already in hand that you plan to execute, or does something spontaneous happen once you are there?

WATT: It's a little of both. It also depends on the printer I am working with. I arrive with some ideas and some things definitely do happen spontaneously. I have ideas that I'll want to execute that

will rely on the technical expertise of the printer I'm working with.

For example, if I am working with Julia D'Amario, then I know I am wanting to work with softground techniques that allow me to capture the texture and nuances of blankets, to play around with an organic shape in the typically rectangular nature of printmaking. Etching and engraving copperplates is Julia's specialty, and there is so much to mine in that area. We've barely scratched the surface. Julia and I are always building upon techniques gleaned from past collaborations.

The work always has an element that relates to the particular context in which it evolved. The question remains: Do I set out to do that? I guess I do arrive with a sheaf of ideas, but sometimes they get thrown out the window [laughter]. The last time I went to Crow's Shadow, I thought I was going to be working with beads and making impressions of glass in the woodblocks. I wasn't thrilled with the results and pivoted to create something very different: the Marvin Gaye–inspired work, *Companion Species (What's Going On)* and *Companion Species (Anthem)* (pp. 144, 145).

There is always a call-and-response activity at work in my practice. There is a conversation between members of the circle that has the effect of triggering different activities, different outcomes. In the same way, within my studio I might create something that goes into the world, and sometimes it comes back to me. When it does, I find myself listening to what happened during its travels. At that point, I can decide to change it and then send it back out into the world again, and so on. This is just to say that I don't necessarily start something knowing the end result. The same thing—what I describe as "call-and-response"—happens in the print studio when there is a one-on-one collaboration with a master printer. Even in a group-setting printshop, at Yale or Inkling,

there is a conversation with peers that inevitably impacts the final work. These dialogues take you down paths that you might not otherwise have traveled. Of course, with a piece of fabric becoming the base layer for a softground etching, there is another kind of call-and-response taking place. In that case, it's between the initial idea, my work on the press with someone like Julia, and the resulting print, which has a relationship to another separate fabric piece of mine. I like to think that there is something improvisational going on throughout this process, something like jazz. I am not a musician, but I did play the flute in high school.

CARTWRIGHT: Tell us about the work you did at Tamarind around the idea of landmarks. Does being provided with a framework for the residency affect the outcome?

WATT: We could pursue any ideas we wanted, but you're right, the concept of landmarks is what initially brought us together. The project, *LandMarks*, was conceived from the start as an exchange between Indigenous artists from North America and Australian Aboriginal artists. Collaboration and exchange were defining elements. All the artists met at the Buku-Larrnggay Mulka Art Centre in Yirrkala, a community in the Northern Territory of Australia. The artists—Djirrirra Wunungmurra, Maria Josette Orsto, Alma Granites, Dyani White Hawk, Chris Pappan, Jewel Shaw, and I—were all new to this site, and we spent a week together immersed in the community and making prints. The print studio was small, so we typically spilled outside onto the exterior porch, which was a shared space for making. Later in the exchange, we gathered in smaller groups at Tamarind Institute, a mecca for lithography in America, located in Albuquerque, and there we were paired with master printers. It was impossible not

FIG. 46. *Landmark: A Thousand Names*, 2013; lithograph on newsprint grey Somerset velvet, 11 × 10 in. (28 × 25.5 cm).

to be affected by the experience of being together, forming friendships, and exchanging stories.

The works I made for *LandMarks* are hybrids, moving between things already important to me and things connected to being at Yirrkala. A print like *Landmark: A Thousand Names* (2013) demonstrates this point (fig. 46 and p. 128). The diamonds I employ are derived from my interest in Star Quilts, but here the diamonds create a scaffold that connects sky and ground. The colors relate to a reclaimed blanket that has a tag indicating it came from India, another kind of landmark. I've never seen a blanket like it—it has a unique pattern with a diamond lattice and constellation-like flowers. I quickly learned, as I was working on the plate that became *Landmark: Water/Sky (Summit)* (p. 122), that the diamond motif—or more accurately my using diamonds in my work—might have potential social-political ramifications. The director of Buku-Larrnggay Mulka Art Centre was concerned because in their community, a similar diamond pattern was

associated with the saltwater crocodile, and it was an inherited right to use this motif—in other words, it could not be used by just anyone. Added to this was the fact that right before we arrived in Yirrkala, a child had been tragically attacked by a saltwater crocodile. Because Yirrkala is situated near a National Reserve, the park authorities were involved. The community expressed that they didn't want the crocodile to be killed. In their view, a child had been taken from them, but taking the crocodile's life wouldn't make things right. The crocodile also held a familial relationship in the community. The park rangers dismissed the community's request and ended up hunting down the crocodile. Ultimately the community gathered to mourn the passing of the child, as well as the passing of the crocodile.

So here is a print where diamonds are derived from points of a star. But having spent time at Yirrkala, I now have an understanding that diamonds relate to the markings of crocodiles and their ancestral storied relationship within this Australian

FIG. 47. Marie Watt at Equity Sewing Circle, Block Museum at Northwestern University, Evanston, Illinois, February 2017. Photograph by Sean Su.

Aboriginal community. We often think of landmarks as natural or manmade sites embedded in the land, but I think this is reminder that they are in the universe and they are our relatives.

CARTWRIGHT: Your work has been embraced in academic contexts, and this exhibition is going to be mounted in several campus museums. Is there anything different about working in university environments from, say, your studio?

WATT: I am drawn to working in academic contexts, especially for the exchange between students, faculty, staff, and community. There are conversations that flow in these settings that recharge my curiosity and filter back into my studio. There is also the opportunity for new friendships to be made and carried on over time. The work is bringing people together, the act of making connections.

In 2017, I collaborated with the Block Museum at Northwestern University, where I enjoyed

engaging with the Indigenous student association on campus as well as with broader Evanston community neighborhood coalitions. We held a sewing circle focused on the theme of equity, and it was exhilarating to participate in a program with over 125 diverse constituents at a shared table (fig. 47). At that event, Melissa Blount, a clinical psychologist, was present and afterward she decided to start a community sewing circle to create Black Lives Matter quilts— the first of which focused on embroidering the names of women and girls who were killed as a result of gun violence in Chicago. Melissa and I remain in touch to this day. So, yes, I do think the residencies and engagements on university campuses represent something unique.

You can't predict or even really know the ways a gathering will connect or move people. You can plant the idea of a collaboration, but in the end it's up to those involved to tend to it. I like to say I set the table, but what it will actually feel like once everyone sits down together is unpredictable. It takes on the

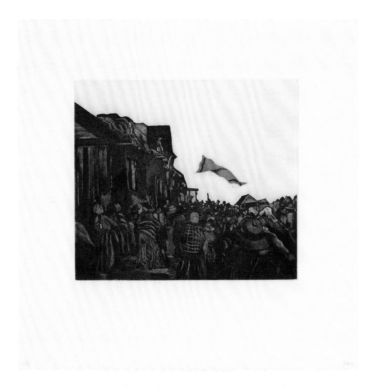

energy of the group flowing in and out of the circle, the table. And truthfully, it's always been my hope that in "setting the table," the people seated around it will make their own connections that are deep and meaningful *for them*.

CARTWRIGHT: As you know, we've been acquiring your work in anticipation of the exhibition. One of the works that we were especially excited about was an early print, *Witness (Quamichan Potlatch, 1913)*, 2014, which you made at Sitka (fig. 48 and p. 135). It strikes me that it's a bit of an outlier. For one, it's representational. It's also based on another image. Could you talk a little bit about the place of figuration in your work?

WATT: I use figuration and abstraction when the idea calls for it. In that particular piece, I had been looking at archival photographs and investigating the timelines associated with them. In 2011, I received a Smithsonian Artist Research Fellowship.

It provided me with a chance to work in the National Museum of the American Indian collections. *Witness (Quamichan Potlatch, 1913)* grew out of that research. I learned that curators at NMAI categorize cradleboards as "transportation objects," and that phrase really captured my imagination. The whole idea of "transportation objects" struck me as incredibly poetic. I remember thinking, "Oh my gosh, a blanket is a transportation object, too!" I realized I could extend that already existing concept in my work even further.

Isn't it amazing that art is something that has the capacity to transport us? Not just physically—I mean metaphysically, too. As I was thinking about "transportation objects," I was digging deeper into images of blankets as they relate to Coast Salish potlatches. I was aware of observers' accounts of there being so many blankets present at these gatherings that they actually touched the rafters of the longhouses. So here I am making these stacked blanket columns for a decade, and I see these totem-like

associations, and then I am simultaneously learning about accounts of blankets as central features of the potlatch. It was while searching through these image records that I landed on the remarkable image of the Quamichan potlatch that serves as a source for *Witness (Quamichan Potlatch, 1913)*.

In that particular archival photograph, a blanket is faintly visible, captured soaring through space. In my head I had the phrase, "transportation object," which was embodied in the photo—this blanket appeared to hover in midair! Looking at the date of the photo, I realized that this was all happening at a time when potlatches were banned in the US and Canada. The photo is pictorial evidence of Indigenous resilience and defiance. The potlatch was not only the continuation of a Coast Salish tradition but also a radical social action, an act of civil disobedience.

There are plenty of other figurative elements in my work. For instance, more recently the she-wolf and canines appear. This grew out of an interest in acknowledging Seneca relationships to animals, but also as a way of prompting a larger conversation about our relatedness, as in our relatedness to one another, animals, and the environment. My eye is on our collective responsibility as stewards. Back to the image of the she-wolf. After looking at this image of the Capitoline Wolf over time, it made me think about what it means to be a mother, even a nonbiological mother. Remember, that's what the she-wolf is to Romulus and Remus—the twins had been cast out to die in the wilderness and the she-wolf took them in, nurtured, protected, and raised them. We all have certain skills that we associate with mothers; it's a loaded word. I don't think that motherhood is necessarily a gendered experience. The very first thing we tend to go to is the biological construct, but contemplating this ancient image of the she-wolf made me think about other mother-

like characteristics and traits we have in common. *Companion Species (Words)* (p. 137) begins to name some of these word associations.

I also wonder about this construct in relation to the matrilineal society that I come from. Maybe that's why I was drawn to this wood engraving depiction of a mother whose body was a shelter, whose ribs are visible, body emaciated, and who has two jovial, plump babies gazing up from beneath her. When you look into the eyes of the she-wolf, you can see they are heavy, and you sense her exhaustion. But I also feel that in a moment's notice she could become ferocious. At our core, we all probably have some kind of animal instinct where we will become ferocious on behalf of something else, something we feel compelled to protect. There is a story that connects us here.

Toggling back to *Witness (Quamichan Potlatch, 1913)*, one thing I found out only after making my print was that there's a related photo by Edward Curtis at LA County Museum of Art, one that represents the same village in which the potlatch occurred (fig. 49). However, this print must be a photogravure because the image is reversed and reads as backward from the photograph image that I know so well. I find myself wanting to understand the relationship between images and events better. For me, getting to know something involves research, and long periods of looking, and in this case reinterpreting the photo as an image on a copperplate as a means of understanding it. I think interpreting the blanket in color, in this case a red trade blanket with black bands, was a way of calling out the transportation object. It functions as a representation of time travel. Looking at a photograph is its own form of connecting past and present. This gathering is celebratory and defiant. It was a story that needed to be amplified.

FIG. 49. EDWARD SHERIFF CURTIS (American, 1868–1952), *Quamutsun Village–Cowichan*, 1912; photogravure on tissue, 6⁹/₁₆ × 7⅞ in. (16.7 × 27 cm). Los Angeles County Museum of Art, www.lacma.org.

CARTWRIGHT: Don't you reuse that same blanket form in other works, abstracting it further?

WATT: Definitely. It appears, for instance, as an even more disembodied, abstracted form in an etching called *Transportation Object (Sunset)*, 2014 (p. 134).

CARTWRIGHT: Another element that recurs in your recent work is text. How important are words to the work you are making today?

WATT: I'm interested in language because it's complicated; I'm fascinated by how loaded words can be. In *Companion Species: Ferocious Mother and Canis Familiaris*, I was thinking about the core traits associated with being a mother and what text communicates those characteristics. In that case, I combined stream-of-consciousness text to conjure something familiar, something already rooted within the image itself. The she-wolf serves as an intermediary for those words. That large textile piece grew out of sewing circles at the Block Museum and subsequently was exhibited there in the show *If You Remember, I'll Remember*. Now it's in the permanent collection of the Portland Art Museum. Since then, or maybe simultaneously, I've been experimenting with text as a key element in prints. I'm uncomfortable with text, because language overwhelms me. When I use text, I feel myself struggling to find my voice. Maybe this is why I defer to a sea of words that can both disengage and engage. I am thinking of the sewing circles here and how the text becomes a prompt for reflection or topical conversation. With the large text pieces I tend to think of them sculpturally, as they include an A side and a B side. I am partial to the B sides—tangled, abstract, intentional.

Working in a space where things are fundamentally unknown, and where you're taking risks and you're trying to understand something—that is what my work with text represents right now. I went from *Companion Species: Ferocious Mother and Canis Familiaris* to considering the intersection between

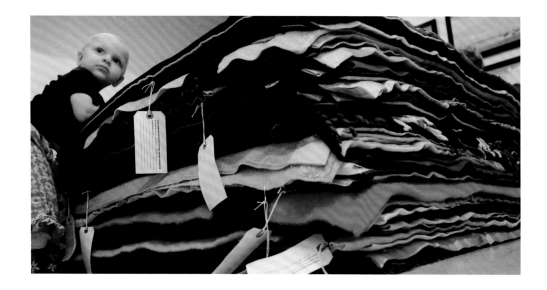

FIG. 50. Andrew Henderson, *Maxine McIsaac, daughter of the artist, Marie Watt, with a pile of blankets that will become part of her mother's installation,* Dwelling, *New York Times,* August 25, 2006. © Andrew Henderson / The New York Times / Redux.

Marvin Gaye knowledge and Indigenous knowledge, to suggest how we're all related. Lately, I have started to incorporate some of the poetry of Joy Harjo in my works.[4] That's another thing I love about the sewing circles, which I've been hosting for almost fifteen years now. They provide a physical relationship to language. What is interesting to me about the act of embroidering text is that you can see a person's hand in the words, in their uniquely formed letters.

I don't think of my work as always being activist or even that I'm creating a particular socially engaged message. I'm making sense of a story that can be read in the overlap between people—many hands, including my hands—at work together. People's hands are embedded in the stitches that make words, and then those words have their own cadence that comes from one's own body. This reminds me of handmade protest signs. The embroidered text panels suggest fundamental connections between bodies. A handmade sign is completely different from something mechanically generated.

Printed text doesn't have the same voice. I think this is because the hand is connected to the body, and the body is connected to our mouths. I'm responsive to the vocal quality of hand-lettered signs.

CARTWRIGHT: "What's Going On," begins with the address "Mother, mother" and goes on to invoke "Brother, brother," etc. Since I am fortunate to know your parents, I wonder if you could speak about family, not purely in terms of printmaking, but in your development as an artist.

WATT: Sure. When I called home from Willamette University and told my parents that I was becoming an art major, they were supportive. They may have had concerns but never expressed them to me. Over time, they saw that I was able to make a living—teaching at Portland Community College, having success with grants—all of which meant I could support myself, more or less, as a professional artist. I've always appreciated the degree to which they never wavered in

FIG. 51. *Pedestrian*, 2000; slate, reinforced concrete, 26 × 180 × 48 in.
(66 × 457 × 122 cm) Collection of Portland Community College,
Sylvania Campus.

their backing. They cultivated their own interest in art in order to understand my path. Another part of how that expresses itself in my practice is that my parents often accompany and assist me with installations, including at the National Gallery of Canada[5] and to Australia. I affectionately refer to them as "my road-ies." Before I had my kids, they were physically helping me with stuff, but after Maxine and Evelyn were born, it became more of a divide-and-conquer approach. My mom helped care for them, while my dad and I would work together on getting installations finished. I remember when Maxine was a small child, she was featured in a photograph in a *New York Times* article where she was shown climbing on a piece called *Dwelling,* an unfolded blanket-stack piece that I did. Mom, Dad, and I were there too, of course, but out of the picture's frame (fig. 50).

My parents have a beautiful relationship. My mom has this presence, and she radiates generosity, kindness, strength. She worked in Indian Education for twenty-seven years and led cultural programming

in the 1970s that included a storytelling circle and, while it was intended for the youth, elders and parents with babies and toddlers joined. My dad reminds me that, as a teen, I resisted attending these programs, but now I can see how this notion of community and storytelling is an intimate part of my work. My dad is quiet, and he is a very good listener, somewhat fitting the stereotype of an engineer. But if you are around him long enough, he talks, and it's usually something important that he has to say. During installations—whether it was *Dwelling* or my first very large public work, a stone bridge called *Pedestrian* (fig. 51)—he'd say, "If we are going to get this done by such and such a time, we need to do this much more today." He's very process-oriented, which is an asset, and he would move me along. Someplace there is a print related to *Pedestrian*—a black-on-black image.

The way that Marvin Gaye began appearing as a significant presence in my work—actually reappeared, since I knew "What's Going On" from way back in the

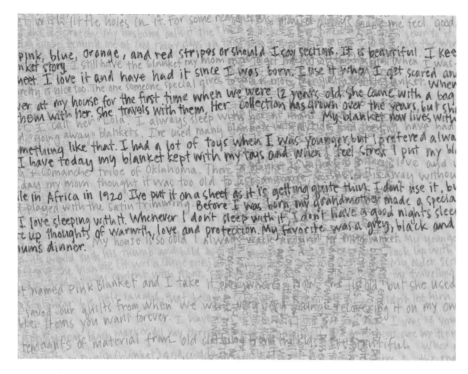

FIG. 52. *Blanket Stories: Continuum (Book 1)*, 2007 (detail of p. 110).

days when AM radio was a thing—is linked to asking myself: "What does this call 'Mother, mother' mean?" Being Seneca, the word *mother* relates not just to a fondness I feel for my own mother, but it also has resonance for our matrilineal society, where, for instance, land-ownership rights are the domain of women; our clan identities are passed down through women; and even our tribal enrollment descends through our mother's side of the family. I was confused when I was learning about feminism initially, because I'd always only known women who are strong, powerful role models, like my mom.

Of course, Marvin Gaye is not just talking about his own mother, his brother, or his sister. He is calling us all, and he wants a response. Embedded in that response is a sense that we are all related. I researched the history of that song, and it led me to consider the time in which it was written, the assassination of Reverend Martin Luther King Jr., the occupation of Alcatraz, and major protests against the Vietnam War. It was actually Obie Benson who penned the lyrics, and Marvin Gaye reworked them and recorded it. Berry Gordy's label did not want to produce music that had an activist slant to it, so Marvin Gaye did what artists sometimes do when people throw up roadblocks: he decided to self-produce the song. Copies were pressed in small numbers, and those singles were played to immense critical acclaim, which then made it advantageous for Motown to release it.

So I am making new work in the context of Standing Rock, Black Lives Matter, and the water crisis in Flint, Michigan; many things are happening in the world that make me think this song has as much resonance today as it did in 1971. My work has not changed, but, in the pandemic, I think people are reflecting more on our relatedness.

CARTWRIGHT: What about your use of text in earlier works, say the two related prints called *Blanket Stories: Continuum* (fig. 52 and p. 110; p. 111)?

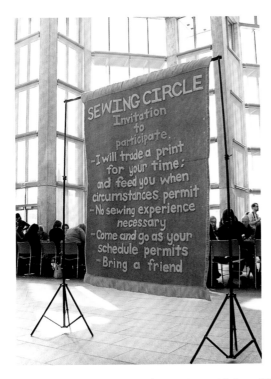

FIG. 53. Marie Watt's sewing circle sign, National Gallery of Canada, Ottawa, 2015. Photo by Andrea Cordonnier.

WATT: Those were both made at the Tamarind Institute. Early on, when I began making the blanket columns, I was still figuring out what was possible with that form. I had the show at NMAI,[6] and in that installation I included a blank book made by the artist Roberta Lavadour. Visitors were invited to record their stories about blankets in the book. I was and am moved by how intimate the stories were. I realized that blankets are markers for memory, and the books became an extension of the life of the object. With subsequent installations of *Blanket Stories*, I continued to use a blank book as a means to capture those narratives. When I got to the Tamarind Institute, I took those books and started transcribing their contents onto the stone, which became the visual equivalent to the warp and weft of a blanket. I am glad you brought that up; it reminds me that I've been using text for a while.

CARTWRIGHT: For some, the sewing circles and other participatory practices in your work seem connected

to relational aesthetics and to people like Rirkrit Tiravanija and Rivane Neuenschwander, among other contemporaries. Those artists treat social practice and activism as core strategies of their work. In looking through images related to your recent projects, I saw a hand-sewn banner that I presume you installed (fig. 53). It said, among other things, "I will trade you a print for your time." That's a generous offer and, at bottom, emphasizes a fundamental reciprocity. Could you talk about the values of exchange in your printmaking?

WATT: The thing that I am most interested in is community. Within that, I am also drawn to the power of storytelling. That power grows out of being part of a community. There is an aspect to the sewing circles that grows out of traditional Indigenous ways of teaching and learning. They are multigenerational and they're cross-disciplinary. People come together and share the same space for an extended period of time, and together they create something new.

What grows out of this way of teaching and learning is something that's embedded in the Native community which I think is highly important. If we look back, this was how information was shared before we had Western academic institutions. Ideally, the sewing circles are neutral zones where intersectional stories and knowledge are shared. There is no particular pressure to talk, but being gathered around a table making something is, I think, an easy space in which to have conversations with both strangers and friends.

The print I give participants is a remembrance of this exchange.

CARTWRIGHT: I love the prints you give to participants in the sewing circles. Where did the Gocco print process that you use to create these come from?

WATT: First, let me say that my most recent small prints were made with Kathy Kuehn, a printer who worked at Pace Editions with Julia D'Amario. Kathy lives in Portland and has a Vandercook proof press that we have been using to make pressure prints (fig. 54). The Vandercook press has a similar efficiency to the Gocco. These newer images are made by stitching onto thin cardstock, and the floss/yarn creates a relief line. You can see that I am bridging my studio practices in embroidery with my print interests again. I really love the three-dimensionality of the image, the way the thread jumps under, disappears, and then resurfaces as a line, with just a little bit of shadow remaining from what's beneath.

I am trying to remember exactly how I got introduced to Gocco. I think it was Adam, my husband, who first suggested it. It's popular in the book arts and calligraphy communities. I still have a Gocco printer, and we'll have to see if I ever go back to it. The machine itself is really analog, a plastic clamshell press that works like a stamp and silkscreen.

FIG. 54. Kathy Kuehn with a Vandercook proof press at the Salient Seedling Press, 2021.

Originally, I think they were used to personalize New Year's or other holiday cards in Japan. Unfortunately, Gocco presses and supplies are no longer being manufactured. Some of the materials are out there on eBay, but the inks tend to be old and don't always work well. I have a dwindling supply and will probably produce a few more Gocco prints, but the experience of working with Kathy resonates more with where I am headed.

CARTWRIGHT: Are you aware of other printmakers who use fabric in the way you've described, as a matrix for creating the softground? I think of someone like Rosemarie Trockel, or even Anni Albers, but their print processes seem to me visibly different from what you've described.

WATT: I can imagine other artists doing similar things, but off the top of my head I am not sure I can name any. I recall the experience, as a printmaking student in college, of putting the tarlatan down on the plate

for the first time and making an etching directly from that material. The memory makes me guess that there are other people doing things with fabric, cloth, and doilies to produce unique textures. Anni Albers is intriguing to me. The Bauhaus and related schools, like Black Mountain College, are pivotal, because they acknowledged the intersection of art and life.

CARTWRIGHT: The word *craft* circulates around a number of the techniques you employ: embroidery, for instance, and glassblowing, even wood carving. Are you comfortable with that designation for your work?

WATT: It might just be the context of having gone to graduate school when and where I did that complicates my relationship to the term *craft*. I feel like there is a whole generation of younger artists who don't have to fight that tired old "fine art versus craft" battle. There is a fluidity that exists between those spheres today. Instinctively, I feel like there should be no distinction, but it can be a challenge to be characterized as an artist who produces craft. I want to be an advocate for reconsidering how the word *craft* gets used and how it denotes value. Part of the craft story is unresolved for me.

My experience as an Indigenous person may frame this particular conversation a little differently than what you are suggesting. Historically, work by Indigenous people was put in anthropology museums and viewed through that distorting lens which presents our cultures as static and fixed in the past. For me, someone whose work addresses this phenomenon is Fred Wilson. I am not just talking about the way that Fred makes things—out of glass, for instance—but also the situations that he stages for rethinking relationships to these institutions and their chosen objects of study. He is someone with whom I feel a deep

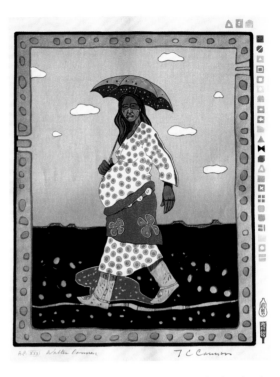

FIG. 55. T. C. CANNON (Caddo/Kiowa, 1946–1978), *Grandmother Gestating Father and the Washita River Runs Ribbon-Like*, 1975; color woodblock, 16½ × 12 in. (41.9 × 30.5 cm). Private Collection. © Courtesy of the Tee Cee Cannon Estate. Image courtesy of the Peabody Essex Museum.

sense of commonality, even though our processes are radically different.

CARTWRIGHT: Besides Fred, who are some other artists who matter to you?

WATT: I am so bad at naming people on demand. Looking at the tower of books by my side, I remind myself that I love the drawings of Alberto Giacometti, and Martin Puryear, with whom I share an interest in both wood sculpture and printmaking. Nancy Spero, Eva Hesse, Brad Kahlhamer, Janine Antoni are all artists I admire, too. T. C. Cannon is someone I should mention. One of the first prints I ever bought for myself is by T. C. Cannon, called *Grandmother Gestating*. It's a beautiful woodblock print (fig. 55). I came to know his work when I was at IAIA in Santa Fe. I was studying with Jean LaMarr at the time, who taught the printmaking courses, and she introduced me to Cannon's work.

One of the unique things about Cannon as a Native artist was that he traveled to Japan where he studied woodblock printing. Some of the ukiyo-e masters are considered national treasures, and he printed with those masters.[7] In the margins of his prints you can see the chops from every single color of the blocks. The one I bought is from a suite of prints that Cannon made in 1978. He is definitely a person I would single out as an enduring influence. Another one for me would be Niki de Saint Phalle. I have a dream of doing a giant she-wolf that would be of the same grandeur as the *Hon* figure that she made in Stockholm in 1966. I've said already how Frankenthaler's woodcuts are a source of lasting wonder for me, and I've also mentioned how much I admire Alison Saar.

CARTWRIGHT: Last question: What's next for Marie Watt?

WATT: I am catching my breath and trying to figure out how to prioritize what comes next. Julia D'Amario reached out about an opportunity to print with her again and I hope to take her up on that offer.

The project with the University of San Diego has been on my mind. The other thing that interests me is resurrecting work I began at Portland Community College with students. I did a print project where they pulled text—Marvin Gaye's language, again—out of a hat and created paper reliefs, like woodcuts, from those words. Student participants then printed their own plates (see fig. 29, p. 40). I later borrowed their plates and printed them with Kathy Kuehn and Brianna Coolbaugh. I am curious to see what could come out of making tapestry-like recombinations of that imagery on a large scale. Overall, the work is going really well and is getting more ambitious.

NOTES

1 This text is based on interviews that took place via video-conference platform on December 16 and 20, 2020. Marie Watt had just returned from Manhattan, where she had completed an installation for a new Loro Piana space in the city's Meatpacking District. What follows is a transcription of those conversations, edited to improve continuity. Additional references in the form of endnotes and bracketed additions clarify topics mentioned in passing. Thanks to the artist for her patience and cooperation in creating this dialogue.

2 See Nancy Doll and Susan Tallman, *Mirror Mirror: The Prints of Alison Saar from the Collections of Jordan D. Schnitzer and His Family Foundation* (Portland, OR: Jordan Schnitzer Family Foundation, 2019).

3 Crow's Shadow Institute of the Arts hosted the "Conduit to the Mainstream" symposium in Pendleton, Oregon, from September 7 to 9, 2001. The event promoted the invitation of "nationally known Native American artists along with professionals from museums and print studios to the Umatilla Indian Reservation."

4 Harjo (Muscogee, Creek) is currently serving in her third term as the twenty-third Poet Laureate of the United States.

5 *Blanket Stories: Seven Generations, Adawe, and Hearth* was part of *Sakahàn: International Indigenous Art* at the National Gallery of Canada, Ottawa, May 17 to September 2, 2013.

6 *Continuum: 12 Artists*, displayed in New York from April 26, 2003, to January 2, 2005.

7 T. C. [Tommy Wayne] Cannon visited Japan in 1975 and learned to print in the ukiyo-e manner by studying with Kentaro Maeda and Matashiro Uchikawa. See Ann E. Marshall et al., *Of God and Mortal Men: T. C. Cannon* (Santa Fe: Museum of New Mexico Press, 2017).

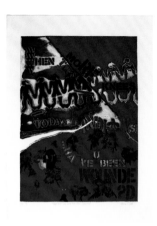

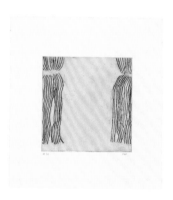

When More Than Knees Have Been Wounded,
1990
Lithograph
29¾ × 22 in. (75.6 × 55.9 cm)
Printed by the artist at the Institute of American
Indian Arts, instructor Jean LaMarr

Corn Husk Turtle Mask, 1992
One-color softground etching and aquatint
18½ × 15½ in. (47 × 39.4 cm)
Printed by the artist at the Institute of American
Indian Arts, instructor Jean LaMarr

Corn Husk Turtle Mask (Ghost Proof), 1992
One-color softground etching and aquatint
18½ × 15½ in. (47 × 39.4 cm)
Edition AP
Printed by the artist at the Institute of American
Indian Arts, instructor Jean LaMarr
Edition number lower left, signed lower right

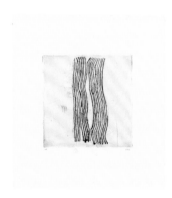

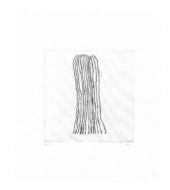

Untitled (Corn Husk Study—Parting), 1996
Engraving with gouge
10⅞ × 9⅞ in. (27.6 × 25.1 cm)
Edition: WP
Printed by the artist at Yale University
Signed lower right in pencil recto

Untitled (Corn Husk Study—Alone), 1996
Engraving with gouge
9¾ × 10¾ in. (24.8 × 27.3 cm)
Edition of 4 AP, 2 TP, 1 WP
Printed by the artist at Yale University
Edition number lower left, signed lower right in
pencil recto

Untitled (Corn Husk Study—Pair), 1996
Engraving with gouge
10 × 10¾ in. (25.4 × 27.3 cm)
Edition of 5 AP, 1 TP, 1 WP, 1 CTP
Printed by the artist at Yale University
Edition number lower left, signed lower right in
pencil recto

Untitled (Braid Variations) I, c. 1996
Etching
Image and sheet: 9 × 17 in. (22.9 × 43.2 cm)
Printed by the artist at Inkling Studio

Untitled (Braid Variations) II, c. 1996
Etching
Image and sheet: 9 × 17 in. (22.9 × 43.2 cm)
Printed by the artist at Inkling Studio

Untitled (Braid Variations) III, c. 1996
Etching
Image and sheet: 9 × 15¼ in. (22.9 × 38.7 cm)
Printed by the artist at Inkling Studio

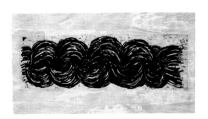

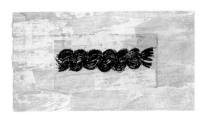

Untitled (Braid Variations) IV, c. 1996
Etching
Image and sheet: 9 × 17¼ in. (22.9 × 43.8 cm)
Printed by the artist at Inkling Studio

Untitled (Braid Variations) V, c. 1996
Etching
Image and sheet: 9 × 17¼ in. (22.9 × 43.8 cm)
Printed by the artist at Inkling Studio

Untitled (Braid Variations) VI, c. 1996
Etching
Image and sheet: 9 × 17¼ in. (22.9 × 43.8 cm)
Printed by the artist at Inkling Studio

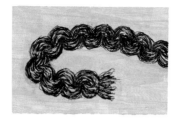

Untitled (Corn, lozenge, brick study), c. 1998
Softground etching and hardground etching
18¼ × 25¼ in. (46.4 × 64.1 cm)
Edition of 12
Printed by the artist at Inkling Studio
Edition number lower left, signed lower right in
pencil recto

Untitled, 2000
Two-color softground etching
7¾ × 11½ in. (19.7 × 29.2 cm)
Variable edition
Printed by the artist at Inkling Studio
Signed and dated lower right in pencil recto

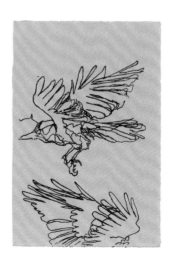

Selection of untitled Gocco prints,
approximately 4 × 6 in. (10.2 × 15.2 cm) each;
edition size variable

Watt made her first Gocco print in 2002.
Since then she has offered signed, limited-
edition Gocco prints to participants at her
sewing circles.

Blanket Relative, 2002
Aquatint and drypont with burnished lines
17½ × 18½ in. (44.5 × 47 cm)
Edition of 4
Printed by Julia D'Amario
Published by the Sitka Center for Art and
Ecology
Edition number lower left verso, signed and
dated lower right in pencil verso

Proposal (Variation), 2002
Color spitbite, sugar lift, and aquatint
Image and sheet: 17½ × 18 in. (44.5 × 45.7 cm)
Edition of 7
Printed by Julia D'Amario
Published by the Sitka Center for Art and
Ecology
Edition number lower left verso, signed and
dated lower right in pencil verso

Gate, 2002
Spitbite, sugar lift, and aquatint
Plate: 5 × 6 in. (12.7 × 15.2 cm)
Sheet: 11 × 12 in. (27.9 × 30.5 cm)
Edition of 7
Printed by Julia D'Amario
Published by the Sitka Center for Art and
Ecology
Edition number lower left, signed and dated
lower right in pencil recto, publisher's blind
stamp

Curtain, 2002
Color spitbite and aquatint
Image: 5⅞ × 5 in. (14.9 × 12.7 cm)
Sheet: 13 × 10 in. (33 × 25.4 cm)
Edition of 7
Printed by Julia D'Amario
Published by the Sitka Center for Art and
Ecology
Edition number lower left, signed and dated
lower right in pencil recto, publisher's blind
stamp

Three Rocks, 2002
Hardground etching and stippling on
Hahnemühle bright white
Image: 5 × 6 in. (12.7 × 15.24 cm)
Sheet: 11 × 12 in. (27.9 × 30.5 cm)
Edition of 7
Printed by Julia D'Amario
Published by the Sitka Center for Art and
Ecology
Edition number lower left, signed lower right
in pencil recto, publisher's blind stamp lower
right margin recto

Cloud/Dust, 2002
Three-color hardground etching and stippling
on Rives BFK cream
Image and sheet: 17¼ × 17¼ in.
(43.8 × 43.8 cm)
Edition of 7
Printed by Julia D'Amario
Published by the Sitka Center for Art and
Ecology
Edition number lower left verso, signed and
dated lower right in pencil verso

Untitled, 2002
Spitbite and whiteground aquatint
Image: 5⅞ × 6 in. (14.9 × 15.2 cm)
Sheet: 11 × 12 in. (27.9 × 30.5 cm)
Edition of 7
Printed by Julia D'Amario
Published by the Sitka Center for Art and
Ecology
Edition number lower left, signed and dated
lower right in pencil recto, publisher's blind
stamp

Proposal, 2002
Whiteground, aquatint, and sugar lift
Image: 5⅞ × 7⅞ in. (14.9 × 20 cm)
Sheet: 11 × 12 in. (27.9 × 30.5 cm)
Edition of 7
Printed by Julia D'Amario
Published by the Sitka Center for Art and
Ecology
Edition number lower left, signed and dated
lower right in pencil recto, publisher's blind
stamp

Portal, 2002
Lithograph on Rives BFK grey
Sheet and image: 17½ × 18 in. (44.5 × 45.7 cm)
Edition of 12
Printed by TMP Frank Janzen
Published by Crow's Shadow Institute of the
Arts [CSP 02-109]
Edition number lower left, signed and dated
lower right in pencil recto, titled lower right in
pencil verso, CSP chop blind-stamped lower
left, printer's chop blind-stamped verso lower
right

Omphalos, 2002
Three-color lithograph on Rives BFK grey
Sheet and image: 17½ × 18 in. (44.5 × 45.7 cm)
Edition of 12
Printed by TMP Frank Janzen
Published by Crow's Shadow Institute
of the Arts [CSP 02-110]
Edition number lower left, signed and dated
lower right in pencil recto, CSP chop
blind-stamped verso lower left, printer's chop
blind-stamped verso lower right

Guardian, 2002
Lithograph on Rives BFK grey
Image and sheet: 17½ × 18 in. (44.5 × 45.7 cm)
Edition of 12
Printed by TMP Frank Janzen
Published by Crow's Shadow Institute of the
Arts [CSP 02-111]
Edition number lower left verso, signed and
dated lower right recto, titled verso center, CSP
chop blind-stamped verso lower left, printer's
chop blind-stamped verso lower right

Sanctuary, 2002
Two-color lithograph on Rives BFK grey
Image and sheet: 17½ × 18 in. (44.5 × 45.7 cm)
Edition of 12
Printed by TMP Frank Janzen
Published by Crow's Shadow Institute of the
Arts [CSP 02-112]
Edition number lower right verso, signed in
pencil lower right recto, titled verso center,
CSP chop blind-stamped verso lower left,
printer's chop blind-stamped verso lower right

Star Quilt, 2003
Six-color lithograph on Rives BFK tan
Image: 14¼ × 13 in. (36.2 × 33 cm)
Sheet: 21¼ × 19 in. (54 × 48.3 cm)
Edition of 14
Printed by TMP Frank Janzen
Published by Crow's Shadow Institute of the
Arts [CSP 03-107]
Signed and dated lower right, CSP chop
blind-stamped verso lower left, printer's chop
blind-stamped verso lower right

Blankets, 2003
Five-color lithograph on Rives BFK grey
Image: 13¾ × 19¾ in. (34.9 × 50.2 cm)
Sheet: 19¾ × 25¾ in. (50.2 × 65.4 cm)
Edition of 16
Printed by TMP Frank Janzen
Published by Crow's Shadow Institute of the
Arts [CSP 03-108]
Edition number lower left, title lower center,
signed and dated in pencil lower right recto,
CSP chop blind-stamped verso lower left,
printer's chop blind-stamped verso lower right

Braid, 2003
Three-color lithograph on Rives BFK grey
Sheet: 14½ × 29 in. (36.8 × 73.7 cm)
Edition of 16
Printed by TMP Frank Janzen
Published by Crow's Shadow Institute of the
Arts [CSP 03-109]
Edition number lower left, titled lower center,
signed and dated lower right, CSP chop
blind-stamped verso lower left, printer's chop
blind-stamped verso lower right

Letter Ghost, 2003
Four-color lithograph on Rives BFK tan
Sheet: 13 × 18 in. (33 × 45.7 cm)
Edition of 16
Printed by TMP Frank Janzen
Published by Crow's Shadow Institute of the
Arts [CSP 03-110]
Edition number lower left, titled lower center,
signed and dated lower right recto, CSP chop
blind-stamped verso lower left, printer's chop
blind-stamped verso lower right

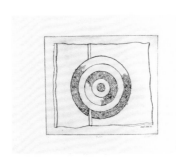

Flag, 2003
Etching
Sheet: 11 × 14¾ in. (27.9 × 37.5 cm)
Edition of 1
Printed by the artist at the Oregon College of
Art and Craft
Edition number lower left, signed lower right in
pencil recto, inscribed in plate: MW OCAC 03

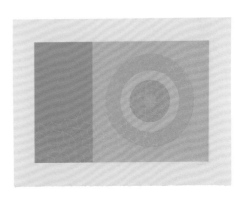

Transit, 2004
Six-color lithograph with chine collé on
Kizukishi chine collé and Rives BFK grey
Sheet: 22 × 30 in. (55.9 × 76.2 cm)
Edition of 25 plus BAT, 2 CTP (K/0R), 3 T,
3 CSPI
Printed by Deborah Chaney and TMP Bill
Lagattuta
Published by the Tamarind Institute [TI 04-323]
Edition number lower left, signed and dated
lower right in pencil recto, Tamarind chop
lower left, printer's chop lower right recto

Receive, 2004
Four-color lithograph on brown Yamato, off-white Rives BFK
Sheet: 17 × 20 in. (43.5 × 50.8 cm)
Edition of 25
Printed by Jim Teskey
Published by the Tamarind Institute [TI 04-324]
Edition number lower left, signed and dated lower right in pencil recto, Tamarind chop lower left, printer's chop lower right recto

Three Ladders, 2005
Lithograph with chine collé on natural Sekishu white Somerset satin
Sheet: 12 × 18 in. (30.5 × 45.7 cm)
Edition of 20
Printed by TMP Bill Lagattuta
Published by the Tamarind Institute [TI 04-325]
Edition number lower left, signed and dated lower right in pencil recto, Tamarind chop lower left, printer's chop lower right recto

Lodge, 2005
Two-color woodcut on Somerset satin white
Image: 8 × 6 in. (20.3 × 15.2 cm)
Sheet: 16½ × 14 in. (41.9 × 35.6 cm)
Edition of 20
Printed by TMP Frank Janzen
Published by Crow's Shadow Institute of the Arts [CSP 05-601]
Edition number lower left, titled lower center, signed in pencil lower right recto, print number verso lower right, CSP chop embossed lower left, printer's chop embossed lower right

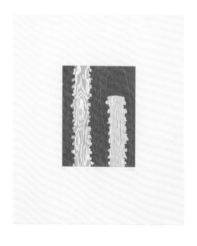

Mend, 2005
Four-color woodcut on Somerset satin white
Image: 8 × 6 in. (20.3 × 15.2 cm)
Sheet: 16½ × 14 in. (41.9 × 35.6 cm)
Edition of 20
Printed by TMP Frank Janzen
Published by Crow's Shadow Institute of the Arts [CSP 05-602]
Edition number lower left, titled lower center, signed in pencil lower right recto, print number verso lower right, CSP chop embossed lower left, printer's chop embossed lower right

Ladder, 2005
Two-color woodcut on Somerset satin white
Image: 8 × 6 in. (20.3 × 15.2 cm)
Sheet: 16½ × 14 in. (41.9 × 35.6 cm)
Edition of 20
Printed by TMP Frank Janzen
Published by Crow's Shadow Institute of the Arts [CSP 05-603]
Edition number lower left, titled lower center, signed in pencil lower right recto, print number verso lower right, CSP chop embossed lower left, printer's chop embossed lower right

Door, 2005
Two-color woodcut on Somerset satin white
Image: 8 × 6 in. (20.3 × 15.2 cm)
Sheet: 16½ × 14 in. (41.9 × 35.6 cm)
Edition of 20
Printed by TMP Frank Janzen
Published by Crow's Shadow Institute of the Arts [CSP 05-604]
Edition number lower left, titled lower center, signed in pencil lower right recto, print number verso lower right, CSP chop embossed lower left, printer's chop embossed lower right

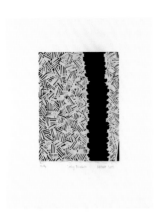

Seeing Blankets, 2005
Linocut with chine collé
Sheet: 14 × 11 in. (35.6 × 27.9 cm)
Edition of 3
Printed by the artist for an invitational portfolio
organized by Melanie Yazzie
Edition number lower left, titled center, signed
and dated in pencil lower right recto

Blanket Stories: Continuum (Book I), 2007
Six-color lithograph with chine collé on natural
Sekishu/white Arches Cover
Image: 15¼ × 22⅜ in. (38.7 × 56.8 cm)
Sheet: 22¼ × 30 in. (56.5 × 76.2 cm)
Edition of 16
Printed by senior printer Aaron Shipps under
the supervision of TMP Bill Lagattuta
Published by the Tamarind Institute [TI 07-801]
Signed in pencil lower right in pencil recto,
Tamarind chop lower left, printer's chop lower
right

Blanket Stories: Continuum (Book I/Book III),
2007
Six-color lithograph with chine collé on natural
Sekishu/white Arches Cover
Image: 15⅜ × 22¼ in. (39 × 56.5 cm)
Sheet: 22¼ × 30 in. (56.5 × 76.2 cm)
Edition of 60
Printed by TMP Bill Lagattuta and Brooke
Steiger
Published by the Tamarind Institute [TI 07-802]
Editioned lower left, signed and dated in pencil
lower right recto, Tamarind chop lower left,
printer's chop lower right recto

Untitled (Flag Raising at Iwo Jima), 2008
Etching
Image: 16 × 11¾ in. (40.6 × 29.8 cm)
Sheet: 17¼ × 13¼ in. (43.8 × 33.7 cm)
Trial proof made at the Lower East Side
Printshop

Untitled (Jim Thorpe), 2008
Etching
Image: 15¾ × 12 in. (40 × 30.5 cm)
Sheet: 22½ × 15½ in. (57 × 39.4 cm)
Trial proof made at the Lower East Side
Printshop

Untitled (Dwight Eisenhower), 2008
Etching
Image: 8¼ × 6½ in. (21 × 16.5 cm)
Trial proof made at the Lower East Side
Printshop

Untitled (Ballad of Ira Hayes), 2008
Etching
Image: 16 × 12 in. (40.6 × 30.5 cm)
Sheet: 22½ × 15¼ in. (57 × 38.7 cm)
Trial proof made at the Lower East Side
Printshop

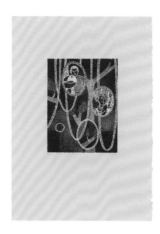

Loom: Betty Feves, Hilda Morris, and Amanda Snyder (off stage), 2009
Lithograph with light-blue Mulberry chine collé on Fabriano Rosaspina cream
Image: 8⅞ × 7 in. (25.6 × 17.8 cm)
Sheet: 19½ × 14⅛ in. (49.5 × 35.9 cm)
Edition of 30
Printed by Mark Mahaffey
Published by the Friends of the Gilkey Center
Edition number lower left, signed and dated lower right in pencil recto

Tether, 2011
Two-color woodcut on Somerset satin white
Image: 11¾ × 7¹⁵/₁₆ in. (29.9 × 20.2 cm)
Sheet: 20¾ × 16 in. (52.7 × 40.6 cm)
Edition of 20
Printed by TMP Frank Janzen
Published by Crow's Shadow Institute of the Arts [CSP 11-602]
Edition number lower left, titled lower center, signed and dated in pencil lower right recto, printer's chop embossed lower right, CSP chop embossed lower left

Plow, 2011
Two-color woodcut on Somerset satin white
Image: 11¾ × 7¹⁵/₁₆ in. (29.9 × 20.2 cm)
Sheet: 20¾ × 16 in. (52.7 × 40.6 cm)
Edition of 20
Printed by TMP Frank Janzen
Published Crow's Shadow Institute of the Arts [CSP 11-603]
Edition number lower left, titled lower center, signed and dated in pencil lower right recto, printer's chop embossed lower right, CSP chop embossed lower right

Camp, 2011
Two-color woodcut on Somerset satin white
Image: 11¾ × 7¹⁵/₁₆ in. (29.9 × 20.2 cm)
Sheet: 20¾ × 16 in. (52.7 × 40.6 cm)
Edition of 20
Printed by TMP Frank Janzen
Published by Crow's Shadow Institute of the Arts [CSP 11-604]
Edition number lower left, titled lower center, signed and dated lower right in pencil recto, printer's chop embossed lower right, CSP chop embossed lower right

Vest, 2011
Two-color woodcut on Somerset satin white
Image: 11¾ × 7¹⁵/₁₆ in. (29.9 × 20.2 cm)
Sheet: 20¾ × 16 in. (52.7 × 40.6 cm)
Edition of 20
Printed by TMP Frank Janzen
Published by Crow's Shadow Institute of the Arts [CSP 11-605]
Edition number lower left, titled lower center, signed and dated lower right in pencil recto, printer's chop embossed lower right, CSP chop embossed lower right

Landmark: Water/Sky (Summit), 2013
Etching
Image: 9⅝ × 9¾ in. (24.4 × 24.8 cm)
Sheet: 18¾ × 15½ in. (47.6 × 39.4 cm)
Edition of 1
Printed by the artist at Yirrkala, Northern Territory, Australia
Signed and dated lower right in pencil recto, titled verso

Landmark: Curtain (India Blanket), 2013
Etching
Image: 9¾ × 9⅝ in. (24.8 × 24.4 cm)
Sheet: 13¾ × 13¾ in. (34.9 × 34.9 cm)
Edition of 1
Printed by the artist at Yirrkala, Northern Territory, Australia
Signed and dated lower right in pencil recto, titled verso

Landmark: Skywalker, 2013
Three-color lithograph on Somerset satin white
Image and sheet: 11 × 10 in. (28 × 25.5 cm)
Edition of 15
Proofed to BAT by Adrian Kellett and Jill Graham
Edition printed by TMP Bill Lagattuta
Published by Tamarind Institute [TI 13-343]
Edition number lower left, signed and dated lower left in pencil recto, Tamarind chop lower left

Landmark: Mound Builder, 2013
Five-color lithograph on newsprint grey Somerset satin
Image and sheet: 11 × 10 in. (28 × 25.5 cm)
Edition of 15
Proofed to BAT by Adrian Kellett and Jill Graham
Edition printed by senior printer Jill Graham under the supervision of TMP Bill Lagattuta
Published by Tamarind Institute [TI 13-344]
Edition number lower left, signed and dated lower right in pencil recto, Tamarind chop lower left

Landmark: A Thousand Names, 2013
Two-color lithograph on newsprint grey Somerset velvet
Image and sheet: 11 × 10 in. (28 × 25.5 cm)
Edition of 15
Printed by Adrian Kellett, Jill Graham, and Bill Lagattuta, TMP
Published by Tamarind Institute [TI 13-345]
Edition number lower left, signed and dated lower right in pencil recto, Tamarind chop lower left

Artifact, 2014
Softground etching with drypoint and burnishing on Hahnemühle warm white
Image: 11⅞ × 12¾ in. (30.1 × 32.4 cm)
Sheet: 17 × 17 in. (43.2 × 43.2 cm)
Edition of 10
Printed by Julia D'Amario and Kathy Keuhn
Published by the Sitka Center for Art & Ecology [MKW 2014-2]
Edition number lower left, signed in pencil lower right recto, signed and dated in pencil lower left verso

Portrait with Chair Caning (Part I), 2014
Softground etching on Hahnemühle warm
white
Image and sheet: 18 × 18 in. (45.7 × 45.7 cm)
Edition of 10
Printed by Julia D'Amario
Published by the Sitka Center for Art and
Ecology [MKW 2014-1]
Edition number lower left, signed in pencil
lower right recto, signed and dated in pencil
lower left verso

Portrait with Chair Caning (Part II), 2014
Softground etching and aquatint on
Hahnemühle warm white
Image: 8¾ × 7½ in. (22.2 × 19 cm)
Sheet: 10 × 7½ in. (25.4 × 19 cm)
Edition of 10
Printed by Julia D'Amario and Kathy Kuehn
Published by the Sitka Center for Art and
Ecology [MKW 2014-5]
Signed lower right recto

Transportation Object (Sunset), 2014
Softground etching, sugar lift, and aquatint on
Hahnemühle warm white
Image: 6 × 8 in. (15.2 × 20.3 cm)
Sheet: 11 × 12 in. (27.9 × 30.5 cm)
Edition of 10
Printed by Julia D'Amario and Kathy Kuehn
Published by the Sitka Center for Art and
Ecology [MKW 2014-4]
Edition number lower left, signed in pencil
lower right recto

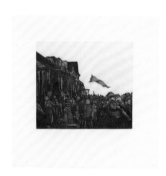

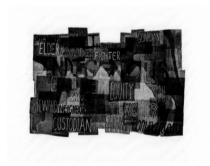

Witness (Quamichan Potlatch, 1913), 2014
Aquatint and whiteground etching with
burnishing on Hahnemühle warm white
Image: 7 × 8 in. (17.8 × 20.3 cm)
Sheet: 12 × 12 in. (30.5 × 30.5 cm)
Edition of 10
Printed by Julia D'Amario and Kathy Keuhn
Published by the Sitka Center for Art and
Ecology [MKW 2014-3]
Edition number lower left, signed in pencil
lower right recto, signed and dated in pencil
lower left verso

Companion Species (Words), 2017
Softground etching, aquatint, drypoint, and
burnishing on medium-weight, smooth,
warm white Hahnemühle
Sheet: 16½ × 22¼ in.
(41.9 × 56.5 cm)
Edition of 20
Printed by Julia D'Amario
Smith College Print Workshop
Edition number lower left, signed and dated
lower right

Companion Species (Mother), 2017
Softground etching, aquatint, drypoint, and
burnishing on medium-weight, smooth, warm
white Hahnemühle
Sheet: 16½ × 22¼ in. (41.9 × 56.5 cm)
Edition of 20
Printed by Julia D'Amario
Smith College Print Workshop
Edition number lower left, signed and dated
lower right in pencil recto

Companion Species (What's Going On), 2017
Four-color woodcut on Somerset satin white
Image and sheet: 17½ × 18½ in. (44.5 × 47 cm)
Edition of 14
Printed by TMP Frank Janzen
Published by Crow's Shadow Institute of the
Arts [CSP 17-601]
Edition number verso lower left, signed in
pencil verso lower right, titled verso center,
print number verso lower right, CSP chop
embossed lower left, printer's chop embossed
lower right

Companion Species (Anthem), 2017
Four-color woodcut on Somerset satin white
Image and sheet: 17½ × 18½ in. (44.5 × 47 cm)
Edition of 14
Printed by TMP Frank Janzen
Published by Crow's Shadow Institute of the
Arts [CSP 17-602]
Edition number verso lower left, signed in
pencil verso lower right, titled verso center,
print number verso lower right, CSP chop
embossed lower left, printer's chop embossed
lower right

Companion Species (Summoning), 2020
Softground etching
Sheet: 10 × 12 in. (25.4 × 30.5 cm)
Edition of 20
Printed by Julia D'Amario
Published by the Sitka Center for Art and
Ecology for 20th Anniversary Folio

Companion Species (Malleable / Brittle), 2021
Softground etching
16½ × 21½ in. (41.9 × 54.6 cm) each
Edition of 5
Printed by Julia D'Amario
Published by the Sitka Center for Art and
Ecology
Edition number lower left in pencil recto
(*Sapling* sheet), signed lower right in pencil
recto (*Flint* sheet)

Note: considered as a single work (diptych)

Companion Species (Benevolent / Trickster),
2021
Softground etching and burnishing
16½ × 21½ in. (41.9 × 54.6 cm) each
Edition of 5
Sheet: 16½ × 22 in. (41.9 × 55.9 cm)
Printed by Julia D'Amario at the Sitka Center for
Art and Ecology
Edition number lower left in pencil recto,
signed lower right in pencil recto

Note: considered as a single work (diptych)

Companion Species (Rock Creek, Ancestor, What's Going On), 2021
Lithography and pressure print on Japanese kozo, collage, and backed with Sekishu
Unique print
40 × 96 in. (est.)
Printed by Paul Mullowney and Harry Schneider at Mullowney Printing
Edition number, signed lower right in pencil recto

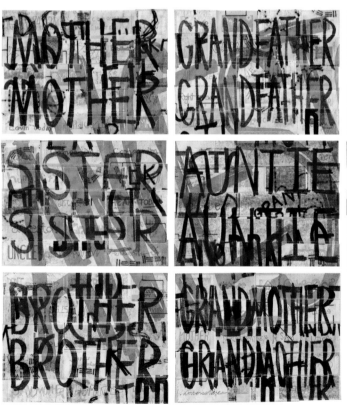

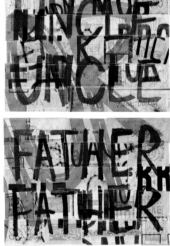

Companion Species (Passage), 2021
Pressure print on Japanese kozo, collage, and backed with Sekishu
72 × 96 in. (182.9 × 243.8 cm); each panel
23½ × 31½ in. (59.7 × 80 cm)
Suite of 8 unique prints
Printed by Paul Mullowney and Harry Schneider at Mullowney Printing
Edition number, signed lower right in pencil recto, printer's chop (blind stamp) lower right

BIBLIOGRAPHY

ahtone, heather, et al. *Crow's Shadow Institute of the Arts at 25*. Seattle: University of Washington Press, 2017.

Ash-Milby, Kathleen. "Landscape: Through an Interior View." In *The Land Has Memory: Indigenous Knowledge, Native Landscapes, and the National Museum of the American Indian*, edited by Duane Blue Spruce and Tanya Thrasher, 71–79. Chapel Hill: University of North Carolina Press, 2008.

Barber, Cynthia. "Feeling the Pulse." *Printmaking Today* 15, nos. 2–3 (Summer–Autumn 2006): 24–25.

Berlo, Janet Catherine. "Back to the Blanket: Marie Watt and the Visual Language of Intercultural Encounter." In *Into the Fray: The Eiteljorg Fellowship for Native American Fine Art*, edited by James Nottage, 111–21. Indianapolis: Eiteljorg Museum of American Indians and Western Art; Seattle: University of Washington Press, 2005.

Besaw, Mindy N. "Marie Watt." In *Art for a New Understanding: Native Voices, 1950s to Now*, edited by Mindy N. Besaw, Candice Hopkins, and Manuela Well-Off-Man, 180. Fayetteville: University of Arkansas Press, 2018.

Bilyeu, Elizabeth Anne. *Witness: Themes of Social Justice in Contemporary Printmaking and Photography: From the Collections of Jordan D. Schnitzer and His Family Foundation*. Portland: Jordan D. Schnitzer Family Foundation in association with Hallie Ford Museum of Art, Willamette University, 2018.

Cipolle, Alex V. "Increasing Exposure for Native Artists," *New York Times*, March 15, 2019.

Cowan, Alison Leigh. "A Pile of Blankets, with Personal History Woven into the Fabric." *New York Times*, August 25, 2006.

Cullen, Cecily. *Cross Currents*. Denver: Center for Visual Art, Metropolitan State University of Denver, 2014. https://issuu.com/centerforvisualart/docs/currentsbook_1-16-14.

Dobkins, Rebecca J. *Marie Watt: Lodge*. Salem, OR: Hallie Ford Museum of Art, Willamette University, 2012.

Ferranto, Matt. "Marie Watt: The Blanket Project at the National Museum of the American Indian." *Art on Paper* 9, no. 3 (2005).

Fowler, Cynthia. "Materiality and Collective Experience: Sewing as Artistic Practice in Work by Marie Watt, Nadia Myre, and Bonnie Devine." *American Indian Quarterly* 34, no. 3 (Summer 2010): 344–64.

Harris, Alicia. "These Objects Call Us Back: Kinship Materiality in Native America." In *Inappropriate Bodies: Art, Design, and Maternity*, edited by Rachel Epp Buller and Charles Reeve, 213–26. Bradford, ON: Demeter Press, 2019.

Kinkel, Marianne. "Cultivating Companion Conversations." In *Marie Watt: Companion Species Calling Companion Species: Work, 2016–2018*, 3–20. Seattle: Greg Kucera Gallery, 2018.

Klein, Richard. *No Reservations: Native American Art History and Culture in Contemporary Art*. Ridgefield, CT: Aldrich Contemporary Art Museum, 2006.

Lovelace, Joyce. "Gather Round: Connecting the Circle of Community Drives Marie Watt's Multifaceted Work," *American Craft Magazine* 77, no. 2 (April/May), 2017.

McDonald, Fiona P. "Marie Watt and an Ecology of Cultural Imagination." *Surface Design Journal* 41, no. 3 (Fall 2017): 12–17.

Mithlo, Nancy Marie. *Knowing Native Arts*. Lincoln: University of Nebraska Press, 2020.

Ortiz, Simon J. "Oopuh: 'Come In.'" In *Marie Watt: Blanket Stories: Almanac*, 13–22. Casper, WY: Nicolaysen Art Museum, 2006.

Rickard, Jolene. "Visualizing Sovereignty in the Time of Biometric Sensors." *South Atlantic Quarterly* 110, no. 2 (Spring 2011): 465–82.

Russell, Karen Kramer, ed. *Shapeshifting: Transformations in Native American Art*. Salem and New Haven: Peabody Essex Museum in association with Yale University Press, 2012.

Taylor, Larry M. "Indigenous Minimalism: Native Interventions." In *Double Desire: Transculturation and Indigenous Contemporary Art*, edited by Ian McLean, 139–56. Newcastle upon Tyne: Cambridge Scholars, 2014.

Tesner, Linda. *Marie Watt Blanket Stories: Receiving*. Portland, OR: Ronna and Eric Hoffman Gallery of Contemporary Art, Lewis & Clark College, 2005.

Thompson, Kara. *Blanket*. New York: Bloomsbury, 2018.

Watt, Marie. "Marie Watt." In *Migrations: New Directions in Native American Art*, edited by Marjorie Devon, 116–25. Albuquerque: University of New Mexico Press, 2006.

Watt, Marie. "In Conversation with Marie Watt: A New Coyote Tale," *Art Journal* 76, no. 2 (Summer 2017): 124–35.

Watt, Marie. "Marie Watt." In *Indelible Ink: Native Women, Printmaking, Collaboration*, edited by Mary Statzer, 30–31. Albuquerque: University of New Mexico Art Museum, 2020. https://issuu.com/unmartmuseum/docs /online_magazine__1_.

White Hawk, Dyani. "Stacks of Generational Wisdom: Marie Watt." In *Hearts of Our People: Native Women Artists*, edited by Jill Ahlberg Yohe and Teri Greeves, 238–41. Minneapolis and Seattle: Minneapolis Institute of Art in association with the University of Washington Press, 2019.

JOHN P. MURPHY is the Philip and Lynn Straus Curator of Prints and Drawings at the Frances Lehman Loeb Art Center, Vassar College. From 2018 to 2021 he served as the Hoehn Curatorial Fellow for Prints at the University Galleries, University of San Diego. His research on American art and print culture has appeared in *Print Quarterly, Art in Print, and Nka: Journal of Contemporary African Art.*

DR. JOLENE RICKARD (Skarù·rę? / Tuscarora) is a visual historian, artist, and curator interested in the intersection of Indigenous knowledge and contemporary art, materiality, and ecocriticism with an emphasis on Hodinöhsö:ni' aesthetics. She is an associate professor in the Departments of History of Art and Art and the former director (2008–20) of the American Indian and Indigenous Studies Program (AIISP) at Cornell University. Jolene is from the Skarù·rę? / Tuscarora Nation (Turtle Clan), Hodinöhsö:ni' Confederacy.

ALSO PUBLISHED BY THE JORDAN SCHNITZER FAMILY FOUNDATION

**Roy Lichtenstein:
Prints, 1956–1997 from
the Collections of
Jordan D. Schnitzer and
His Family Foundation**

Hardcover, 80 pages
ISBN: 978-0975566213

**John Buck:
Iconography**

Hardcover, 144 pages
ISBN: 978-0910524377

**John Baldessari:
A Catalogue Raisonné
of Prints and Multiples,
1971–2007**

Hardcover, 408 pages
ISBN: 978-1555952907

**John Baldessari:
A Print Retrospective
from the Collections of
Jordan D. Schnitzer and
His Family Foundation**

Hardcover, 160 pages
ISBN: 978-1935202103

Letters to Ellsworth

Hardcover, 152 pages
ISBN-13: 978-0984986408

**The Prints of Ellsworth Kelly:
A Catalogue Raisonné**

2 volumes
Hardcover with slipcase,
870 pages
ISBN: 978-0984986422

**Frank Stella: Prints:
A Catalogue Raisonné**

Hardcover, 432 pages
ISBN: 978-0692587072

Andy Warhol Prints

Hardcover, 184 pages
ISBN: 978-0692764473

**Beyond Mammy,
Jezebel & Sapphire:
Reclaiming Images of
Black Women**

Hardcover, 80 pages
ISBN: 978-0692803172

**Amazing!
Mel Bochner Prints
from the Collections of
Jordan D. Schnitzer and
His Family Foundation**

Hardcover, 256 pages
ISBN: 978-1732321205

**Witness: Themes
of Social Justice
in Contemporary
Printmaking and
Photography from
the Collections of
Jordan D. Schnitzer
and His Family
Foundation**

Hardcover, 160 pages
ISBN 978-0-692-16298-9

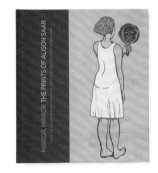

**Mirror, Mirror: The Prints
of Alison Saar from the
Collections of Jordan D.
Schnitzer and His Family
Foundation**

Hardcover, 128 pages
ISBN: 978-1-7323212-1-2

**Global Asias:
Contemporary Asian and
Asian American Art from
the Collections of
Jordan D. Schnitzer and
His Family Foundation**

Hardcover, 104 pages
ISBN: 978-1-7323212-3-6

**The Art of Food
from the Collections of
Jordan D. Schnitzer and
His Family Foundation**

Hardcover, 128 pages
ISBN: 978-1-7323212-4-3

Published by the Jordan Schnitzer Family Foundation

© 2022 by the Jordan Schnitzer Family Foundation, Portland, OR

Works of art © Marie Watt, except as noted

Texts © by the authors

Designed by Phil Kovacevich

Edited by Carolyn Vaughan

Proofread by Carrie Wicks

All measurements are given in inches followed by centimeters. Height proceeds width.

Cover: *Companion Species (Rock Creek, Ancestor, What's Going On)*, 2021, lithography and pressure print on Japanese kozo, collage, and backed with Seikshu (detail of pp. 148–49)

Frontispiece: *Door*, 2005, woodcut (detail of p. 105)

p. 6: *Blanket Stories: Great Grandmother, Pandemic, Daybreak*, 2021, reclaimed blankets, manila tags, cedar (detail of fig. 13, p. 28)

p. 9: *Tether*, 2011, woodcut (detail of p. 115)

p. 10: *Omphalos*, 2002, lithograph (detail of p. 83)

p. 152: Marie Watt at Smith College

ISBN: 978-1-7323212-5-0

Library of Congress Control Number: 2021922881

Printed in Italy

Photography Credits

Bill Bachuber: *Braid*, 2004

Heard Museum, Platt Photography: *Companion Species (Field)*, 2017

Courtesy of the IAIA Museum of Contemporary Native Arts: *When More Than Knees Have Been Wounded*, 1990

Aaron Johanson: *Threshold*, 2006, *Witness*, 2015, *Companion Species (Fortress)*, 2017

Kevin McConnell: *Corn Husk Turtle Mask*, 1992, *Corn Husk Turtle Mask (Ghost Proof)*, 1992, *Untitled (Braid Variations) I–VI*, c. 1996, *Seeing Blankets*, 2005, *Untitled (Flag Raising at Iwo Jima)*, 2008, *Untitled (Jim Thorpe)*, 2008, *Untitled (Dwight Eisenhower)*, 2008, *Untitled (Ballad of Ira Hayes)*, 2008, *Companion Species (Summoning)*, 2020, *Blanket Stories: Great Grandmother, Pandemic, Daybreak*, 2021, *Companion Species (Tree and Stone)*, 2021

Strode Photographic, LLC: *Three Rocks*, 2002, *Cloud/Dust*, 2002, *Loom: Betty Feves, Hilda Morris, and Amanda Snyder (off stage)*, 2009, *Portrait with Chair Caning (Part I)*, 2014, *Portrait with Chair Caning (Part II)*, 2014, *Transportation Object (Sunset)*, 2014, *Witness (Quamichan Potlatch, 1913)*, 2014, *Companion Species (Cosmos)*, 2017, *Companion Species (Listening)*, 2017, p. 159

Courtesy of University of San Diego: *Portal*, 2002, *Omphalos*, 2002, *Guardian*, 2002, *Sanctuary*, 2002, *Flag*, 2003, *Blanket Stories: Continuum (Book I/Book III)*, 2007, *Landmark: Curtain (India Blanket)*, 2013, *Seven Sisters (Shadow Plaid)*, 2016, Gocco prints

Courtesy of Marie Watt Studio: pp. 24, 40, 46, 48, 49, 152, 162, 167, 169, 170

Aaron Wessling Photography: *Untitled (Corn Husk Study—Parting)*, *Untitled (Corn Husk Study—Alone)*, *Untitled (Corn Husk Study—Pair)*, 1996, *Untitled (Corn, lozenge, brick study)*, c. 1998, *Untitled*, 2000, *Blanket Relative*, 2002, *Proposal (Variation)*, 2002, *Gate*, 2002, *Curtain*, 2002, *Untitled*, 2002, *Proposal*, 2002, *Star Quilt*, 2003, *Blankets*, 2003, *Braid*, 2003, *Letter Ghost*, 2003, *Transit*, 2004, *Receive*, 2004, *Three Ladders*, 2005, *Lodge*, 2005, *Mend*, 2005, *Ladder*, 2005, *Door*, 2005, *Almanac: Glacier Park, Granny Beebe, and Satin Ledger*, 2006, *Blanket Stories: Continuum (Book I)*, 2007, *Tether*, 2011, *Plow*, 2011, *Camp*, 2011, *Vest*, 2011, *Cradle*, 2011, *Landmark: Water/Sky (Summit)*, 2013, *Landmark: Skywalker*, 2013, *Landmark: Mound Builder*, 2013, *Landmark: A Thousand Names*, 2013, *Artifact*, 2014, *East Meets West Summit*, 2014, *Mound Builder*, 2014, *Companion Species (Words)*, 2017, *Companion Species (Mother)*, 2017, *Companion Species (Ancient One)*, 2017, *Companion Species (What's Going On)*, 2017, *Companion Species (Anthem)*, 2017, *Companion Species (Malleable/Brittle)*, 2021, *Companion Species (Benevolent/Trickster)*, 2021, *Companion Species (Rock Creek, Ancestor, What's Going On)*, 2021, *Companion Species (Passage)*, 2021, p. 25